COLORFUL
crochet lace

22 chic garments & accessories

BY

Mary Jane Hall

 INTERWEAVE.
interweave.com

EDITOR Michelle Bredeson

TECHNICAL EDITOR Karen Manthey

ASSOCIATE ART DIRECTOR
Charlene Tiedemann

COVER DESIGN Bekah Thrasher

INTERIOR DESIGN Brenda Gallagher

PHOTOGRAPHER Joe Hancock

PHOTO STYLIST Allie Liebgott

HAIR AND MAKEUP Kathy MacKay

PRODUCTION Kerry Jackson

 Interweave
A division of F+W Media, Inc.
4868 Innovation Drive
Fort Collins, CO 80525
interweave.com

Manufactured in China by RR
Donnelley Shenzhen.

Library of Congress Cataloging-in-
Publication Data

Hall, Mary Jane.
 Colorful crochet lace : 22 chic
garments & accessories / Mary Jane
Hall.
 pages cm
 Includes index.
 ISBN 978-1-62033-698-4 (pbk.)
 ISBN: 978-1-62033-699-1 (PDF)
1. Crocheting–Patterns. 2. Lace and
lace making. 3. Dress accessories.
I. Title.
 TT825.H256278 2015
 746.43'4--dc23

2014043818
10 9 8 7 6 5 4 3 2 1

Dedication

I'm dedicating this book to my three children,
Brian, Jamie, and Tracy, as well as to my six precious
grandchildren, who are the delights of my heart.
Aside from God Almighty, you are the reason I can
go on even with the heartaches and trials I've had to
endure. I'm so thankful God allowed me to "borrow"
you for a little while when you were growing up,
and I give Him the glory for everything good and
wonderful in my life!

Contents

Introduction

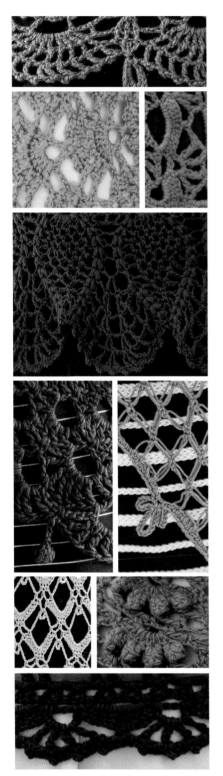

If you picked up this book, it's probably because, like me, you're a lover of crocheted lace. Fashion designers have jumped on the lace crochet bandwagon, showing massive amounts of crocheted lace dresses, tops, skirts, suits, capes, scarves, hats, and bags, and I believe the thousands of crocheters out there will not allow this trend to go away any time soon. The demand is plainly there, and I, a crochet addict myself, am happy to fill their desires by creating easy, wearable pieces for every occasion.

Why do we love lacy things? I don't know about you, but lace appeals to my feminine side as well as reminding me of old-fashioned things like antique furniture, our great-grandparents, romance, and eras gone by of a slower life. Crocheted lace makes me feel connected in a wonderful way with my ancestors, and I love the nostalgic feeling that goes along with it.

But lace has evolved in a good way. Lace garments were once reserved for very dressy occasions, such as weddings, christenings, proms, or a night at the opera. But you'd have to have your head stuck in the sand the last few years to not notice how lace garments have even become everyday apparel. I think our great-great-grandmothers would roll over in their graves if they knew we'd be wearing a lacy top with denim jeans—and holes in them at that! (Actually, they'd probably be shocked to know a woman would be wearing pants—period!)

What Is Lace Anyway?
If you're interested in the history of lace, there are numerous books on the subject, such as *Legacy of Lace: Identifying, Collecting, and Preserving American Lace* by Kathleen Warnick and Shirley Nilsson (Crown, 1988). Crocheted and knitted lace are very popular, but also included in this category are tatting, hairpin or broomstick lace, and knotted lace such as macramé, Bruges lace, bobbin lace, Battenberg lace, and Romanian lace, to name just a few. "What is lace?" may seem like an unnecessary question, but I was curious as to what others would say, so I did an informal survey asking both men and women what their definition of lace is. Surprisingly, I got a variety of interesting answers. The first was, "It's fabric with holes." I had to laugh, but that's one way of putting it. Someone else said, "Intricate patterns that are open with a darker or lighter color in the background allowing the stitches to show up." Others replied, "It's a delicate, frilly fabric, usually loose, open, feminine, and pretty." One of the best answers was, "Lace is a lightweight and airy material with designs in it." I agree with all these answers and wanted to present projects that represent these definitions as well as other ways of looking at crocheted lace.

Variety Is the Spice of Crochet
Some of my lace garment and accessory designs may have a Victorian look with the ever-so-popular shell and fan stitch patterns, but you won't find high necklines, corsets, or skirts that graze the ground here. I have modernized my lace designs

to fit the trends of today. Some are very feminine, but others are simple openwork patterns. If you're not a fan of the frilly and feminine look, but like the openness of lace overlay to be worn over other clothing, there are plenty of everyday, casual lace designs in my collection. You'll find open patterns with squares, long chains, picots, pineapples, popcorns, puffs, the lover's knot, and many special edgings.

I used a variety of yarns to showcase the versatility of crocheted lace, so you'll see some very lightweight lace designs as well as some made with fingering, sport, and DK yarns in a variety of fibers, such as cotton, linen, bamboo, wool, and silk. I even threw a chunky lace neck warmer into the mix to show how lace can be created with heavier yarns. I'm hoping to draw in the newer crocheter who is afraid to work with fine yarns and has only worked with heavier ones.

If you're already familiar with my designs, you know that I have a passion for creating a variety of crochet projects. I love designing both garments and accessories with easy construction, but I hope you'll be challenged with some of the more intermediate or advanced designs. As an added bonus, for many projects, I give instructions for variations: how to lengthen a top to be made into a tunic or dress, how to add sleeves, or even how to make the bags much larger.

Color My World

It used to be that when we thought of crocheted lace, all that came to mind were doilies, tablecloths, and other items worked in white, ecru, or ivory. But not anymore! There are many colorful crocheted garments and accessories everywhere.

Colors make me smile as much as lace does. I just get happy when I see deep, rich jewel tones or a combination of colors from the color wheel. I created a Pinterest board called "Color My World." When I want to be cheered up all I have to do is go there; the images calm my senses and give me such a sense of peace. Colors are amazing and help make the world beautiful. I don't know about you, but I think this world would look pretty boring without colors.

My original intent was to choose medium cool colors (my favorites) for all the projects, but as you'll find, I have also included several warm colors, realizing there are just as many people who prefer that color palette. So I hope you find the perfect project for yourself and will be inspired by the colors and fibers I have chosen. And if you love a project, but prefer a different color, don't be afraid to change it! Making something by hand is all about personalizing it for you.

I've been itching to do this book on lace for a while now and hope you will be just as excited as I am that it's finally come to life. I've created a wide variety of projects and hope you'll find a few you just can't wait to get started on! I love seeing your projects, so please look me up on Ravelry, Pinterest, or Facebook and share your photos. If you have questions about a pattern, send me a message. Please enjoy this book, as I've created these designs for you, my friends!

—Mary Jane Hall

LES NOMS

When I was working on this book I was partly inspired by the architecture, fashions, gardens, and culture of Paris and had fun coming up with French-inspired names for the projects. A photo shoot in Paris was out of the budget, but I think we managed quite nicely to capture the feel at a café/ fromagerie and gardens in sunny Colorado!

The Projects

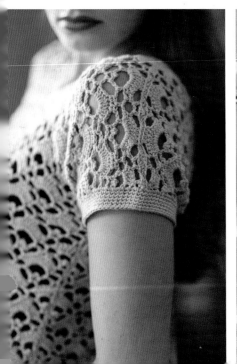

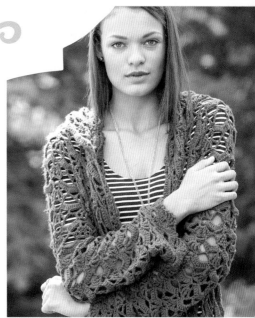
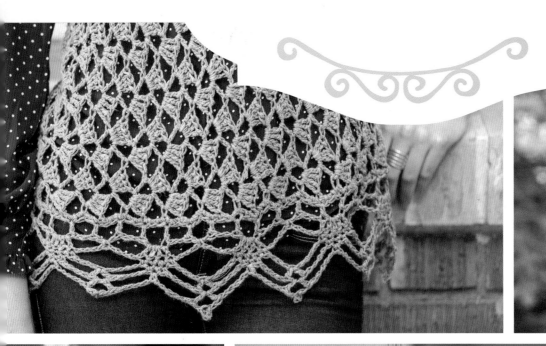

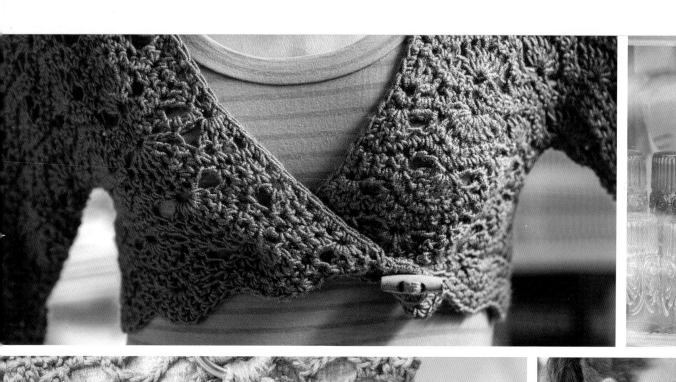

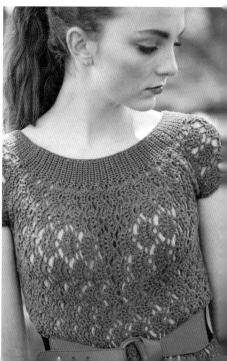

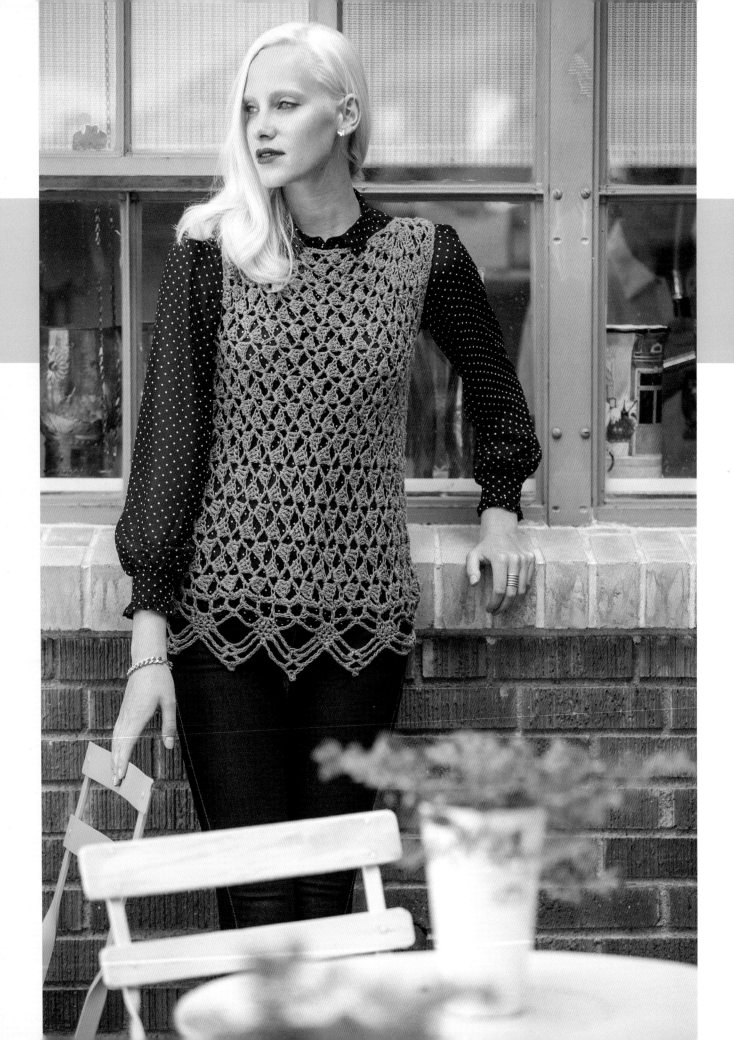

Isabelle
sleeveless tunic

FINISHED SIZES
XS (S, M, L, 1X, 2X, 3X).
Sample shown is size S.

Bust: 33 (36, 39, 42, 45, 48,
51)″ (84 [91.5, 99, 106.5,
114.5, 122, 129.5] cm).

Hips: 44 (48, 52, 56, 60, 64,
68)″ (112 [122, 132, 142,
152.5, 162.5, 173] cm).

Length: 26½ (26½, 26½, 28¼,
28¼, 30, 30)″ (67.5 [67.5,
67.5, 72, 72, 76, 76] cm).

*Note: Instructions are given
for shortening top and for
lengthening to create a longer
top or dress.*

YARN
Sportweight (#2 Fine).

Shown here: Rowan Panama
(55% viscose, 33% cotton,
12% linen; 148 yd [135 m]/1¾
oz [50 g]): #310 Aster, 7 (7, 8,
9, 10, 11, 12) skeins.

HOOKS
Sizes I/9 (5.5 mm) and H/8
(5 mm). Adjust hook size if
necessary to obtain the correct
gauge.

NOTIONS
Stitch markers; yarn needle.

GAUGE
With larger hook, working in
htr-shell pattern, 2 shells and
4 rows in pattern = 4″ (10 cm)
(lower part at hips).

With larger hook, working in
dc-shell pattern, 2 shells and
4 rows in pattern = 3″ (7.5 cm)
(bust and upper back).

Border = 3½″ (9 cm) (from
bottom edge of top to point of
picot).

You'll have this effortless side-to-side garment finished in no time. It uses my Graduated Stitch Method (GSM; see page 152). The lace edging is optional for those who may not like frills, and instructions are given for making the top shorter or lengthening it to make a dress.

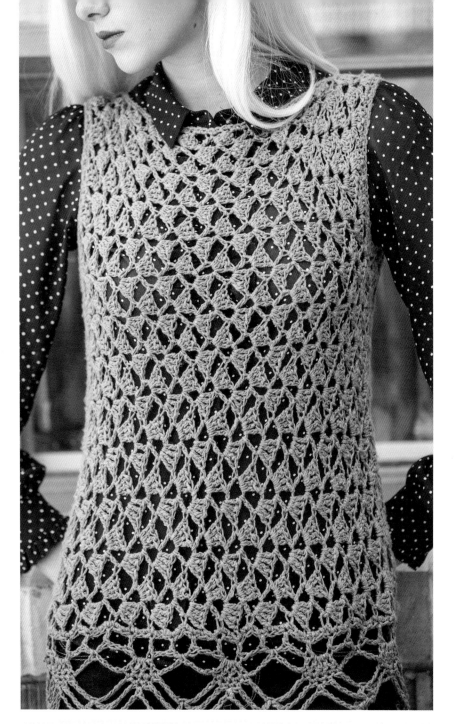

STITCH GUIDE

Half treble crochet (htr):
Yo (twice), insert hook in designated st, yo, draw yarn through st, yo, draw yarn through 2 lps on hook (3 lps on hook), yo, draw yarn through all 3 loops on hook.

Double crochet shell (dc-shell): (4 dc, ch 2, dc) in same st or sp.

Half treble shell (htr-shell): (4 htr, ch 2, htr) in same st or sp.

Picot: Ch 4, sc in 4th ch from hook.

Front/Back (MAKE 2)

Front and back are made in vertical rows beginning at side.

With larger hook, ch 57.

NOTES: *To lengthen top for making a dress, just add to the foundation ch in multiples of 7. To shorten top, subtract sts from your foundation ch in multiples of 7. First 3 rows are at side where side seams will be sewn (below armhole opening).*

Row 1: Sc in 2nd ch from hook and in each ch across, turn—56 sc.

Row 2: Ch 3 (counts as dc on even-numbered rows), skip next 3 sc, *dc-shell in next ch, skip next 6 sc, rep from * 3 times. PM in last dc, *htr-shell in next ch, skip next 6 sc, rep from * twice, htr-shell in last sc, skip 3 sc, htr in last st, turn—4 dc-shells; 4 htr-shells. Move marker up as work progresses.

Row 3: Ch 3 (counts as first htr on odd-numbered rows), htr-shell in each of next 4 ch-2 sps (to next marker), dc-shell in each of next 4 ch-2 sps, dc in top of tch—4 htr-shells; 4 dc-shells.

NOTES

Pattern is worked with my Graduated Stitch Method (GSM, page 152) from side to side with foundation ch at side seam.

Larger shells are worked on the bottom part of skirt to make it wider below the hips.

Place a marker between the last dc-shell and the first htr-shell in Row 2, then move the marker up as work progresses to mark where to change to the other size shell.

All rows are vertical except for the lacy border, which is worked in the round.

STITCH KEY

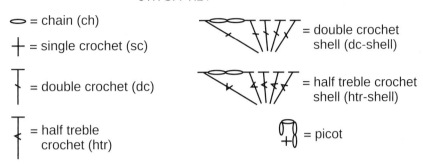

◯ = chain (ch)

✝ = single crochet (sc)

⊤ = double crochet (dc)

⊤ = half treble
crochet (htr)

= double crochet
shell (dc-shell)

= half treble crochet
shell (htr-shell)

= picot

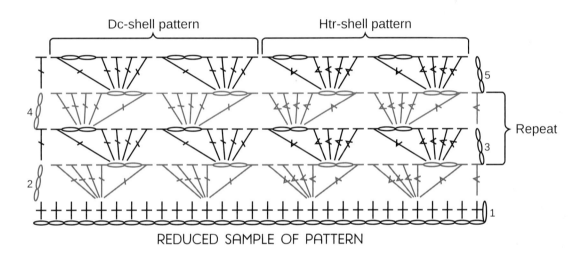

Dc-shell pattern Htr-shell pattern

Repeat

REDUCED SAMPLE OF PATTERN

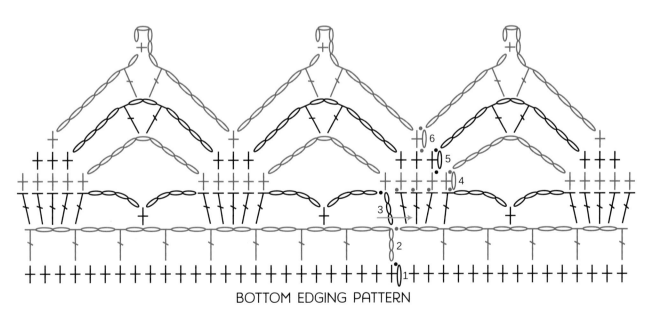

BOTTOM EDGING PATTERN

Sizes L, 1X, 2X, and 3X only

Row 4: Ch 3, dc-shell in each of next 4 ch-2 sps to next marker, htr-shell in each of next 4 ch-2 sps—4 dc-shells; 4 htr-shells.

Row 5: Rep Row 3.

SHAPE FIRST ARMHOLE

Row 1: Ch 30 (30, 30, 37, 37, 44, 44) for armhole, turn, dc-shell in 7th ch from hook, *skip next 6 ch, dc-shell in next ch; rep from * 2 (2, 2, 3, 3, 4, 4) times, dc-shell in each of next 4 ch-2 sps (to next marker), htr-shell in last 4 ch-2 sps, htr in top of tch, turn—8 (8, 8, 9, 9, 10, 10) dc-shells; 4 htr-shells.

Row 2: Ch 3, htr-shell in each of next 4 ch-2 sps (to next marker), dc-shell in each of next 8 (8, 8, 9, 9, 10, 10) ch-2 sps, dc in top of tch—4 htr-shells; 8 (8, 8, 9, 9, 10, 10) dc-shells.

Row 3: Ch 3, dc-shell in each of next 8 (8, 8, 9, 9, 10, 10) ch-2 sps (to next marker), htr-shell in each of next 4 ch-2 sps, htr in top of tch, turn—8 (8, 8, 9, 9, 10, 10) dc-shells; 4 htr-shells.

Rows 4–19 (21, 23, 21, 23, 25, 27): Rep Rows 2–3.

SHAPE SECOND ARMHOLE

Row 1: Ch 3, htr-shell in each of next 4 ch-2 sps to next marker, dc-shell in each of next 4 ch-2 sps, skip next 3 dc, dc in next dc, turn—4 htr-shells; 4 dc-shells.

Row 2: Ch 3, dc-shell in each of next 4 ch-2 sps to next marker, htr-shell in each of next 4 ch-2 sps—4 dc-shells; 4 htr-shells. Fasten off sizes XS, S, and M only.

Sizes L, 1X, 2X, and 3X only

Row 3: Ch 3, dc-shell in each of next 4 ch-2 sps to next marker, htr-shell in each of next 4 ch-2 sps—4 dc-shells; 4 htr-shells.

Row 4: Ch 3, dc-shell in each of next 4 ch-2 sps to next marker, htr-shell in each of next 4 ch-2 sps—4 dc-shells; 4 htr-shells. Fasten off.

TIP: *Hold the front up to your body to see if it fits properly for your size. If not, don't panic. All you have to do is add or delete rows for a custom fit. If the top is too small or too large, add or delete rows in increments of 2 rows to make it 1½" (3.8 cm) larger or 1½" (3.8 cm) smaller.*

SIDE AND SHOULDER SEAMS

With WS of front and back facing, sew side seams. Sew front to back across first 2¼ (2¾, 3¼, 3, 3¼, 3¾, 4¼)" (5.5 [7, 8.5, 7.5, 8.5, 9.5, 11] cm) of shoulders.

ARMHOLE EDGE

With RS facing and smaller hook, join yarn with sl st at bottom of under-arm, ch 1, sc evenly around armhole

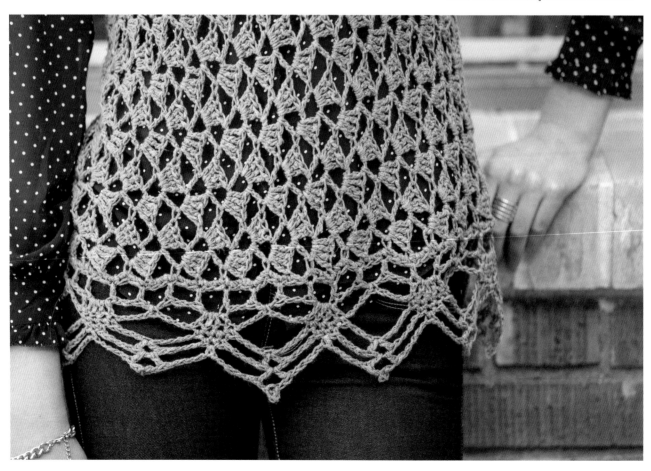

edge, keeping work flat. Try top on and if armhole fits, fasten off yarn. If it's still too big, place 6 markers evenly spaced around entire edge. Work sc around armhole edge, decreasing with sc2tog at markers or skip 1 st at each marker. Fasten off. Rep for other armhole.

NECK EDGE

With RS facing, decide which is the front and which is the back. With size smaller hook, join yarn to any st on back neck edge, ch 1, sc evenly around neck edge, keeping work flat. If you'd like, you can sk one st at each shoulder seam or work sc2tog at those 2 points.

Border for Bottom Edge (MULTIPLE OF 12 STS)

Rnd 1: With larger hook, join yarn with sl st at one side seam, ch 1, work 120 (132, 144, 156, 168, 180) sc evenly spaced around entire bottom edge.

Rnd 2: Ch 5, (counts as first dc, ch 2), skip first 3 sc, *dc in next sc, ch 2, skip

next 2 sc; rep from * around, join with sl st in 3rd ch of beg ch-5, turn—40 (44, 48, 52, 56, 60) ch-2 sps.

Rnd 3: (WS) Ch 3 (counts as dc), *3 dc in next ch-2 sp, dc in next dc, ch 4, sk next ch-2 sp, sc in next ch-2 sp, ch 4, skip next ch-2 sp**, dc in next dc; rep from * around, ending last rep at **, join with sl st in top of tch, do not turn.

Rnd 4: (RS) Sl st in each of next 4 dc, turn, ch 1, starting in same st, *sc in next 5 dc, ch 9, skip next 2 ch-4 sps; rep from * around, join with sl st in first sc.

Rnd 5: Sl st in next sc, ch 1, sc in each of first 3 sc, *ch 4, (dc, ch 2, dc) in center ch of next ch-9, ch 4, sk next sc**, sc in each of next 3 sc; rep from * around, ending last rep at **, join with sl st in first sc.

Rnd 6: Sl st in next sc, ch 1, sc in same st, *ch 5, skip next ch-4 sp, (dc, ch 1, picot, ch 1, dc) in next ch-2 sp, ch 5, skip next sc**, sc in next sc; rep from * around, ending last rep at **, join with sl st in first sc. Fasten off.

Finishing

Weave in ends and secure with Liquid Stitch Fabric Mender or Aleene's Ok to Wash-It so that ends do not ravel during laundering.

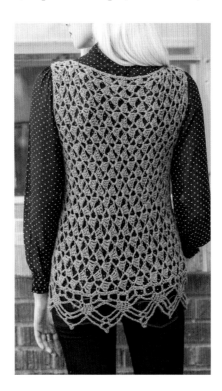

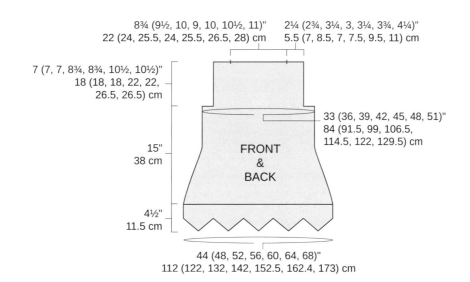

8¾ (9½, 10, 9, 10, 10½, 11)"
22 (24, 25.5, 24, 25.5, 26.5, 28) cm

2¼ (2¾, 3¼, 3, 3¼, 3¾, 4¼)"
5.5 (7, 8.5, 7, 7.5, 9.5, 11) cm

7 (7, 7, 8¾, 8¾, 10½, 10½)"
18 (18, 18, 22, 22, 26.5, 26.5) cm

33 (36, 39, 42, 45, 48, 51)"
84 (91.5, 99, 106.5, 114.5, 122, 129.5) cm

15"
38 cm

FRONT
&
BACK

4½"
11.5 cm

44 (48, 52, 56, 60, 64, 68)"
112 (122, 132, 142, 152.5, 162.4, 173) cm

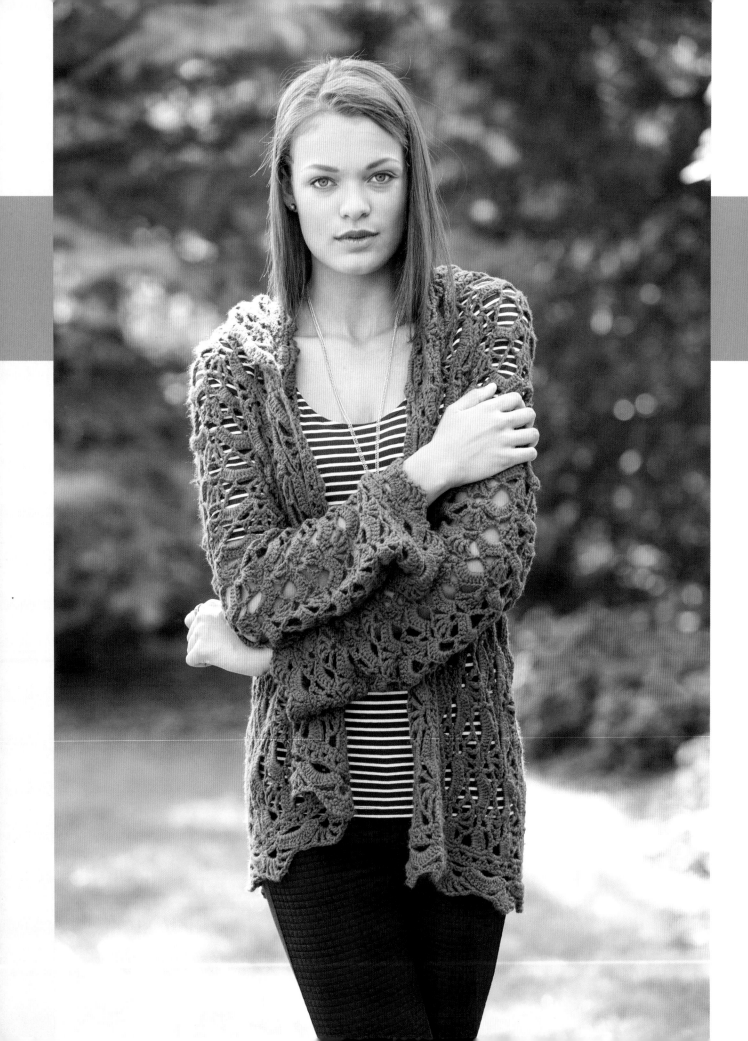

Monique
hooded jacket

FINISHED SIZES
S/M (L, 1X, 2X, 3X). Sample shown is size S/M.

Bust: 42 (46, 52, 56, 60)″ (106.5 [117, 132, 142, 152.5] cm).

Length: 27″ (68.5 cm).

YARN
DK weight (#3 Light).

Shown here: Berroco Comfort DK (50% nylon, 50% acrylic; 178 yd [163 m]/1¾ oz [50 g]): #2753, Agean Sea, 9 (10, 11, 12, 13) skeins.

HOOK
Size H/8 (5 mm). Adjust hook size if necessary to obtain the correct gauge.

NOTIONS
Yarn needle.

GAUGE
(BEFORE BLOCKING)
In body pattern, 1 patt rep = 3″ (7.5 cm); 6 rows = 3½″ (9 cm).

Worked in an airy lace pattern, this jacket is more of a fashion statement than a way to keep warm. Wear it over layers to make it cozier. My fashion- and comfort-loving daughter tried it on and did not want to take it off. She said, "I *have* to have this!"

NOTES

Sweater is worked in 2 main pieces with vertical rows and seamed down the back; the hood is worked separately and sewn on.

Rows are worked vertically in a pretty easy pattern.

This is a wrap sweater. It's meant to be big, so it will overlap in front.

STITCH GUIDE

V-stitch (V-st): (Dc, ch 1, dc) in same st.

Shell: 11 dc in next sp.

Picot: Ch 2, sl st in 2nd ch from hook.

Half treble crochet (htr): Yo (twice), insert hook in designated st, yo, draw yarn through st, yo, draw through 2 lps on hook, yo, draw through all 3 lps on hook.

Half shell: 5 dc in next sp.

Treble crochet shell (tr-shell): Tr, (ch 2, tr) 3 times in same sp.

Right Front and Right Back

Worked in vertical rows, starting at center front/back.

Loosely ch 220 (or use an I/9 (5.5 mm) hook for beg ch only).

NOTE: *For a longer sweater, ch 244 and work 2 extra reps. Keep in mind your sweater will end up a little shorter than your foundation ch, but you also need to know if you use a cotton yarn, which is a heavier yarn, your sweater will stretch and may end up being too long.*

Row 1: (RS) (Dc, ch 1, dc) in 5th ch from hook, *skip next 2 ch, V-st in next ch, rep from * across to within last 2 ch, skip next ch, dc in last ch, turn—72 V-sts.

Row 2: Ch 5 (counts as dc, ch 2), skip next ch-1 sp, sc between next 2 dc, *ch 5, skip next 2 ch-1 sps, sc between next 2 dc, rep from * across to within last ch-1 sp, ch 2, skip next ch-1 sp, skip next dc, dc in 3rd ch of tch, turn—37 ch-5 sps (includes beg ch-5).

Row 3: Ch 3 (counts as dc here and throughout), half shell in next ch-2 sp, *(sc, ch 5, sc) in next ch-5 sp**, shell in next ch-5 sp, rep from * across, ending last rep at **, half shell in next ch-2 sp, dc in 3rd ch of tch, turn—17 shells; 2 half shell; 18 ch-5 sps.

Row 4: Ch 1, sc in first dc, *ch 2, tr-shell in next ch-5 sp, ch 2, skip next 5 dc, sc in next dc; rep from * across, ending with last sc in top of tch, turn—18 tr-shells.

Row 5: Ch 5 (counts as dc, ch 2), skip first ch-2 sp, *sc in next ch-2 sp, ch 5, skip next ch-2 sp, sc in next ch-2 sp**, ch 5, sk next 2 ch-2 sps; rep from * across, ending last rep at **, ch 2, dc in last sc, turn—37 ch-5 lps (includes beg ch-5).

Rows 6–18 (20, 22, 24, 26): Rep Rows 3–5 for patt, ending with Row 3 (5, 4, 3, 5), or to desired width. Fasten off.

Sleeve

PM in center st of last row to mark shoulder.

Sizes S/M and 2X only
Row 1 (Row 4 of patt): With RS facing, skip first 6 repeats (18" [45.5 cm] from right-hand edge), join yarn with sl st in center dc of next shell, ch 1, sc in first dc, *ch 2, tr-shell in next ch-5 sp, ch 2, skip next 5 dc, sc in next dc; rep from * 5 times, turn, leaving rem sts unworked—6 tr-shells.

Rows 2–6: Starting with Row 5, work even in patt for 5 rows, ending with Row 3 of patt.

Sizes L and 3X only
Row 1 (Row 5 of patt): With RS facing, skip first 6 tr-shells (18" [45.5 cm] from right-hand edge), join yarn with sl st in next sc bet tr-shells, ch 5 (counts as dc, ch 2), skip next ch-2 sp, *sc in next ch-2 sp, ch 5, skip next ch-2 sp, sc in next ch-2 sp**, ch 5, sk next 2 ch-2 sps; rep from * 5 times, ending last rep at **, ch 2, dc in next sc, turn, leaving rem sts unworked—12 ch-5 lps (includes beg ch-5).

Rows 2–5: Starting with Row 3, work even in patt for 4 rows, ending with Row 3 of patt.

Size 2X only
Row 1 (Row 3 of patt): With RS facing, skip first 11 ch-5 sps (18" [45.5 cm] from right-hand edge), join yarn with sl st in center of next ch-5 sp, ch 3, half shell in same ch-5 sp, *(sc, ch 5, sc) in next ch-5 sp, shell in next ch-5 sp, rep from * 4 times, (sc, ch 5, sc) in next ch-5 sp, half shell in next ch-5 sp, dc in same ch-5 sp, turn, leaving rem sts unworked—5 shells; 2 half shell; 6 ch-5 sps.

Rows 2–4: Starting with Row 4, work even in patt for 3 rows, ending with Row 3 of patt.

Tapered Sleeves, All Sizes

NOTES: *If you want your sleeves to be the same width all the way to the sleeve cuff (which will be at wrist), continue working even in patt for desired length. For slightly tapered sleeves, work dec rows below. Working these rows will cause your sleeve to narrow toward your wrist, but it will not be fitted (see photo).*

Row 1 (dec): Ch 3, 3 dc in next ch-2 sp, *(sc, ch 5, sc) in next ch-5 sp**, 9 dc in next ch-5 sp, rep from * across, ending last rep at **, 3 dc in next ch-2 sp, dc in 3rd ch of tch, turn—5 shells; 2 half shell; 6 ch-5 sps.

Row 2 (dec): Ch 1, sc in first dc, *ch 1, [tr, ch 1] 4 times in next ch-5 sp, skip next 4 dc, sc in next dc; rep from * across, ending with last sc in top of tch, turn—6 tr-shells.

Row 3 (dec): Ch 5 (counts as dc, ch 2), skip first ch-2 sp, *sc in next ch-2 sp, ch 4, skip next ch-2 sp, sc in next ch-2 sp**, ch 4, sk next 2 ch-2 sps; rep from * across, ending last rep at **, ch 2, dc in last sc, turn—11 ch-4 lps.

Rows 4–9: Rep Rows 1–3 of tapered sleeves (twice).

Row 10 (dec): Ch 3, 2 dc in next ch-2 sp, *(sc, ch 5, sc) in next ch-5 sp**, 7 dc in next ch-5 sp, rep from * across, ending last rep at **, 2 dc in next ch-2 sp, dc in 3rd ch of tch, turn—5 shells; 2 half shell; 6 ch-5 sps.

Row 11: Ch 1, sc in first dc, *ch 1, [tr, ch 1] 4 times in next ch-5 sp, skip next 3 dc, sc in next dc; rep from * across, ending with last sc in top of tch, turn—6 tr-shells.

Row 12: Rep Row 5 of tapered sleeves.

Rows 13–24: Rep Rows 10–12 of tapered sleeves (4 times).

Row 25 (inc): Rep Row 1 of tapered sleeves (9-dc shells).

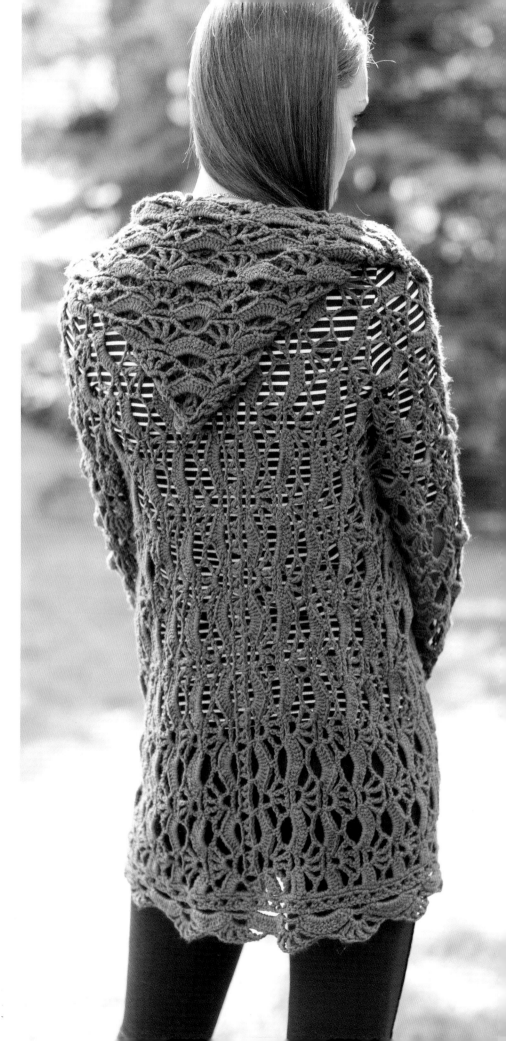

STITCH KEY

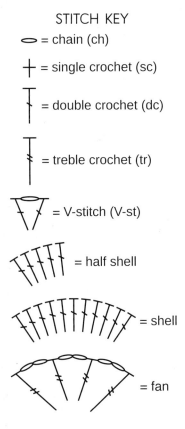

◯ = chain (ch)

+ = single crochet (sc)

⊤ = double crochet (dc)

⊤ = treble crochet (tr)

∨ = V-stitch (V-st)

= half shell

= shell

= fan

Row 26: *Ch 1, sc in first dc, ([tr, picot] 3 times, tr) in next ch-4 sp, ch 1, skip next 4 dc**, (sl st, ch 3, sl st) in center dc of next shell; rep from * across, ending last rep at **, sc in top of tch. Fasten off.

Left Front and Left Back

With RS facing, working on foundation ch of right front/back, join yarn with sl st in ch at base of 36th V-st, next sp is directly below center shell in Row 2 of right front/back.

Row 1 (WS): Ch 112, (dc, ch 1, dc) in 5th ch from hook, *skip next 2 ch, V-st in next ch, rep from * across to within last ch, sl st in next ch of foundation ch at base of next V-st—36 V-sts.

Fasten off. This foundation row will be at the front edge of left front to match the foundation row on right front. Center back will only have one foundation row already worked on right back.

Row 2: With WS facing, working across opposite side of foundation ch of right back, join yarn with sl st in first ch at bottom end of right back, ch 5 (counts as dc, ch 2), skip sc in sp bet next 2 V-sts, *ch 5, skip next sp, sc bet next 2 V-sts, rep from * across to added foundation row, ch 5, skip next ch-1 sp on foundation row, sc bet next 2 dc, **ch 5, skip next 2 ch-1 sps, sc bet next 2 dc; rep from * across to within last ch-1 sp, ch 2, skip next ch-1 sp, skip next dc, dc in 3rd ch of tch, turn—37 ch-5 sps (includes beg ch-5).

Starting with Row 3, work same as right front/back through sleeve. Fasten off.

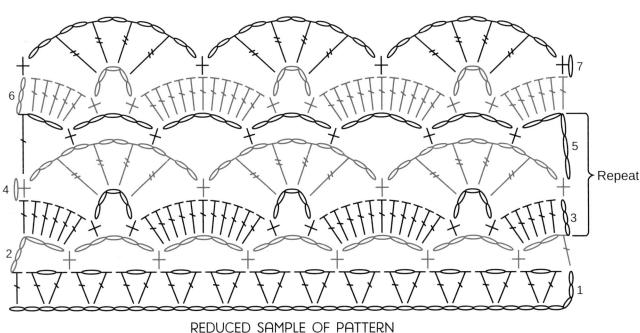

REDUCED SAMPLE OF PATTERN

Border
(LOWER EDGE OF JACKET)

PM in bottom left-hand corner and bottom right-hand corner. Place 14 (15, 16, 17, 18) markers, evenly spaced bet 2 corner markers.

Foundation Row: With RS facing, join yarn with sl st at bottom right-hand corner of left front, ch 1, sc in corner st, *work 12 sc evenly spaced across to next marker, rep from * across to corner of right front—181 (193, 205, 217, 229) sc. If Row 1 does not lay flat (too many or too few sts), redo Row 1, adjusting number of st in multiples of 12 sts. Another option if your work is puckering (too tight), you could use a larger hook to work the border.

Row 1: Ch 3, skip 1 sc, V-st in next sc, *skip next 2 sc, V-st in next sc, rep from * across to within last 2 sts, skip next sc, dc in last sc, turn—60 (64, 68, 72, 76) V-sts.

Row 2: Ch 5, skip next ch-1 sp, sc bet next 2 dc, *ch 5, skip next 2 ch-1 sps, sc bet next 2 dc, rep from * across to within last ch-1 sp, ch 2, skip next ch-1 sp, skip next dc, dc in 3rd
ch of tch, turn—30 (32, 34, 36, 38) ch-5 sps (includes beg ch-5).

Row 3: Ch 3, half shell in next ch-2 sp, *(sc, ch 5, sc) in next ch-5 sp**, shell in next ch-5 sp, rep from * across, ending last rep at **, half shell in next ch-2 sp, dc in 3rd ch of tch, turn—15 (16, 17, 18, 19) shells; 2 half shell; 16 (17, 18, 19, 20) ch-5 sps.

Row 4: Ch 1, sc in first dc, *ch 2, tr-shell in next ch-5 sp, ch 2, skip next 5 dc, sc in next dc; rep from * across, ending with last sc in top of tch, turn—16 (17, 18, 19, 20) tr-shells.

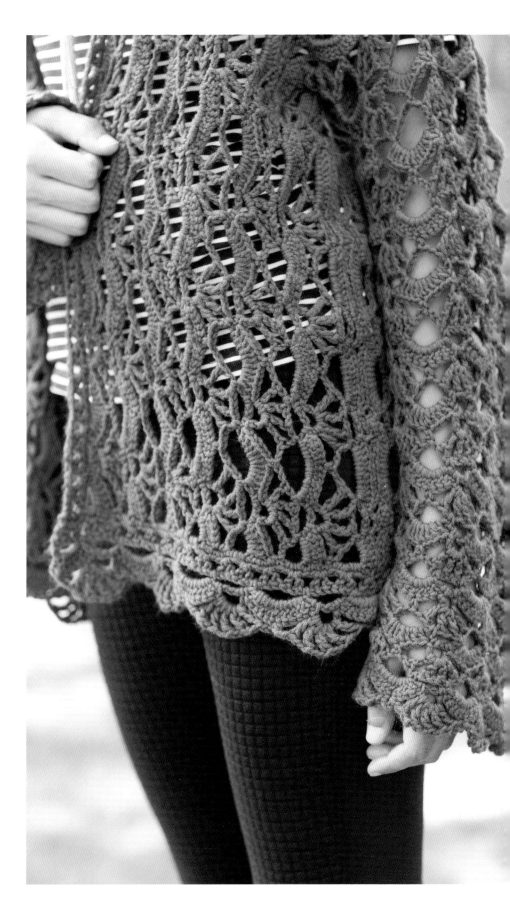

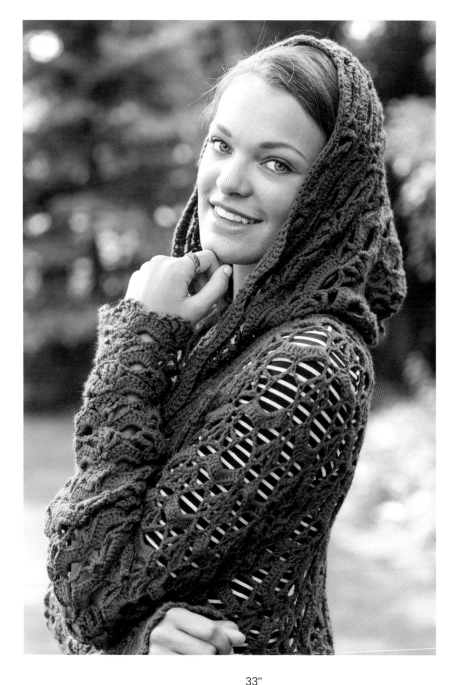

Hood

Hood is worked separately in one piece, folded and seamed up the back, then sewn to neck edge.

Starting at back of hood, ch 76.

Row 1: (RS) Work patt Row 1 of right front/back—24 V-sts.

Row 2: Work patt Row 2—13 ch-5 sps.

Row 3: Work patt Row 3—6 shells.

Row 4 (inc): Ch 1, sc in first dc, sc in next dc, ch 2, continue in patt Row 4 across, ending with sc in 5th dc of last half shell, ch 4, sc in top of tch, turn—6 tr-shells.

Row 5 (inc): Ch 5, sc in next ch-4, ch 5, continue in patt Row 5 across to last ch-2 sp, ch 5, sc in last ch-4 sp, ch 4, sl st in last sc, turn—13 ch-5 sps with ch-4 on each end.

Row 6 (inc): Ch 1, (sc, ch 4, sc) in first ch-4 sp, shell in next ch-5 sp, continue in patt Row 3 across to last ch-5 sp, shell in last ch-5 sp, (sc, ch 4, sc) in last ch-4 sp, turn—7 shells.

Row 7 (inc): Ch 1, sl st in first sp, ch 6 (counts as tr, ch 2), [tr, ch 2] 3 times in same sp, continue in patt Row 4 across to last sc, [ch 2, tr] 4 times in last ch-4 sp, turn—9 tr-shells.

Row 8 (inc): Ch 5, sc in first sp, ch 5, continue in patt Row 5 across, end with sc in last sp, ch 2, dc in 4th ch of tch, turn—19 ch-5 sps.

Row 9: Work patt Row 3—7 shells; 2 half shells.

Row 10: Work patt Row 4—8 tr-shells.

Row 11: Work patt Row 5—16 ch-5 sps.

Row 12: Work patt Row 3.

Row 13 (inc): Rep row 4 of hood—8 tr-shells; ch-4 on each end.

Row 14 (inc): Rep Row 5 of hood—19 ch-5 sps.

Row 15 (inc): Rep Row 6 of hood—9 shells.

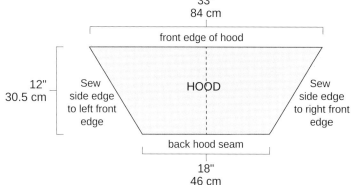

33"
84 cm

front edge of hood

12"
30.5 cm

Sew side edge to left front edge

HOOD

Sew side edge to right front edge

back hood seam

18"
46 cm

Row 16 (inc): Rep Row 7 of hood—10 tr-shells.

Row 17 (inc): Rep Row 8 of hood—21 ch-5 sps.

Row 18: Work patt Row 3—9 shells; 2 half shells.

Row 19: Work patt Row 4—10 tr-shells.

Row 20: Work patt Row 5—21 ch-5 sps.

Row 21 (inc): Ch 3, 6 dc in first sp, continue in patt Row 3 across, ending with 6 dc in last sp, dc in top of tch—9 shells; 7 dc on each end.

Row 22 (inc): Ch 5, sc in 2nd dc, ch 2, cont in patt Row 4 across, ending with sc in 5th dc, ch 5, sl st in top of tch—10 tr-shells; ch-5 on each end.

Row 23 (inc): Sl st in first sp, ch 5, cont in patt Row 5 across, ending with ch 5, 3 sc in last sp, turn—21 ch-5 sps.

Row 24: *Note: This row forms the* *pointed corner at each end of hood.* Ch 4 (counts as tr), tr in each of next 2 sc, (htr, 7 dc) in next ch-5 sp, *sc in next ch-5 sp, sc in same sp working around ch-2 sp of prev row (between 2 tr), sc in same ch-5 sp** *(Note: You should have worked 3 sc in same ch-5 sp, the center sc connects it to row below.)*, 9 dc in next ch-5 sp, rep from * across, ending last rep at **, ending with (7 dc, htr) in next ch-5 sp, 3 tr in last ch-5 sp. Do not fasten off.

First Side Edging

Working across side edge of hood, ch 1, work 2 sc in corner st, sc evenly across to next corner working about 53 sc, keeping work flat. Fasten off.

Second Side Edging

With RS facing, join yarn in right-hand corner of other side edge of hood, ch 1, work 2 sc in corner st, sc evenly across to next corner working about 53 sc, keeping work flat. Fasten off. Steam block to shape if needed.

Hood Seams

With RS tog, fold hood in half crosswise, bringing left and right sides of row 1 tog (back of hood). Matching sts across foundation ch, sew back seam. Fasten off.

With RS tog, matching fold to seam at top of back, pin side edgings of hood to front edges, bringing pointed corners around edges at sides of neck as in photo. Sew seam with yarn and yarn needle.

Finishing

Weave in ends. Steam block sweater to match finished measurements if needed.

21 (23, 26, 28, 30)"
53.5 (58.5, 66, 71, 76) cm

RIGHT BACK LEFT BACK

54"
137 cm

RIGHT SLEEVE LEFT SLEEVE

18"
45.5 cm

12"
30.5 cm

9"
23 cm

18"
45.5 cm

RIGHT FRONT LEFT FRONT

18"
45.5 cm

18 (18½, 19, 18, 18½)"
45.5 (47, 48.5, 45.5, 47) cm

10½ (11½, 13, 14, 15)"
26.5 (29, 33, 35.5, 38) cm

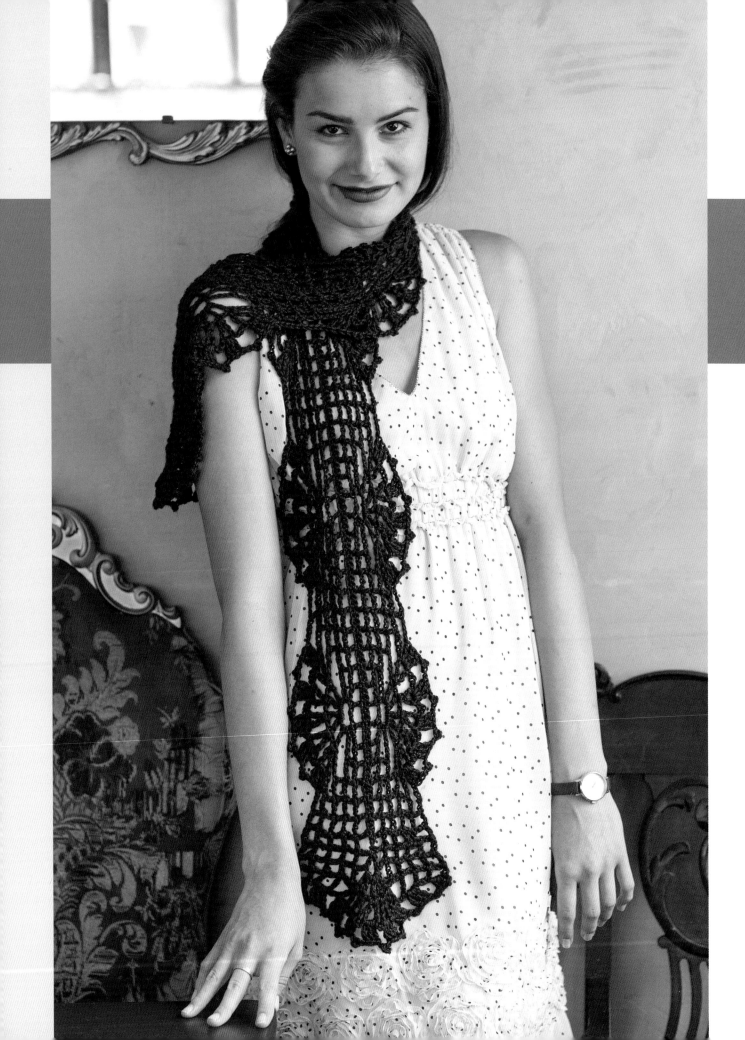

Juliette scarf

FINISHED SIZE
8" (20.5 cm) wide x 59" (150 cm) long.

YARN
DK weight (#3 Light).

Shown here: Patons Silk Bamboo DK (70% viscose from bamboo, 30% silk; 102 yd [93 m]/ 2⅛ oz [62 g]): #85310 orchid, 2 balls.

HOOK
Size G/6 (4mm). Adjust hook size if necessary to obtain the correct gauge.

NOTIONS
Yarn needle.

GAUGE
17 sts = 4" (10 cm); Rows 1–4 of first side (4 rows dc) = 2½" (6.5 cm).

I don't know about you, but I love the feminine, Victorian look of lacy fans. Wear this fan-edged scarf simply looped around your neck or tied with a knot. This gorgeous design also looks fabulous wrapped around as a cowl, showcasing the fans.

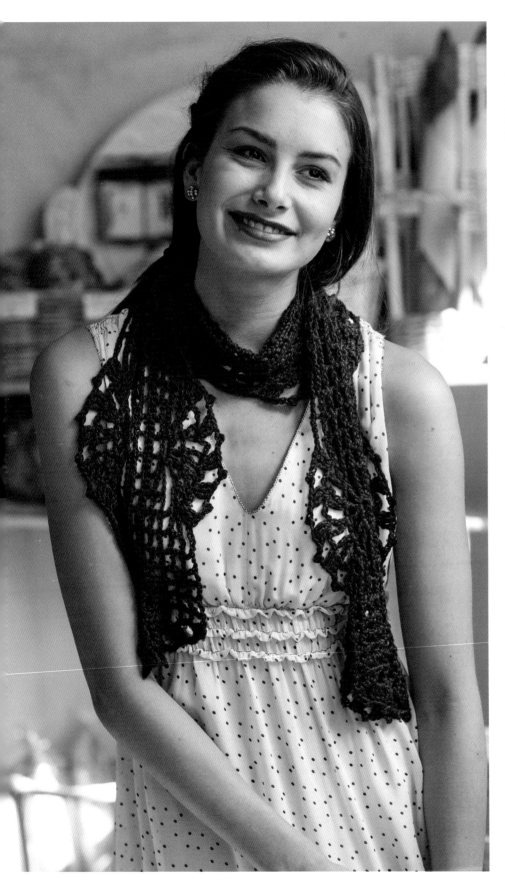

NOTES
Scarf is worked in 2 sides.
Row 1 of second side will be
worked onto the Foundation
Row of the first side. Then a
scarf end is worked on each
end of the scarf.

STITCH GUIDE
Picot: Ch 3, sc in 3rd ch from hook.

Scarf

FIRST SIDE
Ch 206.

Foundation Row (WS): Sc in 2nd ch from hook and in each ch across, turn—205 sc.

Row 1: Ch 5 (counts as dc, ch 2 here and throughout), skip first 3 sc, dc in next sc, *ch 2, skip next 2 sc, dc in next sc; rep from * across, turn—69 dc; 68 ch-2 sps.

Row 2: Ch 5, skip next ch-2 sp, dc in next dc, (ch 2, dc) in each of next 3 dc, *ch 4, skip next 2 ch-2 sps, sc in next dc, ch 5, sc in next dc, ch 4, skip next 2 ch-2 sps, dc in next dc, **, (ch 2, dc) in each of next 6 dc; rep from * across, ending last rep at **, (ch 2, dc) in each of next 3 dc, ch 2, dc in 3rd ch of tch, turn—45 dc; 6 ch-5 sps.

Row 3: Ch 5, skip next ch-2 sp, dc in next dc, (ch 2, dc) in each of next 2 dc, *ch 4, skip next 2 ch-sps, (tr, [ch 1, tr] 4 times) in next ch-5 sp, ch 4, skip next 2 ch-sps, dc in next dc **, (ch 2, dc) in each of next 4 dc; rep from * across, ending last rep at **, (ch 2, dc) in each of next 2 dc, ch 2, dc in 3rd ch of tch, turn.

Row 4: Ch 5, skip next ch-2 sp, dc in next dc, ch 2, dc in next dc, *ch 4, skip next 2 ch-sps, (tr, ch 1, tr, ch 3) in each of next 4 tr, (tr, ch 1, tr) in next tr, ch

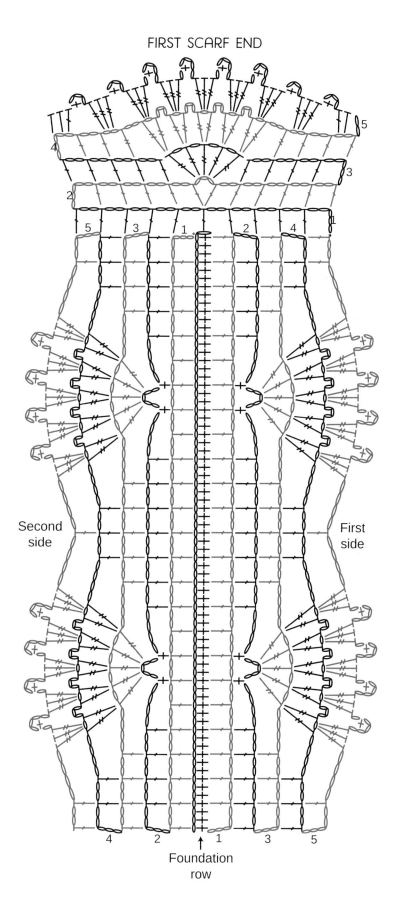

FIRST SCARF END

STITCH KEY

◯ = chain (ch)

• = slip st (sl st)

+ = single crochet (sc)

T = half double crochet (hdc)

T̸ = double crochet (dc)

T̸ = treble crochet (tr)

🪝 = picot

Second side

First side

Foundation row

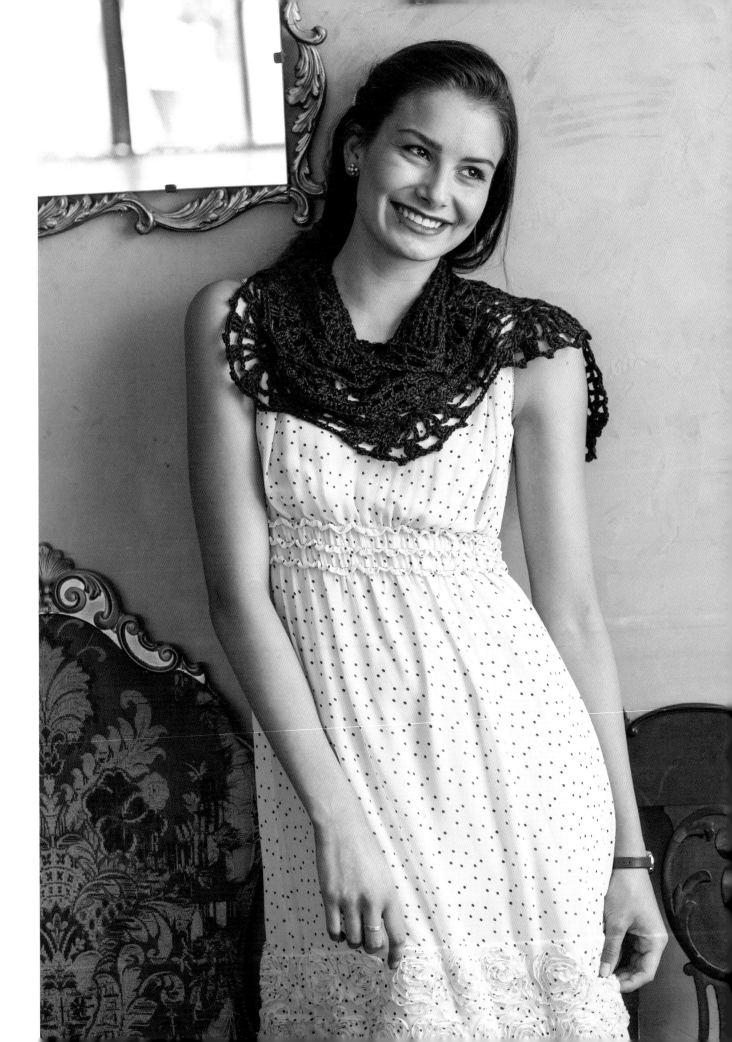

4, skip next 2 ch-sps, dc in next dc, (ch 2, dc) in each of next 2 dc; rep from * across, ending with last dc in 3rd ch of tch, turn.

Row 5: Ch 5, skip next ch-2 sp, dc in next dc, *ch 4, skip next 2 ch-sps, [3 tr in next ch-1 sp, ch 1, picot, ch 1, skip next ch-3 loop] 4 times, 3 tr in next ch-1 sp, ch 4, skip next 2 ch-sps, dc in next dc; rep from * across to tch, ending with last dc in 3rd ch of tch, do not turn. Fasten off.

SECOND SIDE
Rotate the scarf to work across the opposite side of the Foundation Row.

Row 1: With RS facing, join yarn with sl st in first ch of Foundation Row, ch 5, skip first 3 sc, dc in next sc, *ch 2, skip next 2 sc, dc in next sc, rep from * across, turn—69 dc; 68 ch-2 sps.

Rows 2–5: Rep Rows 2–5 of first side. Fasten off.

FIRST SCARF END
Row 1: With RS facing, working across one short end of scarf, join yarn with sl st in top of last dc in Row 5 of first side, ch 5, dc in top of next row-end st, (ch 2, dc) in top of each of next 3 row-end dc, ch 2, dc in end of Foundation Row, (ch 2, dc) in top of each of next 5 row-end dc, turn—11 dc, 10 ch-2 sps.

Row 2: Ch 5, skip next ch-2 sp, (dc, ch 2) in each of next 4 dc, (dc, ch 3, dc) in next dc, (ch 2, dc) in each of next 5 dc, working last dc in 3rd ch of tch, turn—12 dc; 11 ch-2 sps.

Row 3: Ch 5, skip next ch-2 sp, (dc, ch 2) in each of next 3 dc, dc in next dc, (tr [ch 1, tr] 4 times) in next ch-3 sp, skip next dc, (dc, ch 2) in each of next 4 dc, dc in 3rd ch of tch, turn—10 dc; 5 tr, 8 ch-2 sps; 4 ch-1 sps.

Row 4: Ch 5, skip next ch-2 sp, dc in next dc, ch 2, dc in next dc, ch 2, tr in next dc, ch 2, skip dc, (tr, ch 3, tr, picot) in each of next 4 tr, (tr, ch 3, tr) last ch-3, ch 2, skip ch-2 sp, tr in next

dc (ch 2, dc) in each of next 2 dc, ch 2, dc in 3rd ch of tch, turn.

Row 5: Ch 2 (counts as hdc), (hdc, dc) in first ch-2 sp, picot, skip next ch-2 sp, 3 tr in next ch-2 sp, picot, skip next ch-2 sp, [3 tr in next ch-1 sp, ch 1, picot, ch 1, skip next ch-3 loop] 4 times, 3 tr in next ch-1 sp, picot, skip next ch-2 sp, 3 tr in next ch-2 sp, picot, skip ch-2, (dc, hdc) in last sp, hdc in 3rd ch of tch. Fasten off.

SECOND SCARF END
Row 1: With RS facing, working across other short end of scarf, join

yarn with sl st in top of last dc in Row 5 of second side, ch 5, dc in top of next row-end st, (ch 2, dc) in top of each of next 3 row-end dc, ch 2, dc in end of Foundation Row, (ch 2, dc) in top of each of next 5 row-end dc, turn—11 dc, 10 ch-2 sps.

Rows 2–5: Rep Rows 2–5 of first scarf end.

Finishing
Weave in ends and block if necessary.

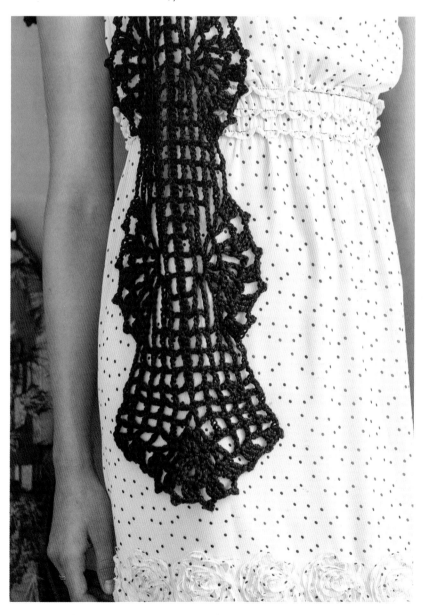

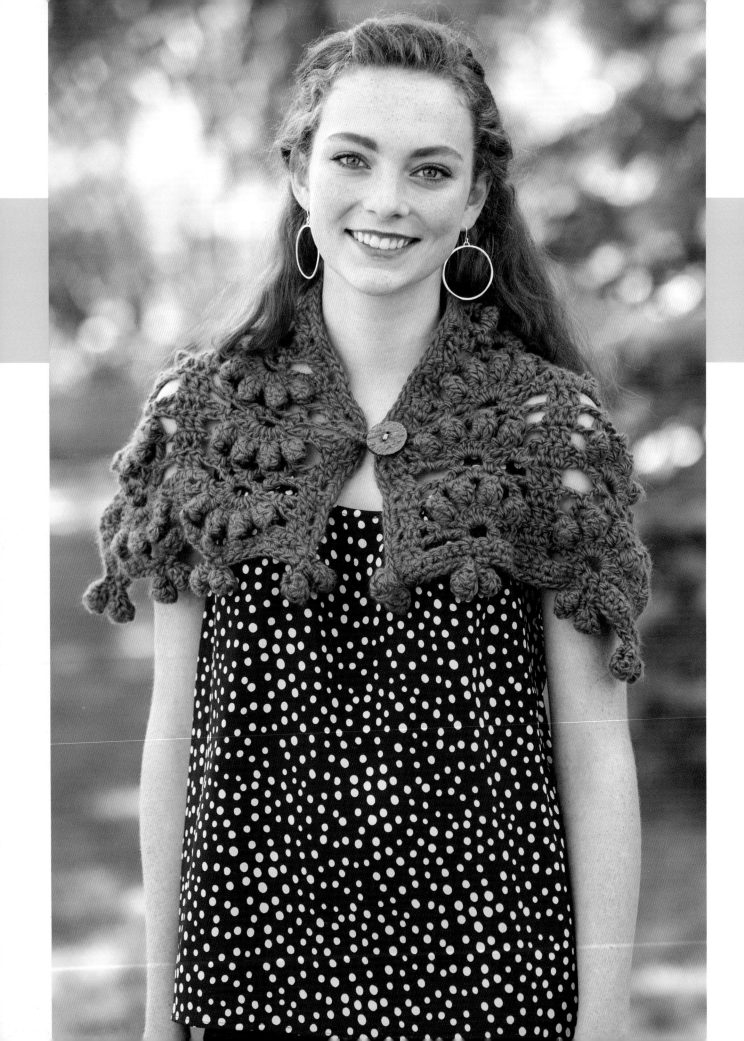

Très Chic
neck warmer

FINISHED SIZE
12″ (30.5 cm) wide x 34″ (86.5 cm) long with popcorn edging.

YARN
Worsted weight (#4 Medium).

Shown here: Universal Yarns Classic Shades Solids (30% wool, 70% acrylic; 197 yd [180 m]/3½ oz [100 g]): #607 evergreen, 3 skeins.

HOOK
J/10 (6 mm). Adjust hook size if necessary to obtain the correct gauge.

NOTIONS
Stitch markers; yarn needle; one or two 1¼–1½″ (3.2–3.8 cm) wooden buttons.

GAUGE
With 2 strands of yarn held together, one pattern repeat (14 sts in Row 1) = 5½″ (14 cm); 4 rows = 3½″ (9 cm).

Who says an item that keeps you warm has to be plain? If you're a fashion-conscious gal, you'll really appreciate this pretty but practical neck warmer when the snow starts flying! Instructions are also given for creating a taller and wider wrap.

STITCH KEY

⬯ = chain (ch)

⬮ = elongated chain (ech)

• = slip st (sl st)

+ = single crochet (sc)

┬ = double crochet (dc)

⋏ = single crochet 2 together (sc2tog)

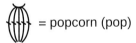 = popcorn (pop)

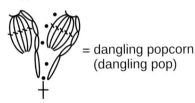 = dangling popcorn (dangling pop)

* = marker

marker, dangling pop in next marked st; rep from ** across bottom edge to next corner marker, rep from * to * across other side edge to marked corner st, join with sl st in first sc—14 dangling pops. Fasten off.

Finishing

With RS facing, place marker 6" (15 cm) to the left of top right-hand corner for loop placement; place a marker 6" (15 cm) to the right of top left-hand corner for button place-

ment. If you want your neck warmer to be a little more closed and prefer 2 buttons, sew the 2nd one about 3" (7.5 cm) below first button.

BUTTON LOOP

With RS facing, join one strand of yarn, 1" (2.5 cm) below top edge at right-hand marker. For a 1½" (3.8 cm) button, ch 12, sl st to base of ch. Fasten off. Sew button 1" (2.5 cm) below marker on left-hand side. Front edge will overlap back edge when buttoned. Weave in ends.

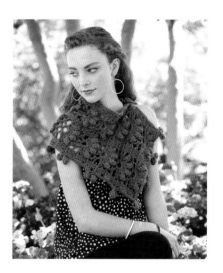

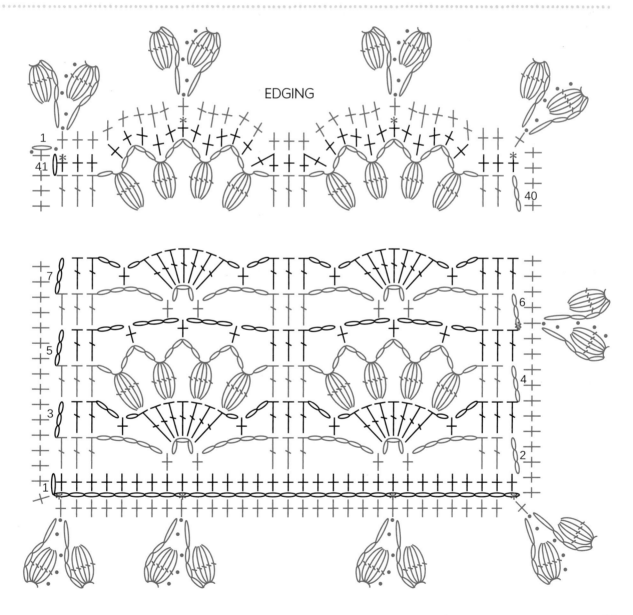

EDGING

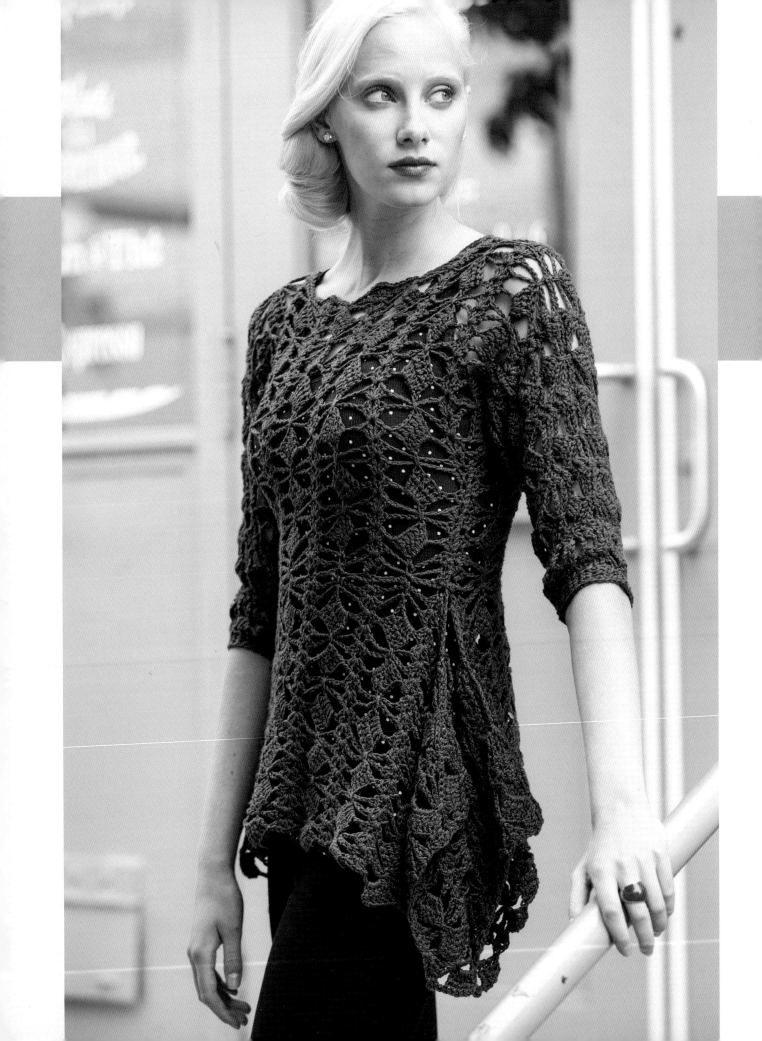

Tunique Unique pullover

FINISHED SIZES
XS/S (M, L, 1X/2X, 3X).
Sample shown is size XS/S.

Bust: 30 (36, 42, 48, 54)″ (76
[91.5, 106.5, 122, 137] cm).

YARN
Fingering weight (#1 Super
Fine).

Shown here: Rowan Wool
Cotton Fingering (50% wool,
50% cotton; 197 yd [180
m]/1¾ oz [50 g]): #495 marine,
7 (8, 9, 9, 10) skeins.

HOOK
Size H/8 (5 mm). Adjust hook
size if necessary to obtain the
correct gauge.

NOTIONS
Stitch markers; yarn needle.

GAUGE
In Body patt, 1 rep = 3″ (7.5
cm); 6 rows = 3½″ (9 cm),
before steam blocking.

This shaped tunic will flatter just about anyone's shape and will even camouflage any flaws you might have. The pattern emphasizes the waist and helps it look smaller. The sleeves are worked with my Graduated Stitch Method (GSM; see page 152), so there are no increases or decreases here to worry about. Wear it with or without a belt for two great looks.

NOTES

Lower front and back rectangles are worked first, beginning at the top edge. These are the pieces that will have side slits on each side and will drape (see schematic). Body front and sleeves and body back and sleeves are worked separately and then sewn together at the shoulders and side seams, leaving a 10″ (25.5 cm) opening for the neck. Lower rectangles will be sewn at the waist only to the front and back, leaving a section on each side with slit openings that will drape loosely, hanging down toward the sides of the body.

STITCH GUIDE

Single crochet shell (sc shell): (2 sc, ch 1, 2 sc) in same st or sp.

Half double crochet shell (hdc shell): (2 hdc, ch 1, 2 hdc) in same st or sp.

Double crochet shell (dc shell): (2 dc, ch 1, 2 dc) in same st or sp.

Pattern Stitch:

Row 1: 2 dc in 4th ch from hook, *ch 8, skip next 11 ch, (2 dc, ch 1, 2 dc) in next ch; rep from * across, ending last rep at **, 3 dc in last ch, turn.

Row 2: Ch 3 (counts as dc here and throughout), 2 dc in first dc, *ch 4, sc over ch-8 lp in row below and ch-11 lp of foundation ch**, ch 4, dc-shell in next ch-1 sp, rep from * across, ending last rep at **, skip next 2 dc, 3 dc in next top of tch, turn.

Row 3: Ch 3, 2 dc in first dc, *ch 5, skip next ch-4 sp, sc in next sc, ch 2 (counts as short dc), turn, 5 dc in next ch-5 lp, ch 2 (counts as short dc), turn, skip first dc, dc in each of next 5 sts (including top of ch-2) forming a dc-square, skip next ch-4 sp**, shell in next ch-1 sp; rep from * across, ending last rep at **, skip next 2 dc, 3 dc in top of tch, turn.

NOTE: *The only time you work ch-2 for dc will be on dc squares—all other dc at beg of rows will be ch-3 when it counts as a dc.*

Row 4: Ch 3, 2 dc in first dc, *ch 8, skip next dc-square**, shell in next ch-1 sp, rep from * across, ending last rep at **, skip next 2 dc, 3 dc in top of of tch, turn.

Row 5: Ch 3, 2 dc in first dc, *ch 4, sc over ch-8 lp into top of next dc-square 2 rows below, skip next ch-4 sp**, shell in next ch-1 sp; rep from * across, ending last rep at **, skip next 2 dc, 3 dc in top of tch, turn.

Rep Rows 3–5 for patt.

Front/Back
LOWER RECTANGLE (MAKE 2)

NOTE: *Bottom edge of this piece will later be sewn to the body at the waist area.*

Ch 136 (148, 160, 172, 184) loosely.

Row 1: 2 dc in 4th ch from hook, *ch 8, skip next 11 ch, shell in next ch; rep from * across, ending last rep at **, 3 dc in last ch, turn—11 (12, 13, 14, 15) ch-8 lps.

Row 2: Work Row 2 of patt st—22 (24, 26, 28, 30) ch-4 lps.

Row 3: Work Row 3 of patt—11 (12, 13, 14, 15) dc-squares.

Row 4: Work Row 4 of patt—11 (12, 13, 14, 15) ch-8 lps.

Row 5: Work Row 5 of patt—22 (24, 26, 28, 30) ch-4 lps.

Rows 6–18: Work even in patt until piece measures 10½″ (26.5 cm), ending with Row 3 of patt. Fasten off.

Body and Sleeves (Make 2)

Ch 64 (76, 88, 100, 112).

Row 1: Work Row 1 of patt—5 (6, 7, 8, 9) ch-8 lps.

Rows 2–7: Work even in patt, ending with Row 4 of patt. Piece should measure 4″ (10 cm).

Begin Sleeves

NOTE: *Graduated st rows will be on sleeve rows only. Center front and back will be worked same as previous 7 rows.*

Row 1: Loosely ch 61 (for first sleeve), turn, 3 sc in 2nd ch from hook, ch 4, sc over foundation ch, ch 4, sk 11 ch of

foundation ch, sc-shell in next ch, [ch 4, sc over foundation ch, ch 4, sk 11 ch of foundation ch, hdc-shell in next shell] twice, [ch 4, sc over foundation ch, ch 4, sk 11 ch of foundation ch, dc-shell in next shell] twice, ending with last dc-shell in first st of work in patt Row 5 across to last marker, [ch 4, sc over foundation ch, ch 4, sk 11 ch of foundation ch, dc-shell in next shell] twice, [ch 4, sc over foundation ch, ch 4, sk 11 ch of foundation ch, hdc-shell in next ch] twice, ch 4, sc over foundation ch, ch 4, sk 11 ch of foundation ch, sc-shell in next ch, ch 4, sc over foundation ch, ch 4, sk 11 ch of foundation ch, 3 sc in last 3 ch, turn—2 sc-shells; 4 hdc-shells; 8 (9, 10, 11, 12) dc-shells; 30 (32, 34, 36, 38) ch-4 lps. Pm in first and last dc-shell. Move markers up as work progresses.

Row 2: Ch 1, sc in each of first 3 sc, ch 5, skip next ch-4 sp, sc in next sc, turn, ch 1, 3 sc in next ch-5 sp, turn, ch 1, sc in each of next 3 sc, ch 3, skip next ch-4 sp, sc-shell in next shell, [ch 5, skip next ch-4 sp, sc in next sc, turn, ch 2, 4 hdc in next ch-5 sp, turn, ch 2 (counts a hdc here and throughout), hdc in each of next 4 sts, ch 2, skip next ch-4 sp, hdc-shell in next shell] twice, work in patt Row 3 across to next marker, [ch 5, skip next ch-4 sp, sc in next sc, turn, ch 2, 4 hdc in next ch-5 sp, turn, ch 2, hdc in each of next 4 sts, ch 2, skip next ch-4 sp, hdc-shell in next shell] twice, ch 5, skip next ch-4 sp, sc in next sc, turn, ch 1, 3 sc in next ch-5 sp, turn, ch 1, sc in each of next 3 sc, ch 3, skip next ch-4 sp, sc-shell in next shell, ch 5, skip next ch-4 sp, sc in next sc, turn, ch 1, 3 sc in next ch-5 sp, turn, ch 1, sc in each of next 3 sc, ch 3, skip next ch-4 sp, sc in each of last 3 sc, turn—2 sc-squares; 4 hdc-squares; 9 (10, 11, 12, 13) dc-squares.

Row 3: Ch 1, sc in each of first 3 sc, ch 8, skip next square, sc-shell in next shell, [ch 8, skip next square, hdc-shell in next shell] twice, work in patt Row 4 across to next marker,

[ch 8, skip next square, hdc-shell in next shell] twice, ch 8, skip next square, sc-shell in next shell, ch 8, skip next square, sc in each of last 3 sc, turn—15 (16, 17, 18, 19) ch-8 lps.

Row 4: Ch 1, sc in each of first 3 sc, *ch 4, sc over ch-8 lp into top of next square 2 rows below, skip next ch-4 sp**, shell in next ch-1 sp, rep from * across, ending last rep at **, sc in each of last 3 sc, turn—30 (32, 34, 26, 39) ch-4 sps.

Rows 5–16: Rep Rows 2–4 (3 times). Fasten off.

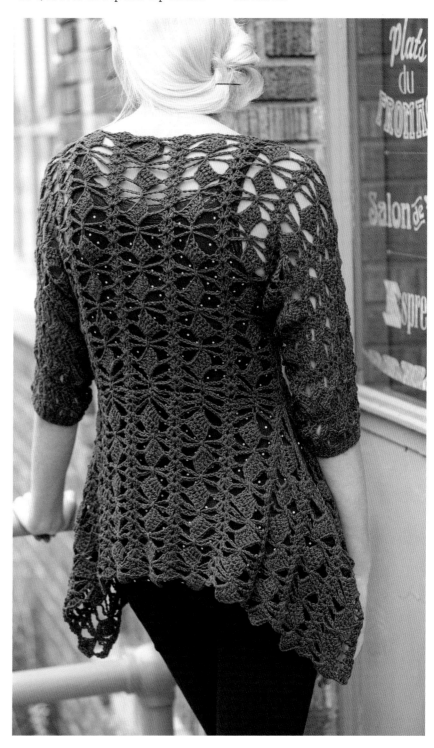

STITCH KEY

- ⬭ = chain (ch)
- ✚ = single crochet (sc)
- ⊤ = half double crochet (hdc)
- ⊤ = double crochet (dc)
- ✕⊤⊤⊤✕ = sc-shell
- ⊤⧄⧅ = hdc-shell
- ⊤⧄⧅ = dc-shell

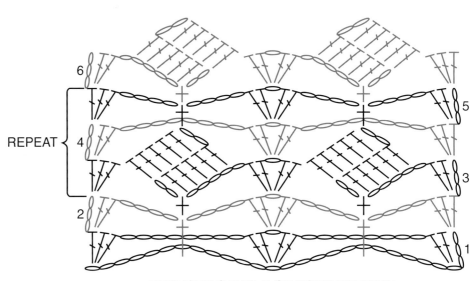

REDUCED SAMPLE OF BODY PATTERN

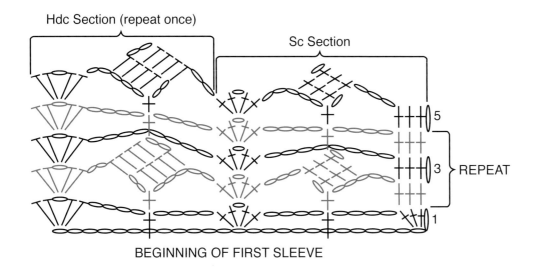

BEGINNING OF FIRST SLEEVE

Finishing

Steam block all 4 pieces if needed before sewing seams.

ASSEMBLY

With RS of front and back tog, matching sts, pin along side seams and lower seam of sleeve to hold in place. Sew seam with yarn and yarn needle. Rep for the other side.

PM at each end of the center 10" (25.5 cm) on the top edges for the neck opening. With RS tog matching sts, sew the shoulder and top sleeve seams. Rep for the other side.

CUFF EDGING

Turn the tunic RS out. Join yarn with sl st in any st on the cuff edge of the sleeve, ch 1, sc evenly around the cuff edge, join with a sl st in the first sc. Fasten off. Rep for the other sleeve cuff. Weave in the ends.

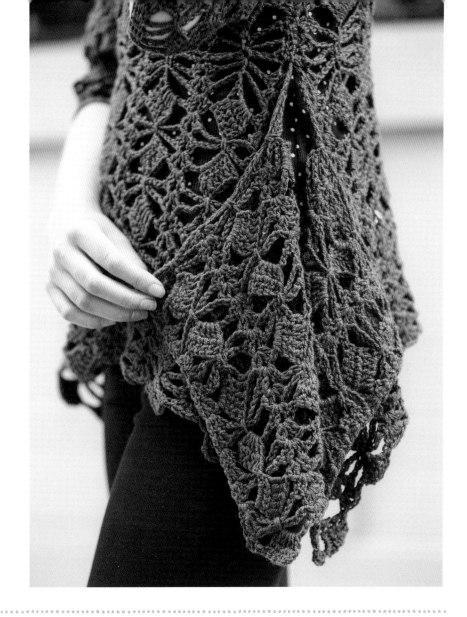

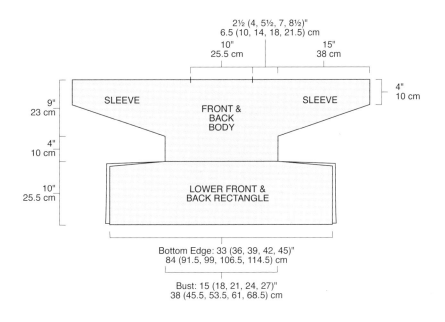

2½ (4, 5½, 7, 8½)"
6.5 (10, 14, 18, 21.5) cm

10"
25.5 cm

15"
38 cm

4"
10 cm

SLEEVE

FRONT & BACK BODY

SLEEVE

9"
23 cm

4"
10 cm

10"
25.5 cm

LOWER FRONT & BACK RECTANGLE

Bottom Edge: 33 (36, 39, 42, 45)"
84 (91.5, 99, 106.5, 114.5) cm

Bust: 15 (18, 21, 24, 27)"
38 (45.5, 53.5, 61, 68.5) cm

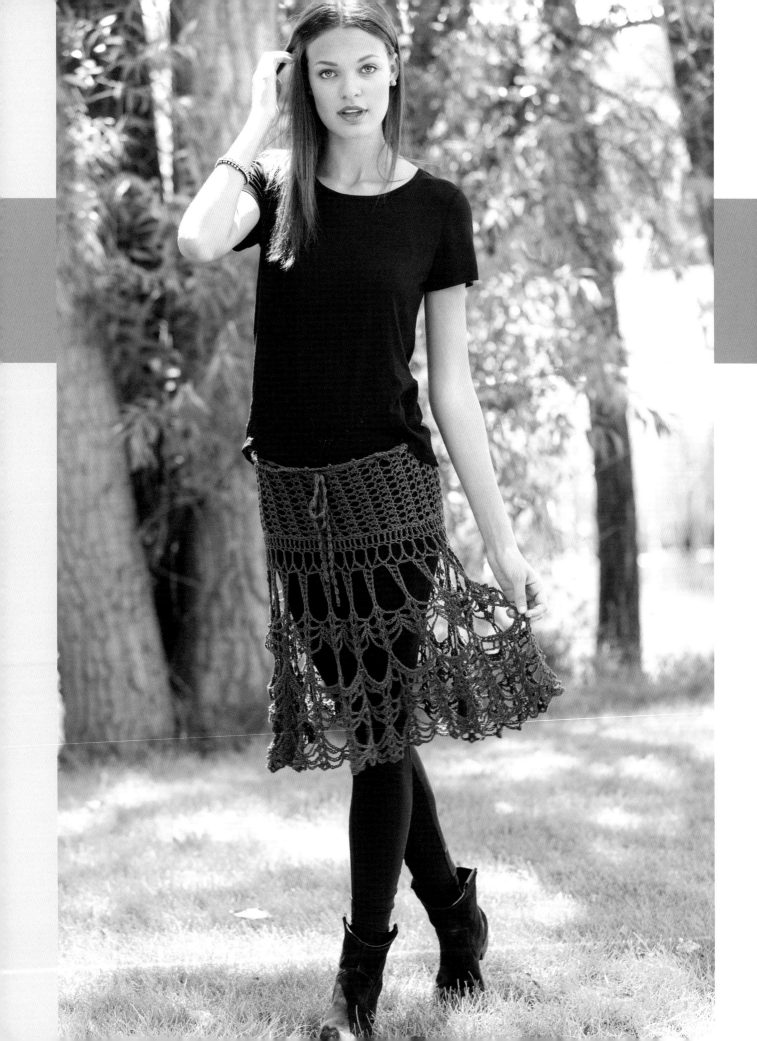

Le Chocolat *skirt*

FINISHED SIZES
XS (S, M, L, 1X, 2X). Sample shown is size S.

Hips: 30½ (33½, 37½, 41½, 46½, 48)″ (77.5 [85, 95, 105.5, 118, 122] cm).

Note: Hip band stretches 3–4″ (7.5–10 cm) more.

Length: 22″ (56 cm).

YARN
Fingering weight (#1 Super Fine).

Shown here: SMC Egypto Cotton Fingering (100% cotton; 196 yd [179 m]/1¾ oz [50 g]): #0110 mocha, 4 (4, 5, 6, 6, 6) skeins.

HOOKS
Sizes H/8 (5 mm) and G/6 (4 mm). Adjust hook size if necessary to obtain the correct gauge.

NOTIONS
Stitch markers; yarn needle.

GAUGE
Hip band: 10 sts = 3″ (7.5 cm) on Row 1; 6 dc rows = 4″ (10 cm).

Circle skirt section: 12 sts = 4″ (10 cm) on Rnd 2.

This cute, flouncy skirt is so much fun to wear. It can be worn over a straight skirt or full skirt, or with leggings underneath, or even as a poncho! The yarn may be thinner than what you're used to working with, but trust me, this works up pretty quickly with the recommended larger hook. To make this for your little girl, just use a hook that's two or three sizes smaller.

Hip Band

NOTE: *Hip band is worked in vertical rows. Foundation ch is at the side of the skirt.*

Loosely ch 24.

Row 1: (RS) Dc in 6th ch from hook (beg ch counts as dc, ch 1), *ch 1, sk next ch, dc in next ch, rep from * across, turn—11 dc; 10 ch-1 sps. This row should measure about 5½" (14 cm) without stretching.

Row 2: Ch 3 (counts as dc here and throughout), *skip next ch-1 sp, 2 dc in blo of next dc; rep from * across, ending with 2 dc in 3rd ch of tch, turn—21 dc.

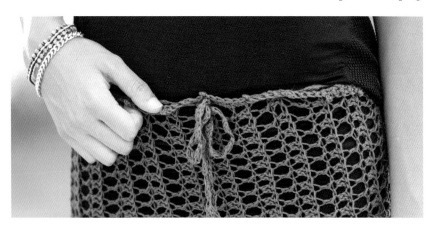

NOTES

The band for the hip area of the skirt is worked in vertical rows, so you can get a custom fit. It is also worked in the back loops only, which causes the band to stretch around the hips.

This openwork skirt can also be used as a beach cover, a poncho, or lengthened into a maxi (see "how-to" below in Rnd 18).

The skirt is designed so you can wear the waistband at the hips or at the waist.

Row 3: Ch 4 (counts as dc, ch-1), skip first 2 dc, *dc in blo of next dc, ch 1, skip next dc; rep from * across to tch, dc in top of tch, turn—11 dc; 10 ch-1 sps.

Rows 4–46 (50, 56, 62, 70, 72): Rep Rows 2–3 (21 [23, 26, 29, 33, 34] times); rep Row 2.

TIP: *If the hip band is too small to fit around your hips (about 1½"–2" [3.8–5 cm] below your waist), you need to add rows in multiples of 2. If the hip band is too large, delete rows to fit loosely, since this will most likely be worn over another skirt.*

With RS of short ends tog, match up sts and sew seam using yarn and yarn needle. You have the option of keeping

STITCH GUIDE

V-stitch (V-st): (Dc, ch 2, dc) in same sp.

Shell: (2 dc, ch 2, 2 dc) in same sp.

Puff stitch (puff st): [Yo, insert hook into 1st ch, pull up lp about ⅓" (8 mm) from ch) 3 times, yo and pull lp through all 7 lps at once.

Picot: Ch 3, sl st in 3rd ch from hook.

this seam open if you think you'll have trouble getting the skirt over your head or hips. Waistband will be worked last. Turn the hip band RS out.

Circle Skirt

There are 46 (50, 56, 62, 70, 72) horizontal rows on the hip band.

You will be placing 2 sc at end of each horizontal dc row, so do the following, which will be in multiples of 24 for each size. Work loose crochet sts or use a larger hook to work the first sc rnd, making sure your work lies flat and does not bunch up. We're deleting sc here to make sure they are in multiples of 24, but we are not trying to make this rnd smaller, so that's why you will need to use a larger hook to keep your work flat. Since you'll be working 2 sc around each dc on the bottom edge of the hip band,

STITCH KEY

- ⬯ = chain (ch)
- • = slip st (sl st)
- ┼ = single crochet (sc)
- ┬ = half double crochet (hdc)
- ┬ = double crochet (dc)
- ┬ = treble crochet (tr)
- ⋎ = V-st
- ⋓ = shell
- ⑂ = puff st
- ⑆ = picot

CIRCLE SKIRT

but will need sts in multiples of 24, do the following:

Sizes XS, M, and XL only

Rnd 1: Place 4 (8, 4) markers evenly spaced around bottom edge of the hip band. With RS facing, join yarn at side seam and work in dc row-ends around the bottom edge of the hip band, work 2 sc in each dc row-end around; at each marker, work an inc by working 3 sc in dc row-end, join with sl st in first sc—96 (120, 144) sc.

Sizes S and L only

Rnd 1: Place 4 markers evenly spaced around the bottom edge of the hip band. With RS facing, join yarn at side seam, working in dc row-ends around bottom edge of the hip band; work 2 sc in each dc row-end around, at each marker, work a dec by working only 1 sc in dc row-end, join

with sl st in first sc—96 (120) sc.

Size 2X only

Rnd 1: With RS facing, join yarn at side seam, working in dc row-ends around bottom edge of the hip band; work 2 sc in each dc row-end around, join with sl st in first sc—144 sc.

All Sizes

Rnd 2: Ch 4 (counts as tr), tr in each sc around, join with sl st in top of beg ch-4—96 (96, 120, 120, 144, 144) tr.

NOTE: *If you do not want your skirt to be as full as the one in the photo and would like it to be more of an A-line, skip 2 tr in Rnd 3 instead of skipping 1 tr. This will produce 32 (32, 40, 40, 48, 48) ch-6 slps.*

Row 3: Ch 3 (counts as dc here and throughout), skip next tr, *dc in next tr, ch 6, skip next tr, rep from *

around, join with sl st in top of beg ch-3—48 (48, 60, 60, 72, 72) ch-6 lps.

Rnd 4: Sl st to center of first ch-6 lp, ch 1, sc in same lp, *loosely ch 11, (sc in 5th ch from hook, hdc in next ch, dc in each of next 2 ch, tr in each of next 3 ch, sc in next ch-6 lp, ch 3**, sc in next ch-6 lp, rep from * around, ending last rep at **, join with sl st in first sc—24 (24, 30, 30, 36, 36) petals. Fasten off.

Rnd 5: With RS facing, join yarn in ch-4 sp at end of any petal, ch 3, (dc, ch 2, 2 dc) in same sp, *ch 5, shell in sp at tip of next petal; rep from * around to last petal, ch 5, sl st in top of beg of ch-3—24 (24, 30, 30, 36, 36) shells.

Rnd 6: Sl st to center of first shell, ch 3, (dc, ch 2, 2 dc) in same sp, *ch 4, sc in next ch-5 sp, ch 4**, shell in next shell, rep from * around, ending last rep at **, join with sl st in top of beg ch-3—24 (24, 30, 30, 36, 36) shells; 48 (48, 60, 60, 72, 72) ch-4 sps.

STITCH KEY

\ominus = chain (ch)

• = slip st (sl st)

$+$ = single crochet (sc)

\top = half double crochet (hdc)

\dagger = double crochet (dc)

\ddagger = treble crochet (tr)

 = V-st

 = shell

$\left(\right)$ = puff st

= picot

Tie

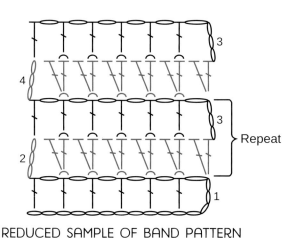

REDUCED SAMPLE OF BAND PATTERN

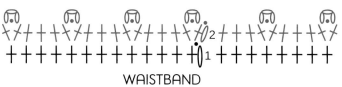

WAISTBAND

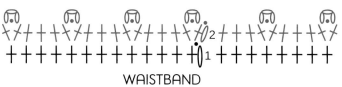

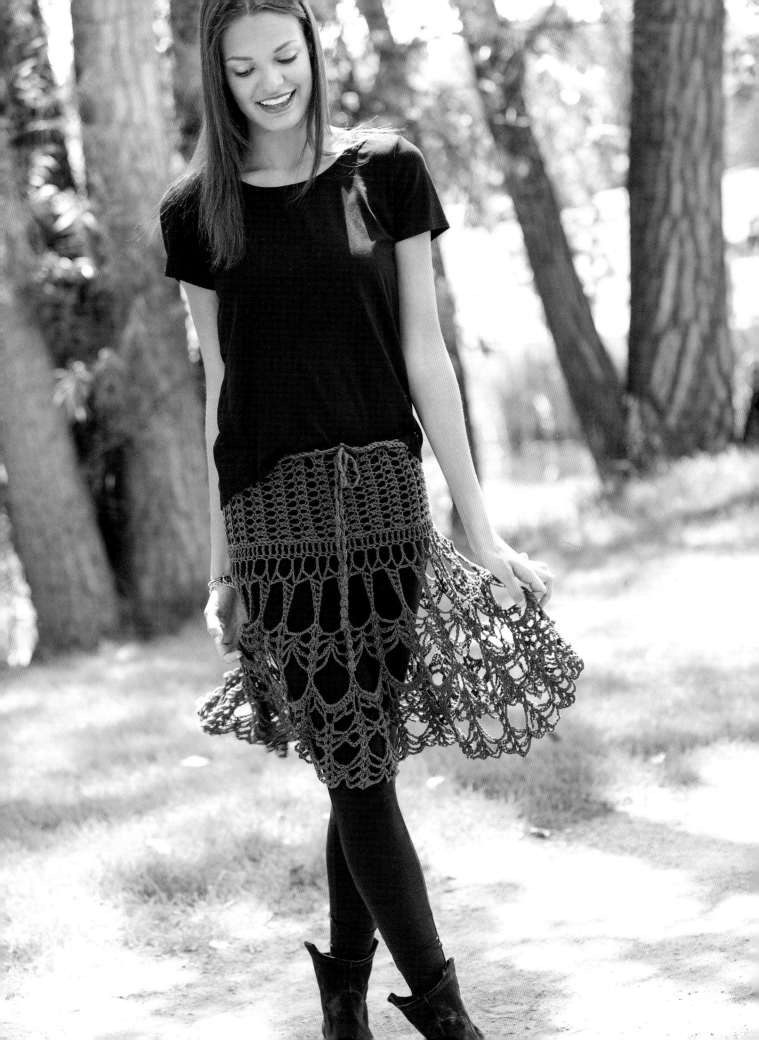

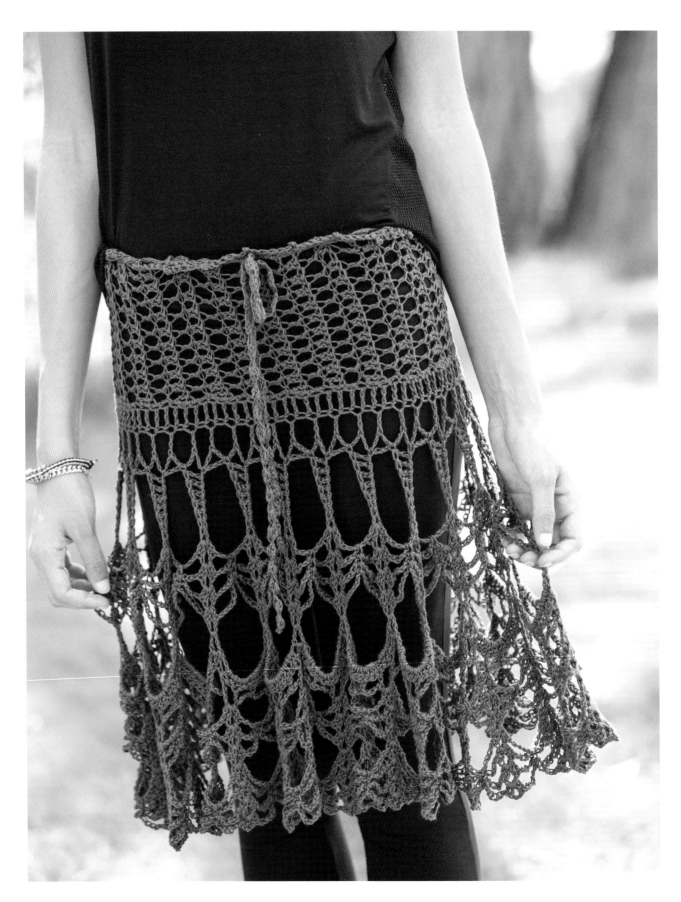

Rnd 7: Sl st to center of first shell, ch 3, (dc, ch 2, 2 dc) in same sp, *ch 6, skip next ch-4 sp, sc in next sc, ch 6, skip next ch-4 sp**, shell in next shell, rep from * around, ending last rep at **, join with sl st in top of beg ch-3—24 (24, 30, 30, 36, 36) shells; 48 (48, 60, 60, 72, 72) ch-6 sps.

Rnd 8: Sl st to center of first shell, ch 3, (dc, ch 2, 2 dc) in same sp, *ch 7, skip next ch-4 sp, sc in next sc, ch 7, skip next ch-4 sp**, shell in next shell, rep from * around, ending last rep at **, join with sl st in top of beg ch-3—24 (24, 30, 30, 36, 36) shells; 48 (48, 60, 60, 72, 72) ch-7 sps.

Rnd 9: Sl st to center of sh, ch 5 (counts as dc, ch 2), dc in same sp (counts as V-st), *ch 13, V-st in next shell, rep from * around to last shell, ch 13, join with sl st in 3rd ch of beg ch-5—24 (24, 30, 30, 36, 36) shells; 24 (24, 30, 30, 36, 36) ch-13 lps.

Rnd 10: Sl st in first ch-2 sp, ch 3, dc in same sp, *13 dc in next ch-13 lp**, 2 dc in next ch-2 sp; rep from * around, join with sl st in top of beg ch-3—360 (360, 450, 450, 540, 540) dc.

Rnd 11: Ch 6 (counts as dc, ch 3), skip next 2 dc, dc in next dc, *ch 3, skip next 2 dc**, dc in next dc; rep from * around, ending last rep at **, join with sl st in 3rd ch of beg ch-6—120 (120, 150, 150, 180, 180) ch-3 sps.

Rnd 12: Sl st in next sp, ch 3, (dc, ch 2, 2 dc) in same sp, *ch 7, skip next 2 sps**, shell in next sp, rep from * around, ending last rep at **, join with sl st in top of beg ch-3—40 (40, 50, 50, 60, 60) shells; 40 (40, 50, 50, 60, 60) ch-6 sps.

Rnd 13: Sl st to center of first shell, ch 3, (dc, ch 2, 2 dc) in same sp, *ch 4, sc in next ch-7 sp, ch 4, shell in next shell, rep from * around, ending last rep at **, join with sl st in top of beg ch-3—40 (40, 50, 50, 60, 60) shells; 80 (80, 100, 100, 120, 120) ch-4 sps.

Rnd 14: Sl st to center of first shell, ch 3, (dc, ch 2, 2 dc) in same sp, *ch 5, skip next ch-4 sp, sc in next sc, ch 5, skip next ch-4 sp**, shell in next shell; rep from *, ending last rep at **, join with sl st in top of beg ch-3—40 (40, 50, 50, 60, 60) shells; 80 (80, 100, 100, 120, 120) ch-5 sps.

Rnd 15: Sl st to center of first shell, ch 3 (dc, ch 2, 2 dc) in same sp, *ch 10 skip next 2 ch-5 sps**, shell in next shell, rep from * around, ending last rep at **, join with sl st in top of beg ch-3—40 (40, 50, 50, 60, 60) shells; 40 (40, 50, 50, 60, 60) ch-10 lps.

Rnd 16: Sl st to center of first shell, ch 3, (dc, ch 2, 2 dc) in same sp, *ch 5, sc in next ch-7 sp, ch 5, shell in next shell, rep from * around, ending last rep at **, join with sl st in top of beg ch-3—40 (40, 50, 50, 60, 60) shells; 80 (80, 100, 100, 120, 120) ch-5 sps.

Rnd 17: Sl st to center of first shell, ch 3, (dc, ch 2, 2 dc) in same sp, *ch 6, skip next ch-5 sp, sc in next sc, ch 6, skip next ch-5 sp**, shell in next shell, rep from *, ending last rep at **, join with sl st in top of beg ch-3—40 (40, 50, 50, 60, 60) shells; 80 (80, 100, 100, 120, 120) ch-6 sps.

Rnd 18: Sl st to center of first shell, ch 3, (dc, ch 2, 2 dc) in same sp, *ch 6, skip next ch-6 sp, sc in next sc, ch 6, skip next ch-6 sp**, shell in next shell, rep from *, ending last rep at **, join with sl st in top of beg ch-3—40 (40, 50, 50, 60, 60) shells; 80 (80, 100, 100, 120, 120) ch-6 sps. Fasten off.

TIP: To lengthen the skirt a little or as much as desired after Rnd 18, do not fasten off. Continue repeating Rnds 5–18 to the desired length. On Rnd 5, work in the ch-3 sps of shells rather than in the tips of the petals.

Waistband

Rnd 1: With RS facing, join yarn with sl st in any st on the top edge of the hip band ch 1, work 2 sc in each row-end dc around, keeping work flat, joining with sl st in first sc—92 (100, 112, 124, 140, 144) sc.

Rnd 2: Ch 1, (sc, picot, sc) in first st, *sc in each of next 3 sc, (sc, picot, sc) in next sc; rep from * around, ending last rep at **, join with sl st in first sc.

Tie

This method eliminates having to work a long ch, so you can make it as long as you want without having to count sts. Just make it as long as necessary to fit around your waist with enough length to tie it into a bow.

With smaller hook, *ch 4, puff st in 4th ch from hook, rep from * to desired length. Fasten off and place a small bead on ends if desired. Weave the tie through the larger sps at the top of the waistband (below first sc rnd) and tie into a bow at the skirt front. Weave in ends.

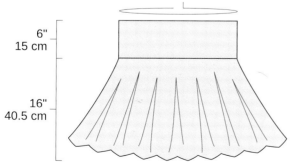

34½ (37½, 42, 46½, 52½, 54)"
87.5 (95, 106.5, 118, 133.5, 137) cm

6"
15 cm

16"
40.5 cm

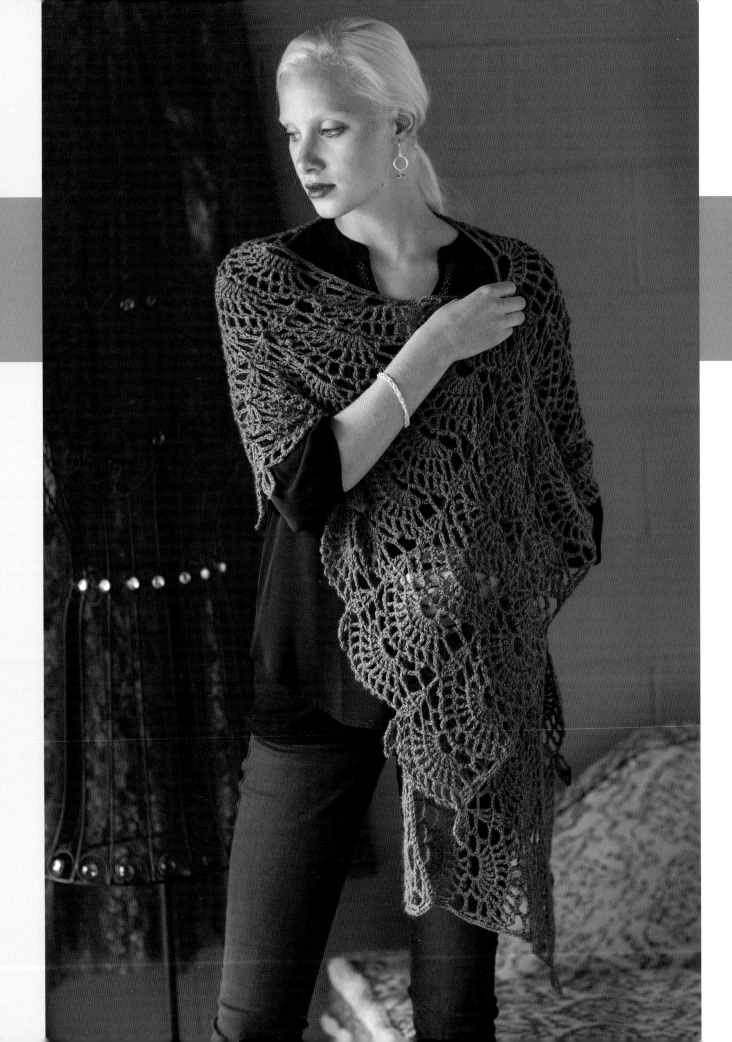

La Vie en Rose
rectangular shawl

FINISHED SIZE
18″ (45.5) deep x 74″ (188 cm) wide.

YARN
Laceweight (#0 Lace).

Shown here: Juniper Moon Farm Findley (50% merino wool, 50% silk; 798 yd [730 m]/3½ oz [100 g]): #12 bloom, 2 balls.

HOOK
Size H/8 (5mm). Adjust hook size if necessary to obtain the correct gauge.

NOTIONS
Stitch markers; yarn needle.

GAUGE
One pattern rep = 5½″ (14 cm); 6 rows = 4″ (10 cm).

This lightweight shawl is perfect for cool summer evenings and will complement any outfit. The laceweight yarn is doubled to make your work on this crescent fan pattern go faster. There are many ways the shawl can be worn, so use your creativity!

STITCH GUIDE

Picot: Ch 3, sl st in 3rd ch from hook.

Double crochet three together (dc3tog): [Yo, insert hook in next st, yo, draw yarn through st, yo, draw yarn through 2 lps on hook] 3 times, yo, draw yarn through 4 lps on hook.

NOTES

If you do not like the idea of working numerous picot sts, you have the option of working a ch-1 in each sp where a picot is worked.

Shawl is worked with 2 strands of yarn held together, which is equal to 1 strand sportweight yarn.

Shawl

Begins at lower edge.

With 2 strands of yarn held together as 1 throughout, ch 238.

Row 1: (WS) Dc in 4th ch from hook (tch counts as dc), *ch 3, skip next 2 ch, dc in next ch, [ch 5, sk next 3 ch, dc in next ch] 3 times, ch 3, skip next 2 ch, dc in next ch; rep from * across, turn—67 dc; 26 ch-3 sps; 39 ch-5 sps.

Row 2: Ch 4 (counts as tr here and throughout), tr in first dc, *ch 3, skip next ch-3 sp, dc in next ch-5 sp, 9 tr in next ch-5 sp, dc in next ch-5 sp, ch 3, skip next ch-3 sp**, 3 tr in next dc; rep from * across, ending last rep at **, 2 tr in last dc, skip tch, turn—13 fans.

Row 3: Ch 2 (does not count as a st), dc in each of first 2 tr, *ch 1, skip next ch-3 sp, skip next dc, (tr, ch 1) in each of next 9 tr, skip next ch-3 sp**, dc in each of next 3 tr; rep from * across, ending last rep at **, dc in each of last 2 tr, turn.

Row 4: Ch 2 (does not count as a st), dc in first dc, skip next ch-1 sp, *ch 1, (tr, picot) in each of next 4 tr, (tr, picot, tr) in next tr, (picot, tr) in each of next 4 tr, ch 1**, dc3tog (see Glossary) over

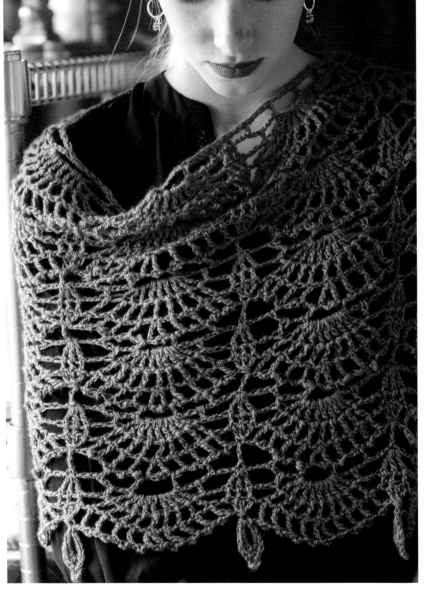

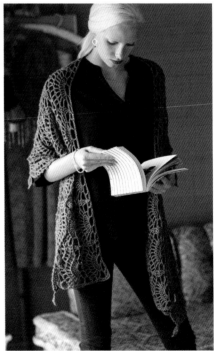

next 3 tr; rep from * across, ending last rep at **, dc in last dc, skip tch, turn—117 picots.

Row 5: Ch 7 (counts as tr, ch 3), skip next 2 picots, *dc in next tr, ch 5, skip next 2 picots, dc in sp after last picot (before the next tr), ch 5, skip next (tr, picot, tr), dc in sp after last tr (before next picot), ch 5, skip next 2 picots, dc in next tr, ch 3, skip next 2 picots and ch-1 sp**, tr in next dc3tog, ch 3; rep from * across, ending last rep at **, ch 3, tr in last dc, skip tch, turn.

Rows 6–23: Rep Rows 2–5 (4 times); then rep Rows 2–3.

Row 24: Ch 2 (does not count as a st), dc in first dc, skip next ch-1 sp, *ch 1, (tr, picot) in each of next 4 tr, (tr, picot,

tr) in next tr, (picot, tr) in each of next 4 tr, ch 1**, dc3tog over next 3 tr, turn, ch 10, sl st to base of ch-10, ch 1, (sl st, 2 sc, hdc, 2 dc, ch 6, sl st to first ch of ch-6, 2 dc, hdc, 2 sc, sl st) in ch-10 lp, sl st to base of ch-10; rep from * across, ending last rep at **, dc in last dc, skip tch, turn—117 picots. Do not fasten off.

Edging

Ch 1, rotate to work across short edge of shawl, keeping work flat, sc evenly spaced across side edge, top edge, and other side edge, working 2 or 3 sc in each corner if necessary. Fasten off. Weave in the ends and block the shawl to correct the measurements.

STITCH KEY

⬯ = chain (ch)

• = slip stitch (sl st)

✛ = single crochet (sc)

T = half double crochet (hdc)

† = double crochet (dc)

‡ = treble crochet (tr)

⋀ = cluster

⌓ = picot

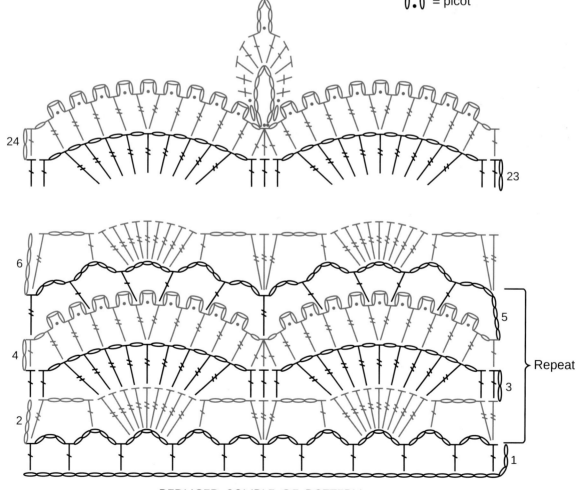

REDUCED SAMPLE OF PATTERN

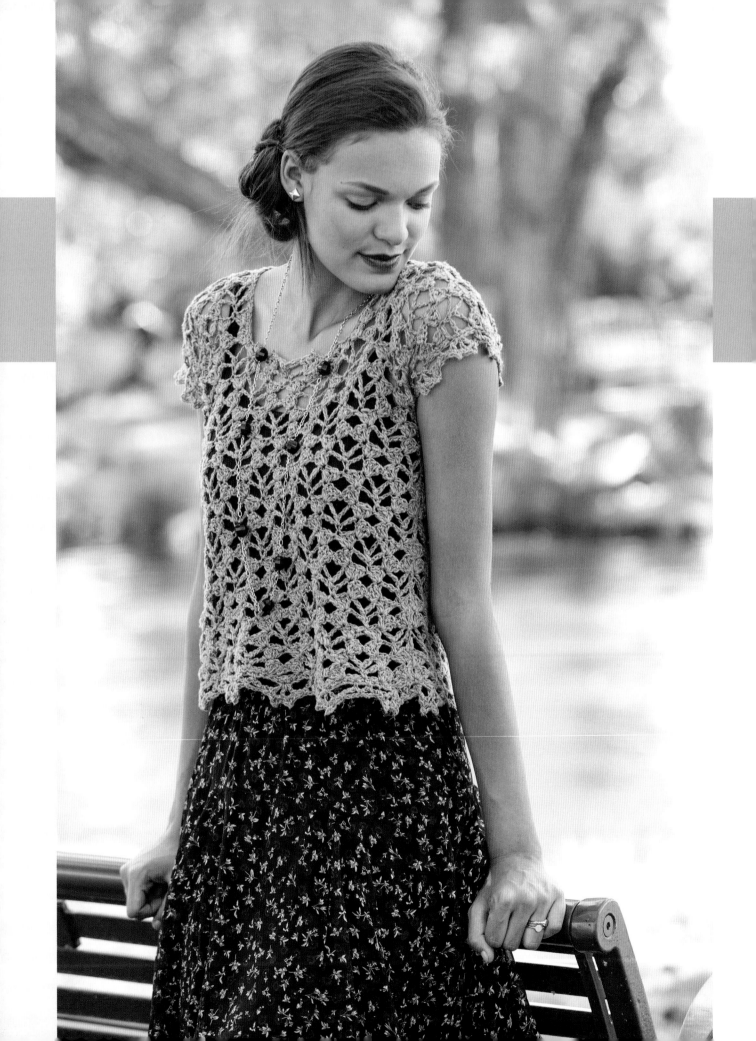

Au Naturel
cropped top

FINISHED SIZES
S/M (L, 1X, 2X, 3X). Sample shown is size S/M.

Bust: 36 (42, 49, 55, 62)″ (91.5 [106.5, 124.5, 139.5, 157.5] cm).

Length: 18½ (20, 21, 20, 21)″ (47 [51, 53.5, 51, 53.5] cm).

YARN
DK weight (#3 Light).

Shown here: Juniper Moon Farm Zooey (60% cotton, 40 % linen; 284 yd [260 m]/3½ oz [100 g]): #08 all spice, 2 (3, 4, 4, 4) balls.

HOOK
Size H/8 (5 mm). Adjust hook size if necessary to obtain the correct gauge.

NOTIONS
Yarn needle.

GAUGE
1 patt rep (12 sts on Row 1) = 3¼″ (8.5 cm); 5 rows = 3″ (7.5 cm).

The natural color of this simple lace top worked in a cotton/linen blend yarn goes with just about anything. It will look especially good with jeans or shorts to fit into today's styles, but would look equally stylish with a skirt for a day or evening look. The edging finishes it off and makes it extra special.

NOTES

Top is worked in 2 pieces with seams at the sides and shoulders.

Beg ch is at the lower edge.

If you prefer a looser top, use a size larger hook. Top is meant to be loose, but if you want a more fitted top, you should consider making a smaller size—see actual measurements.

Even though this is a DK-weight yarn, there will be times it is more like a fingering yarn—thick and thin. Just make sure you don't work your sts too tight when the thin part comes up. Keep your sts even.

Washing or wetting linen yarn makes it much softer.

STITCH GUIDE

Shell: (Dc, ch 1, dc, ch 1, dc) in same st.

Back

Loosely ch 68 (80, 92, 104, 116).

Row 1: (RS) Sc in 2nd ch and in each ch across, turn—67 (79, 91, 103, 115, 127).

Row 2: Ch 3 (counts as first dc here and throughout), 3 dc in same st, skip next 5 sc, 4 dc in next sc, *ch 3, skip next 2 sc, sc in next sc, ch 3, skip next 2 sc, 4 dc in next sc, skip next 5 sc, 4 dc in next sc; rep from * across, turn—48 (56, 64, 72, 80) dc, 10 (12, 14, 16, 18) ch-3 sps.

Row 3: Ch 3, 3 dc in first dc, skip next 6 dc, 4 dc in next dc, *ch 3, skip next ch-3 sp, sc in next sc, ch 3, skip next ch-3 sp, 4 dc in next dc, skip 6 dc, 4 dc in next dc; rep from *, ending with 4 dc in top of ch-3 tch, turn—48 (56, 64, 72, 80) dc, 10 (12, 14, 16, 18) ch-3 sps.

Row 4: Ch 6 (counts as dc, ch 3 here and throughout), skip first 4 dc, sc in next dc, ch 3, skip next 2 dc, *4 dc in next dc, skip next 2 ch-3 sps, 4 dc in next dc, ch 3, skip next 3 dc, sc in next dc, ch 3; rep from * across, ending with skip next 2 dc, dc in top of ch-3 tch, turn—40 (48, 56, 64, 72) dc, 12 (14, 16, 18, 20) ch-3 sps.

Row 5: Ch 6, skip next ch-3 sp, sc in next sc, ch 3, skip next ch-3 sp, *4 dc in next dc, skip next 6 dc, 4 dc in next dc, ch 3, skip next ch-3 sp, sc in next sc, ch 3 skip next ch-3 sp; rep from * across, ending with dc in 3rd ch of ch-6 tch, turn—40 (48, 56, 64, 72) dc, 12 (14, 16, 18, 20) ch-3 sps.

Row 6: Ch 3, 3 dc in first dc, skip next 2 ch-3 sps, 4 dc in next dc, *ch 3, skip next 3 dc, sc in next dc, ch 3, skip next 2 dc, 4 dc in next dc, skip next 2 ch-3 sps**, 4 dc in next dc; rep from * across, ending last rep at **, with 4 dc in 3rd ch of beg ch-6, turn—48 (56, 64, 72, 80) dc, 10 (12, 14, 16, 18) ch-3 sps.

Rows 7–31 (33, 35, 33, 35): Rep rows 3–6 (5 [6, 6, 6, 6] times); work evenly in pattern for 1 (3, 1, 3, 1) more rows, ending with Row 3 (5, 3, 5, 3) of patt. Pull up last lp on hook and set Back aside. Do not fasten off.

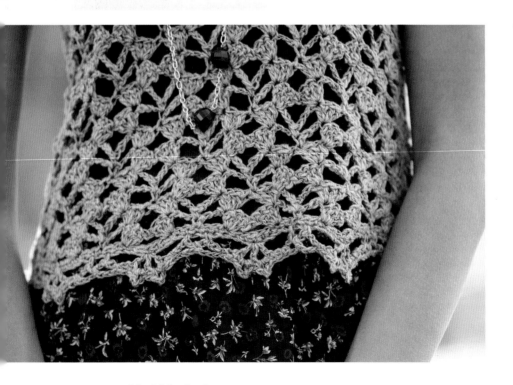

STITCH KEY

⌒ = chain (ch)

• = slip st (sl st)

┼ = single crochet (sc)

┬ = double crochet (dc)

= shell

Front

Work same as back through Row 23 (25, 27, 25, 27). Front should measure 13 (14½, 15½, 14½, 15½)" (33 [37, 39.5, 37, 39.5] cm) from beginning. Pull up last lp on hook and set front aside. Do not fasten off.

SHAPE NECK AND RIGHT SHOULDER

With WS of work facing, PM in center sc of last row worked. Counting outward from this sc (at marker), PM at 11th st to each side of center marker.

Sizes S, L, and 2X only

Row 1: Pick up dropped lp on Front, ch 6, skip first 4 dc, sc in next dc, *ch 3, skip next 2 dc, 4 dc in next dc, skip next 2 ch-3 sps, 4 dc in next dc**, ch 3, skip next 3 dc, sc in next dc, rep from * 0 (1, 2) times; rep from * to ** once, working last dc in first marked st, turn—16 (24, 32) dc; 4 (6, 8) ch-3 sps.

Row 2: Ch 3, 3 dc in first dc, skip next 6 dc, 4 dc in next dc, *ch 3, sc in

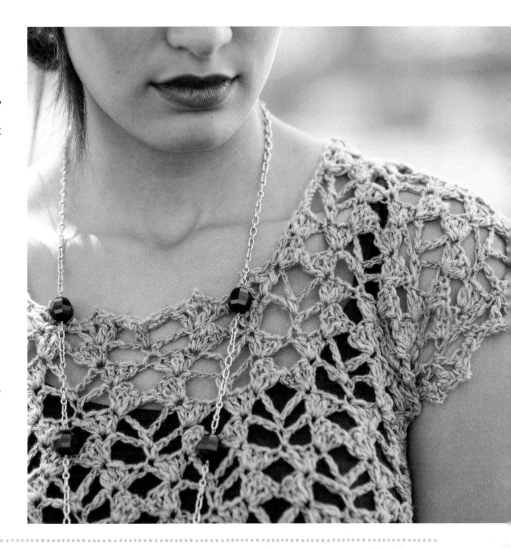

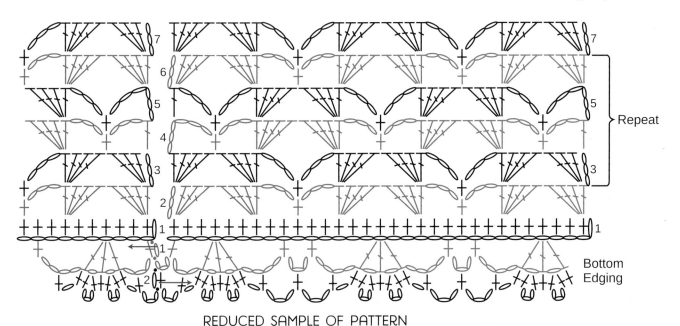

REDUCED SAMPLE OF PATTERN

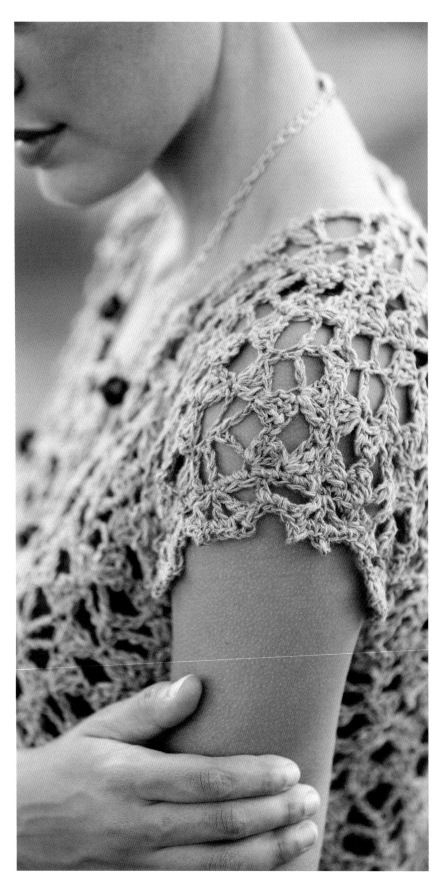

next sc, ch 3**, 4 dc in next dc, skip next 6 dc, 4 dc in next dc; rep from * across, ending last rep at **, skip next 3 ch, dc in next ch, turn—16 (24, 32) dc; 4 (6, 8) ch-3 sps.

Row 3: Ch 3, 3 dc in first dc, skip next 2 ch-3 sps, 4 dc in next dc, *ch 3, skip next 3 dc, sc in next dc, ch 3, skip next 2 dc**, 4 dc in next dc, skip next 2 ch-3 sps, 4 dc in next dc, rep from * 0 (1, 2) times; rep from * to ** once, dc in top of ch-3 tch, turn—16 (24, 32) dc; 4 (6, 8) ch-3 sps.

Row 4: Ch 6, skip next ch-3 sp, sc in next sc, *ch 3, skip next ch-3 sp, 4 dc in next dc, skip next 6 dc, 4 dc in next dc**, ch 3, skip next ch-3 sp, sc in next sc, rep from * 0 (1, 2) times; rep from * to ** once, working last 4 dc in top of ch-3 tch, turn—16 (24, 32) dc; 4 (6, 8) ch-3 sps.

Rows 5–8: Rep Rows 1–4 once. Fasten off.

SHAPE NECK AND LEFT SHOULDER

Row 1: With WS facing, skip 11 sts to the left of last st of right shoulder, join yarn in next marked st, ch 3, 3 dc in first dc, skip next 2 ch-3 sps, 4 dc in next dc, *ch 3, skip next 3 dc, sc in next dc, ch 3, skip next 2 dc**, 4 dc in next dc, skip next 2 ch-3 sps, 4 dc in next dc, rep from * 0 (1, 2) times; rep from * to ** once, dc in top of ch-3 tch, turn—16 (24, 32) dc; 4 (6, 8) ch-3 sps.

Row 2: Work same as Row 4 of right shoulder.

Row 3: Work same as Row 1 of right shoulder.

Row 4: Work same as Row 2 of right shoulder.

Rows 5–8: Rep Rows 1–4 once. Fasten off.

For Medium, 1X, and 3X only

Row 1: Pick up dropped lp on Front, ch 3, 3 dc in first dc, skip next 2 ch-3sps, 4 dc in next dc, *ch 3, skip

next 3 dc, sc in next dc, ch 3, skip next 2 dc, 4 dc in next dc, skip next 2 ch-3 sp**, 4 dc in next dc; rep from * across, ending last rep at **, 4 dc in 3rd ch of ch-6 tch, turn—24 (32) dc; 4 (6) ch-3 sps.

Rows 2–8: Starting with Row 3 of patt, work evenly in patt. Fasten off.

SHAPE NECK AND LEFT SHOULDER

Row 1: With WS facing, skip 11 sts to the left of last st of right shoulder, join yarn in next marked st, ch 3, 3 dc in first dc, skip next 2 ch-3sps, 4 dc in next dc, *ch 3, skip next 3 dc, sc in next dc, ch 3, skip next 2 dc, 4 dc in next dc, skip next 2 ch-3 sp**, 4 dc in next dc; rep from * across, ending last rep at **, 4 dc in 3rd ch of ch-6 tch, turn—24 (32) dc; 4 (6) ch-3 sps.

Finishing

Sew shoulder seams. Sew side seams, leaving 6 (6½, 7, 7½, 8)" (15 [16.5, 18, 19, 20.5] cm) armhole openings.

BOTTOM EDGING

Rnd 1: With WS facing, working across opposite side of foundation ch, join yarn with sl st in first ch to the left of one side seam (this will be at the base of the first 3-dc group), ch 1, sc in same ch, ch 3, skip next 2 ch, ** *shell in next ch, ch 4, skip next 4 chs, sc in next ch, ch 3, skip next ch, sc in next ch, ch 4, skip next 4 chs, rep from * across to within 8 ch sts of next side seam, skip next 4 chs, shell in next ch, ch 3, skip next 2 chs, sc in next ch (at base of last 4-dc group), ch 3, skip seam**, sc in next ch; rep from ** to ** once, join with sl st in first sc, turn.

Rnd 2: (RS) Sl st in first ch-3 sp, ch 1, sc in same sp, ch 3, sc in next ch-3 sp, *ch 1, [sc in next dc, (sc, ch 3, sc) in next ch-1 sp] twice, sc in next dc,

ch 1, sc in next ch-4 sp, ch 3**, sc in next ch-3 sp, ch 3, sc in next ch-4 sp; rep from * around, ending last rep at **, join with sl st in first sc. Fasten off.

NECK EDGING

With RS facing, join yarn in left shoulder seam of front, ch 1, sc in same sp, sc evenly across left neck edge to corner, keeping work flat, *sc in next dc, (sc, ch 2, sc) bet next 2 dc, skip next dc, sc in next dc, sc in sp before next dc, sc in next dc, (sc, ch 2, sc) in sp before next dc, skip next dc, sc in next dc*, 2 sc in each of next 2 ch-3 sps; rep from * to * once, sc evenly across right neck edge to shoulder seam, sc evenly across back neck edge, keeping work flat, join with sl st in first sc. Fasten off.

ARMHOLE EDGING

Rnd 1: With RS facing, join yarn with sl st at underarm seam, ch 1, sc in same sp, sc evenly around armhole working 42 (49, 55, 61, 67) sc, join with sl st in first sc.

Rnd 2: Ch 1, sl st in each of first 6 sc, *ch 3, skip next 2 sc, shell in next sc, ch 3, skip next 2 sc, sc in next sc, rep from * 4 (5, 6, 7, 8) times, sl st in each of next 6 sc, sl st in first sl st. Fasten off.

Rnd 3: With RS facing, join yarn to 2nd ch of first ch-3 at beg of last rnd, *[sc in next dc, (sc, ch 3, sc) in next ch-1 sp] twice, sc in next dc, sc in next ch-3 sp, sc in next sc, sc in next ch-3 sp; rep from * 4 (5, 6, 7, 8) times, sl st in 2nd ch of last ch-3 sp. Fasten off. Weave in ends. Block to correct size if needed.

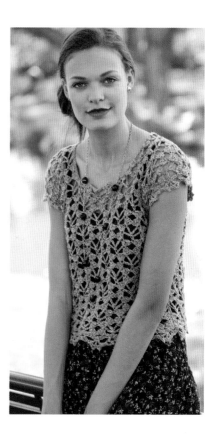

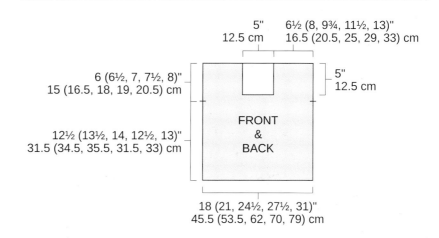

5"
12.5 cm

6½ (8, 9¾, 11½, 13)"
16.5 (20.5, 25, 29, 33) cm

6 (6½, 7, 7½, 8)"
15 (16.5, 18, 19, 20.5) cm

5"
12.5 cm

FRONT & BACK

12½ (13½, 14, 12½, 13)"
31.5 (34.5, 35.5, 31.5, 33) cm

18 (21, 24½, 27½, 31)"
45.5 (53.5, 62, 70, 79) cm

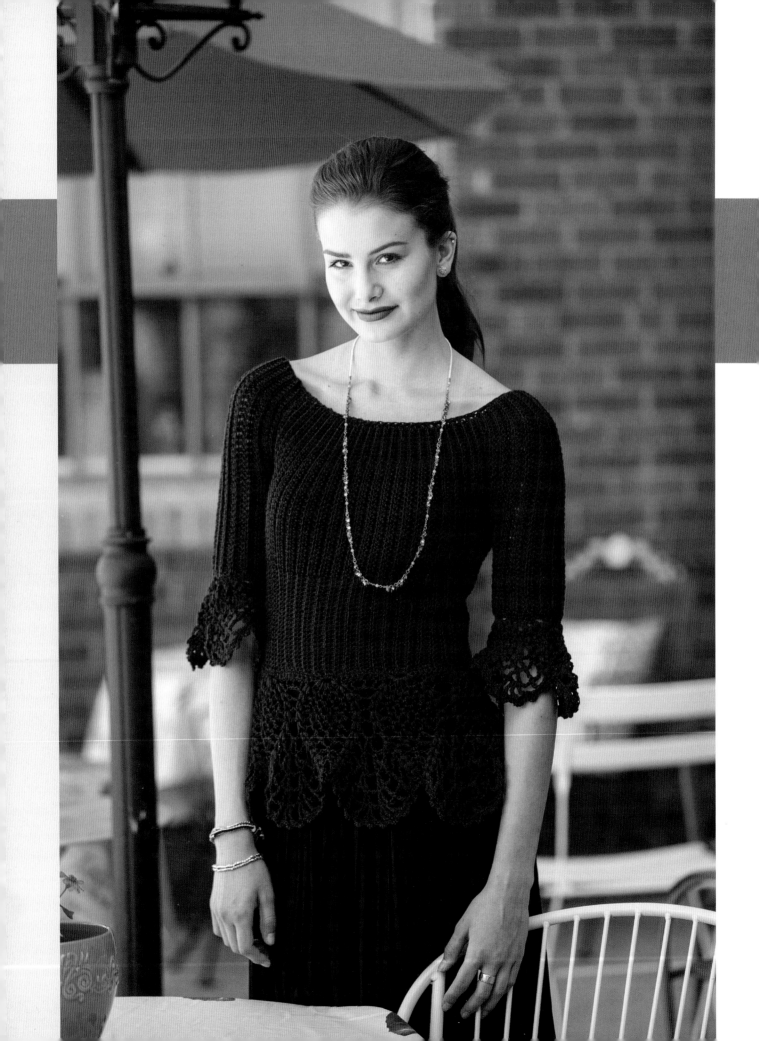

Haute Couture
peplum top

This showstopper is probably my favorite project in the book and is made with the Graduated Stitch Method (GSM; see page 152). Unlike many of the designs in this collection, the main part of the pattern is plain, and the pineapple lace is used just as an accent. The gorgeous plum color will flatter any complexion.

FINISHED SIZES
XS (S, M, L, 1X, 2X). Sample shown is size XS.

Bust: 31 (34, 37, 39, 42, 45, 48)″ (79 [86.5, 94, 99, 106.5, 114.5, 122] cm).

Length: 21½″ (54.5 cm).

YARN
Sportweight (#2 Fine).

Shown here: Cascade Ultra Pima Cotton Fine (100% pima cotton; 136 yd [124 m]/1¾ oz [50 g]): #3704 syrah, 6 (7, 7, 8, 9, 10) hanks.

HOOKS
Sizes I/9 (5.5 mm) and H/8 (5 mm). Adjust hook size if necessary to obtain the correct gauge.

NOTIONS
Stitch markers; yarn needle; bead elastic in black (optional).

GAUGE
Bust area: With larger hook, 15 hdc and 12 hdc rows in blo = 4″ (10 cm).

Waist area: With larger hook, 15 sc and 16 sc rows in blo = 4″ (10 cm).

Neck ribbing: With smaller hook, 18 sc and 17 sc rows in blo = 4″ (10 cm).

NOTES

Front and back bodice and waist above peplum will be worked in vertical rows and seamed at the sides. Sleeves will be made and attached with seams to the arm and neck openings. Then yarn will be attached to the waist, and the peplum will be worked in rounds. Front and back bodice will always be worked in the back loop only (blo), which causes the garment to stretch and form to the body.

You can make this top as snug or as loose as you like. Adding more rows is all it takes to make it less formfitting. Remember to place a marker in the first hdc after the neck ribbing, moving the marker up as you work each row. Marking the hdc will make it easier to see where to begin the sc section with the smaller hook.

Top will look small for your size, but it will stretch due to working in the blo.

GETTING A CUSTOM FIT

The ch 54 includes 1 ch for tch, 9 chs for neck ribbing, 22 chs for bust area and 22 chs for waist area. If you have a large bust, you may want to add sts to the bust area on the beg ch to lengthen the body in that area. Ch 54 and work Rows 1–3 according to the instructions before deciding to add sts. After you've worked a few rows, hold piece up to your chest (vertically with beg ch at side), making sure the hdc are at your bust. If it seems too small, add some chs to the beg ch, making sure you put a note on the patt adding the extra sts to the hdc bust area. This would also be a good time to make sure the length to your waist is not too short or too long. If it's too short, add ch sts to the waist area, keeping in mind cotton stretches, and the peplum will pull it down. If it's too long, delete some ch sts on the foundation ch.

STITCH GUIDE

Picot: Ch 3, sc in 3rd ch from hook.

Puff stitch (puff st): [Yo, insert hook in next st, yo, draw yarn through st and up to about ½″ (1.3 cm)] 3 times in same st, holding hook up tightly to keep lps even, yo, draw yarn through all 7 lps on hook.

Puff-stitch cluster (puff-st cluster): [Yo, insert hook in next st, yo, draw yarn through st and up to about ½″ (1.3 cm)] 3 times in same st, insert hook in next hdc and draw up to about ½″ (1.3 cm), [yo, insert hook in next st, yo, draw yarn through st and up to about ½″ (1.3 cm)] 3 times in same st, holding hook up tightly to keep lps even, yo, draw yarn through all 14 lps on hook.

Shell: (Puff st, ch 1, puff st) in same sp.

V-stitch (V-st): (Tr, ch 1, tr) in same st or sp.

NOTE: For first puff st of rnd, draw up lp on hook to ½″ (1.3 cm), [yo, insert hook in next st, yo, draw yarn through st and up to about ½″ (1.3 cm)] 3 times in same st, holding hook up tightly to keep lps even, yo, draw yarn through all 7 lps on hook.

Front/Back (MAKE 2)

With larger hook, ch 54 (see Getting a Custom Fit, left).

Row 1: Change to smaller hook, sc in 2nd ch from hook and in next 8 chs (neck ribbing), change to larger hook, hdc in each of next 22 chs (bust area), cont with larger hook, sc in each of last 22 chs (waist area), turn—9 sc; 22 hdc; 22 sc; 53 sts total.

NOTE: In order to keep up with the sts that change heights, you may want to place a marker between each section, indicating the change to a sc from hdc or from hdc to a sc. It's a small price to pay to get a perfect custom fit!

Row 2: With larger hook, ch 1, sc in each of first 22 sc, hdc in each of next 22 hdc, change to smaller hook, sc in each of next 9 sc, turn—53 sts. Band at neck (sc) should measure about 2″ (5 cm).

Row 3: With smaller hook, ch 1, sc in each of first 9 sc, change to larger hook, hdc in each of next 22 hdc, sc in each of last 22 sc, turn—53 sts.

Rows 4–47 (51, 55, 58, 63, 67, 73): Rep Rows 2–3 (22 [24, 26, 27, 30, 32, 35] times); rep Row 2 (0 [0, 0, 1, 0, 0] times) or to desired width across bust and waist. If your gauge is off, add or delete rows to fit. Fasten off.

ASSEMBLY

With WS tog, match up sts at sides and pin in place. With yarn needle and yarn, sew sides leaving a 5½ (6,

6½, 7, 7½, 8, 8½)" (14 [15, 16.5, 18, 19, 20.5, 21.5] cm) opening at the top of the body for the armhole, where the sleeve and neck piece will be attached.

NOTE: If this seems as though the opening is not large enough, keep in mind the sc sts on each edge of the sleeve will not be seamed at the shoulders. They will be seamed a few inches below the shoulders.

Sleeve (MAKE 2)

With larger hook, loosely ch 45 (47, 49, 51, 53, 55, 57).

Row 1: With smaller hook, sc in 2nd ch and in each of next 8 chs (neck area), change to larger hook, hdc in each of next 34 chs (upper arm), cont with larger hook, sc in last ch—9 sc; 34 hdc; 1 sc at bottom edge; 44 sts total.

Row 2: With larger hook, ch 1, sc in first sc, hdc in each of next 34 hdc, change to smaller hook, sc in each of last 9 sc—1 sc; 34 hdc; 9 sc; 44 sts total.

Row 3: With smaller hook, ch 1, sc in each of first 9 sc, change to larger hook, hdc in each of next 34 hdc, sc in last sc—9 sc; 34 hdc; 1 sc; 44 sts total.

Rows 4–27 (29, 31, 35, 37, 41, 43): Rep Rows 2–3 (12 [13, 14, 16, 17, 19, 20] times) or to desired width.

PM on each side of sleeve from top edge at 5½ (6, 6½, 7, 7½, 8, 8½)" (14 [15, 16.5, 18, 19, 20.5, 21.5] cm) below neck edge, or to match opening on bodice. Beg at bottom edge of sleeve, work 32 sc to marker. Fasten off. Rep on other side of sleeve.

With WS tog, matching sts on each side of sleeve, sew sleeve seam, leaving opening at top for armhole. Turn RS out. With RS of front and one sleeve facing, pin upper edge of sleeve to front opening. Sew front edge of sleeve to front. Sew back edge of sleeve to back. Rep for other sleeve.

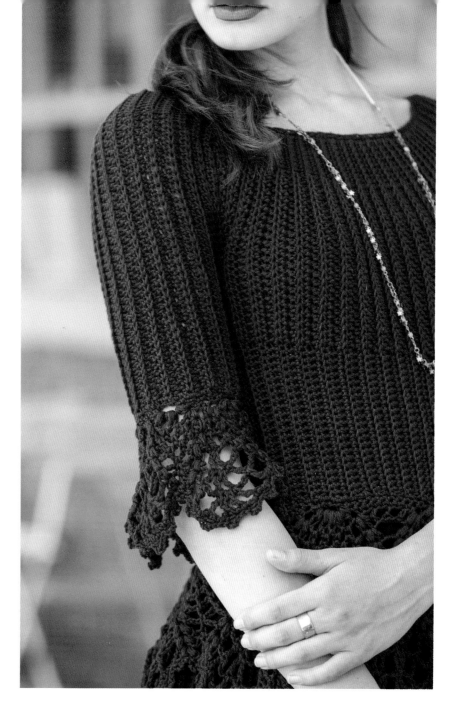

Neck Edging

Try top on to determine if you need to dec sts when working a sc row around neck edge. If you would like to work elastic around neck edge, place bead elastic along the neck edge as you work the sc row, encasing elastic in sts as you go. With a smaller hook, join yarn in with sl st in one seam on neck edge, sc evenly around the neck opening, working over elastic used, join with sl st in first sc. Cut the elastic and tie in a secure knot to the loose end of the elastic at the beg of the row, pulling elastic as much as you need to make the neck edge fit as desired.

Peplum

With bottom edge of waist on top, starting at side seam, place 8 (8, 10, 10, 12, 12) markers evenly spaced around bottom edge.

Rnd 1: With RS facing, join yarn in side seam at one marker, ch 1, *work 15 sc evenly spaced across to next

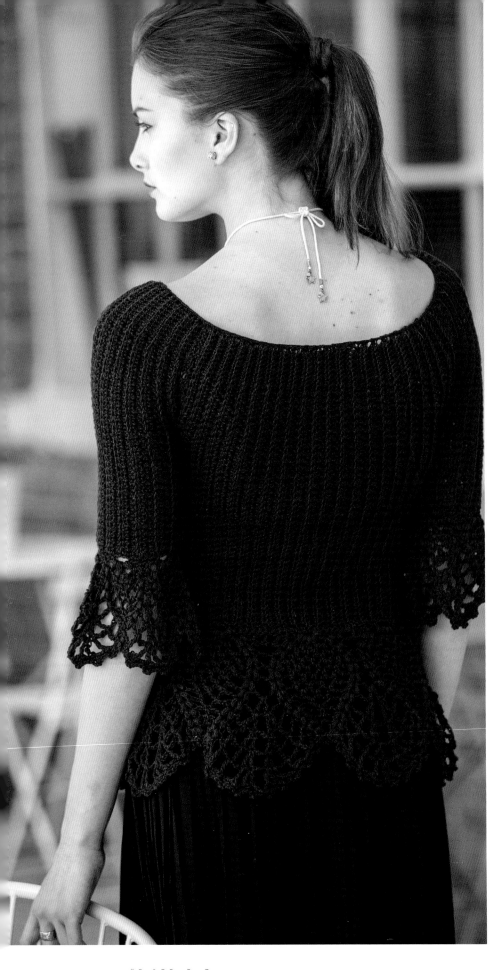

marker; rep from * around, join with sl st in first sc to any st—120 (120, 150, 150, 180, 180) sc. Fasten off.

NOTE: If it flares out a little, that is okay because the peplum needs to flare in order to fit around the hips.

Sizes S, M, 2X, and 3X only
PM in center st of Back, join yarn in 8th st to the right of the center marker on the back bottom edge.

Sizes L and 1X only
Join yarn in 8th st to the right of any marker on the back bottom edge. (These sizes will not have a pineapple in the center.)

All sizes
Rnd 2: Ch 1, sc in same sp as joining, sc in each of next 5 sc, *ch 4 tightly, sk next 4 sc**, sc in each of next 11 sc, rep from * around, ending last rep at **, sc in each of last 5 sc, join with sl st in first sc—8 (8, 10, 10, 12, 12) ch-5 lps; 11 sc between ch-4 sps. Fasten off.

Rnd 3: With RS facing, join yarn 2 sc to the left of any ch-4 sp in Rnd 2, ch 1, sc in each of first 9 sc, sk next sc, *([puff, ch 3] 4 times, puff st) in next ch-4 sp, sk next sc**, sc in each of next 9 sc, sk next sc; rep from * around, ending last rep at **, join with sl st in first sc—9 sc between each pineapple. Fasten off.

Rnd 4: With RS facing and puff st group at left, join yarn in sp to the right of first puff st of a group, shell in same sp where yarn was attached, *ch 3, sk next puff st, (sc, ch 3) in each of next 4 ch-3 sps, skip next puff st, shell in sp before next sc, ch 1, skip next 2 sc, dc in next sc, [ch 1, skip next sc, dc in next sc] twice, skip next 2 sc**, shell in next sp before next puff st st, rep from * around, ending last rep at **, join with sl st in first puff st —16 (16, 20, 20, 24, 24) shells; 5 ch-5 sps bet shells.

Rnd 5: Sl st in next ch-1 sp, shell in same sp, *(ch 3, sc) in each of next

5 ch-3 sps, ch 3, shell in next shell, ch 2, skip next 2 ch-2 sps**, shell in next shell, rep from * around, ending last rep at **, join with sl st in first puff st—8 (8, 10, 10, 12, 12) pineapples started; 6 ch-3 sps for each pineapple.

Rnd 6: Sl st in next ch-1 sp, shell in same sp, *(ch 3, sc in next ch-3 sp) 6 times, ch 3, shell in next shell, ch 1, skip next ch-2 sp**, shell in next shell; rep from * around, ending last rep at **, join with sl st in first puff st—7 ch-3 sps for each pineapple.

Rnd 7: Sl st in next ch-1 sp, shell in same sp, *ch 3, skip next ch-3 sp, (sc, ch 3) in each of next 5 ch-3 sps, skip next ch-3 sp, shell in next shell, skip next ch-1 sp**, shell in next shell; rep from * around, ending last rep at **, join with sl st in first puff st—6 ch-3 sps for each pineapple.

STITCH KEY

⬯ = chain (ch)

• = slip st (sl st)

✛ = single crochet (sc)

Т = half double crochet (hdc)

Ŧ = double crochet (dc)

Ŧ = treble crochet (tr)

〤 = V-stitch (V-st)

◗ = puff st

▽ = shell

⬠ = picot

Rnd 8: Sl st in next ch-1 sp, shell in same sp, *ch 2, skip next ch-3 sp, (sc, ch 3) in each of next 3 ch-3 sps, sc in next ch-3 sp, ch 2, skip next ch-3 sp, shell in next shell, ch 4**, shell in next shell; rep from * around, ending last rep at **, join with sl st in first puff st—3 ch-3 sps in each pineapple.

Rnd 9: Sl st in next ch-1 sp, shell in same sp, *ch 2, skip next ch-2 sp, (sc, ch 3) in each of next 2 ch-3 sps, sc in next ch-3 sp, ch 2, skip last ch-2 sp, shell in next shell, ch 3, V-st, in next ch-4 sp, ch 3; rep from * around, ending last rep at **, join with sl st in first puff st—2 ch-3 sps for each pineapple.

Rnd 10: Sl st in next ch-1 sp, shell in same sp, *ch 2, skip ch-2, sc in next ch-3 sp, ch 3, sc in next ch-3 sp, ch 2, shell in next shell, (ch 3, V-st) in each of next 2 tr, ch 3**, shell in next shell, rep from * around, ending last rep at **, join with sl st in first puff st—(ch 2, ch-3, ch 2) sps in pineapple; 4 tr in fan section.

Rnd 11: Sl st in next ch-1 sp, shell in same sp, *ch 2, skip next ch-2 sp, sc in next ch-3 sp, ch 2, skip next ch-2 sp, shell in next shell, ch 3, tr in next tr, (ch 3, V-st) in each of next 2 tr, ch 3, tr in next tr, ch 3**, shell in next shell, rep from * around, ending last rep at **, join with sl st in first puff st—ch-2, hdc, ch-2 in each pineapple; 6 tr in fan section.

Rnd 12: Sl st in next ch-1 sp, shell in same sp, *ch 1, skip next ch-2 sp, hdc in next sc, ch 1, skip next ch-2 sp, shell in next shell, (ch 3, tr) in each of next 2 tr, (ch 3, V-st) in each of next 2 tr, (ch 3, tr) in each of next 2 tr, ch 3**, shell in next shell, rep from * around, ending last rep at **, join with sl st in first puff st—2 ch-1 sps in each pineapple; 8 tr in fan section.

Rnd 13: Sl st in next ch-1 sp, shell in same sp, *ch 1, skip next ch-1 sp, hdc in next hdc, ch 1, skip next ch-1 sp, shell in next shell, (ch 3, tr) in each of next 3 tr, (ch 3, V-st) in each of next 2 tr), (ch 3, tr) in each of next 3 tr, ch 3**, shell in next shell, rep from * around, ending last rep at **, join with sl st in first puff st—2 ch-1 sps in each pineapple; 10 tr in fan section.

Rnd 14: Sl st in next ch-1 sp, shell in same sp, *ch 1, skip next 2 ch-1 sps, shell in next shell, ch 1, [2 sc in next ch-3 sp, sc in next tr] 4 times, sc in next ch-1 sp of V-st, sc in next tr, 2 sc in next ch-3 sp, sc in next tr, sc in next ch-1 sp, sc in next tr, [2 sc in next ch-3 sp, sc in next tr] 3 times, 2 sc in next ch-3 sp, ch 1**, shell in next shell; rep from * around, ending last rep at **, join with sl st in first puff st—30 sc in each fan.

Rnd 15: Sl st in next ch-1 sp, * work picot, skip next ch-1 sp, sl st in ch-1 of next puff st, sl st in next st, [picot,

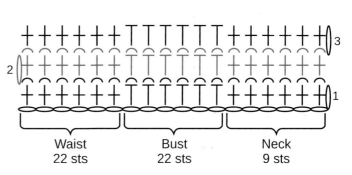

REDUCED SAMPLE OF BODY PATTERN

skip 1 sc, sl st in each of next 2 sc]
10 times, picot, skip next 2 sts **, sl
st in ch-1 sp of next shell, rep from
* around, ending last rep at **, join
with sl st in first sl st—11 picots over
each fan; 1 picot over each pineapple.

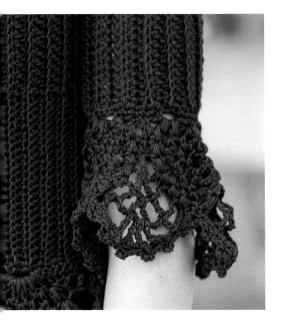

Sleeve Border

Sleeve border will be a scaled-down
version of the peplum. Peplum has 2
puff sts on each side of the pineap-
ples, but the pineapples on the sleeve
border have 1 puff st on each side of
each pineapple.

Rnd 1: Place 5 (5, 6, 6, 7, 7, 7) mark-
ers evenly spaced around bottom
edge of sleeve. With RS facing, join
yarn in seam on cuff edge of sleeve,
ch 1, work 6 sc evenly spaced across
to next marker, rep from * around,
join with sl st in first sc—30 (30, 36,
36, 42, 42, 42) sc. Fasten off. Move
markers up to mark position of each
ch-3 sp in Rnd 2.

Rnd 2: With RS facing, join yarn in sc
at left of any marker, ch 1, sc in each
of first 4 sc, ch 3, skip next 2 sc, *sc in
each of next 4 sc, ch 3, skip 2 sc; rep
from * around, join with a sl st in first
sc—5 (5, 6, 6, 7, 7, 7) ch-3 sps.

STITCH KEY

⬯ = chain (ch)

• = slip st (sl st)

✛ = single crochet (sc)

T = half double crochet (hdc)

╆ = double crochet (dc)

╪ = treble crochet (tr)

⋀ = V-stitch (V-st)

▯ = puff st

⬥ = shell

⌂ = picot

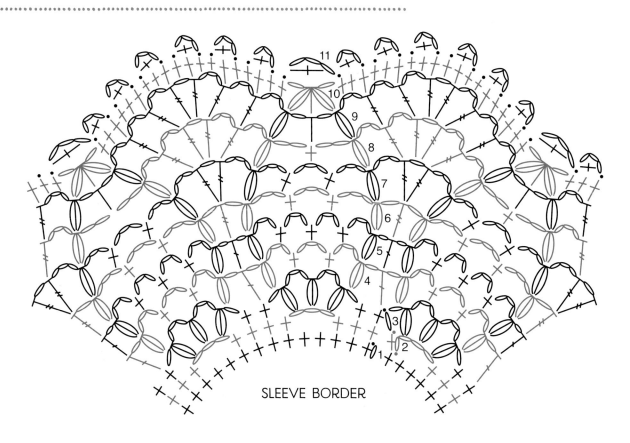

SLEEVE BORDER

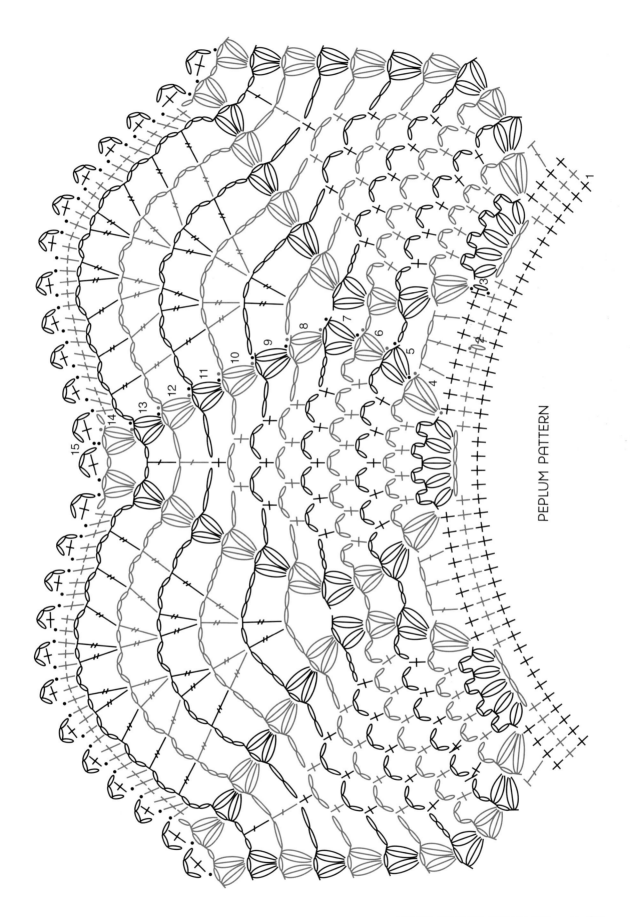

PEPLUM PATTERN

Rnd 3: Ch 1, skip first sc, *sc in each of next 2 sc, ch 1, skip next sc that is right before next ch-3 lp, ([puff st, ch 3] twice, puff st) in next ch-3 sp, skip next sc, rep from * around, join with sl st in first sc. Fasten off.

Rnd 4: With RS facing, join yarn in first ch-1 sp to the right of next puff-st group, puff st in first ch-1, ch 3, [sc, ch 3] in each of next 3 ch 3 sps, puff st in next ch-1 sp, ch 1, dc in next sc, ch 1**, puff st in next ch-1 sp, rep from * around, ending last rep at **, join with sl st in first puff st—5 (5, 6, 6, 7, 7, 7) pineapples started; 3 puff sts in each pineapple.

Rnd 5: Sl st in next ch-1 sp, puff st in first puff st, *(ch 3, sc) in each of next 3 ch-3 sps, ch 3, puff st in next puff st, ch 1, dc in next dc, ch 1, puff st in next puff st; rep from * around, ending last rep at **, join with sl st in first puff st—4 ch-3 sps in each pineapple.

Rnd 6: Sl st in next ch-1 sp, puff st in first puff st, *ch 3, skip next ch-3, (sc, ch 3) in each of next 2 ch-3 sps, skip next ch-3 sp, puff st in next puff st, ch 2, tr in next dc, ch 2**, puff st

in next puff st; rep from * around, ending last rep at **, join with sl st in first puff st—3 ch-3 sps in each pineapple.

Rnd 7: Sl st in next ch-1 sp, puff st in first puff st, *ch 3, skip next ch-3, sc in next ch-3 sp, ch 3, skip next ch-3 sp, ch 3, puff st in next puff st, ch 3, V-st in next tr, ch 3**, puff st in next puff st; rep from * around, ending last rep at **, join with sl st in first puff st—3 ch-3 sps in each pineapple.

Rnd 8: Sl st in next ch-1 sp, puff st in first puff st, *ch 2, skip next ch-3 sp, sc in next ch-3 sp, ch 2, skip next ch-3 sp, puff st in next puff st, ch 3, tr in next tr, ch 3, V-st in next V-st, ch 3, tr in next tr, ch 3**, puff st in next puff st, rep from * around, ending last rep at **, join with sl st in first puff st—2 ch-2 sps in each pineapple; 4 tr in each fan.

Rnd 9: Sl st in next ch-1 sp, puff st in first puff st, *ch 1, skip next ch-2 sp, hdc in next sc, ch 1, skip next ch-2 sp, puff st in next puff st, (ch 3, tr) in each of next 2 tr, ch 3, V-st in next V-st, (ch 3, tr) in each of next 2 tr, ch 3**, puff in next puff st; rep

from * around, ending last rep at **, join with sl st in first puff st—6 tr in each fan.

Rnd 10: Draw up lp on hook to to ½" (1.3 cm), puff-st cluster over first (puff st, hdc and next puff st), *ch 1, [2 sc in next ch-3 sp, sc in next tr] 3 times, sc in next ch-1 sp, [sc in next tr, 2 sc in next ch-3 sp] 3 times, ch 1, puff st cluster over next (puff st, hdc and next puff st); rep from * around, ending last rep at **, join with sl st in first puff-st cluster—19 sc over each fan; 5 (5, 6, 6, 7, 7) cluster. Fasten off.

Rnd 11: With RS facing, join yarn with sl st in sc to right of center sc of pineapple, *work picot, skip next 2 ch-1 sps, [sl st in each of next 2 sc, picot] 6 times, sl st in next sc, rep from * around, join with sl st in first sl st—6 picots over each fan; 1 picot over each pineapple.

Finishing

Weave in ends. Steam block peplum and sleeve border.

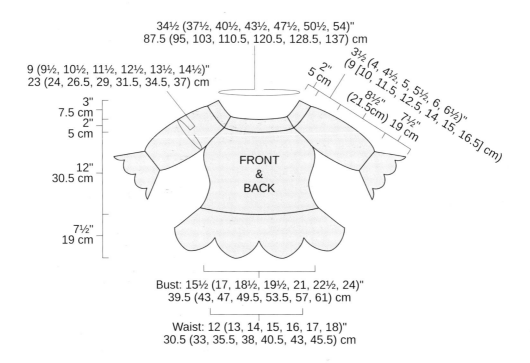

34½ (37½, 40½, 43½, 47½, 50½, 54)"
87.5 (95, 103, 110.5, 120.5, 128.5, 137) cm

9 (9½, 10½, 11½, 12½, 13½, 14½)"
23 (24, 26.5, 29, 31.5, 34.5, 37) cm

3½ (4, 4½, 5, 5½, 6, 6½)"
(9 [10, 11.5, 12.5, 14, 15, 16.5] cm)

2"
5 cm

8½"
(21.5cm)

7½"
19 cm

3"
7.5 cm

2"
5 cm

12"
30.5 cm

7½"
19 cm

FRONT & BACK

Bust: 15½ (17, 18½, 19½, 21, 22½, 24)"
39.5 (43, 47, 49.5, 53.5, 57, 61) cm

Waist: 12 (13, 14, 15, 16, 17, 18)"
30.5 (33, 35.5, 38, 40.5, 43, 45.5) cm

Amélie
triangular shawl

FINISHED SIZES
Child: Fits any size.

Measures 28″ (71 cm) across top edge.

Adult: S (M, L, XL, 2X, 3X). Sample shown is size S.

Measures 34 (40, 44, 48, 52, 56)″ (86.5 [101.5, 112, 122, 132, 142] cm) across top edge (foundation row).

YARN
DK weight (#3 Light).

Shown here: Knit One Crochet Too Nautika (85% microfiber acrylic, 15% nylon; 98 yd [90 m]/1¾ oz [50 g]): #295 deep pink; child's size 2 skeins; adult sizes 3 (3, 4, 4, 5, 5) skeins.

HOOK
Size I/9 (5.5 mm). Adjust hook size if necessary to obtain the correct gauge.

NOTIONS
Stitch markers; yarn needle.

GAUGE
12 sc, 3 full Double Lover's Knots (DLK) and 4 rows in patt = 4″ (10 cm).

This shawl is worked in a very simple Lover's Knot pattern, which is amazingly easy and fun to stitch and creates a lightweight fabric. A simple clover edging finishes it off. Wear it as a shawl, as a hip scarf tied to the side, as a beach wrap, or around the neck kerchief style. You can even sew two together to make a poncho!

Single Lover's Knot (LK): Pull up loop on hook to 1⅛" (2.8 cm), yo, pull through loop, sc in back thread of long loop.

Double Lover's Knot (DKL): (Pull up loop on hook to 1⅛", yo, pull through loop, sc in back thread of long loop) 2 times.

Clover: Sc in designated sp, ch 9, sl st in side edge of sc, ch 14, sl st in same sp as last sl st, ch 9, sl st in same sp as last 2 sl sts.

NOTES

You'll work the longest row first, which will be at the neck, decrease 1 DLK in each row, and eventually end up with 1 DLK at the bottom tip.

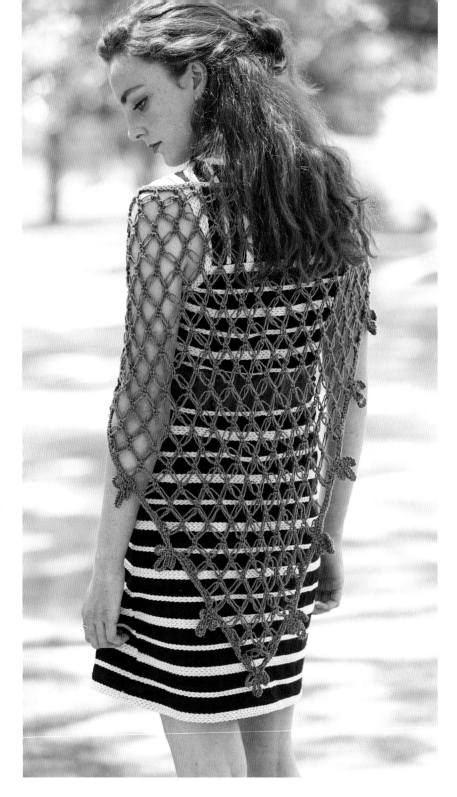

Shawl

Ch 86 (110, 122, 134, 146, 158, 170) loosely.

NOTE: If you crochet tighter than most, it's very important that you use a larger hook on your beg ch, then work the remaining rows with the hook recommended.

Row 1: (RS) Sc in 2nd ch from hook and in each ch across, turn—89 (109, 121, 133, 145, 157, 169) sc.

Row 2: Ch 1, sc in first sc, *DLK, skip next 3 sc, sc in next sc; rep from * across, turn—21 (27, 30, 33, 36, 39, 42) DLK.

NOTE: You will begin decreasing 1 DLK in each row.

Row 3: Pull up loop on hook to 1⅛" (2.8 cm), insert hook into sc in center of first DLK, yo, pull up loop, yo, pull through both loops on hook, ch 1, *DLK, sc in center of next DLK; rep from * across, turn—20 (26, 29, 32, 35, 38, 41) DLK.

Rows 4–22 (28, 31, 34, 37, 40, 43): Rep Row 3—1 DLK. Fasten off.

Edging

NOTE: Top edge will be all sc and not have any clover sts.

Place a marker in each corner of the scarf. Place 6 (7, 8, 9, 10, 11, 12, 13) markers evenly spaced across each diagonal side (about 4" [10 cm]

apart). With RS facing, join yarn at top right-hand corner, ch 1, work clover in marked corner st; working across to opposite side of foundation ch (top edge), sc in each ch across to next corner, work clover in next corner, *work 12 sc evenly spaced across to next marker, work clover in next marker; rep from * across to next corner, then across other diagonal side to beg corner, join with sl st in first sc.

Finishing

Weave in the ends. Steam block clovers if needed.

TIES

To be sewn to each top corner, if desired.

Join yarn to back side of either clover at top corner, loosely ch 36, sl st in 2nd ch from hook and in each ch across, sl st to same sp at base of clover. Rep on other corner.

STITCH KEY

⬯ = chain (ch)

• = slip st (sl st)

╬ = single crochet (sc)

= Lover's Knot (LK)

= Double Lover's Knot (DLK)

= Clover

✳ = marker

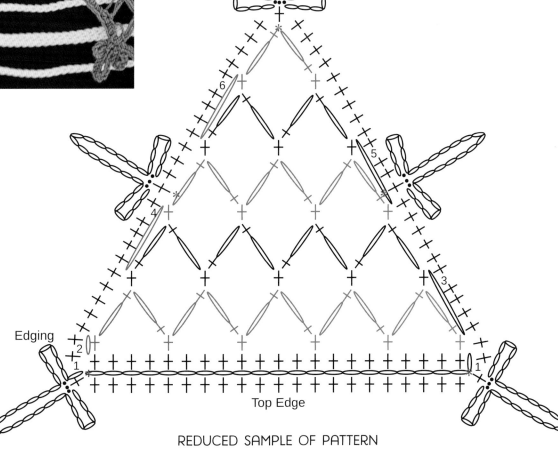

REDUCED SAMPLE OF PATTERN

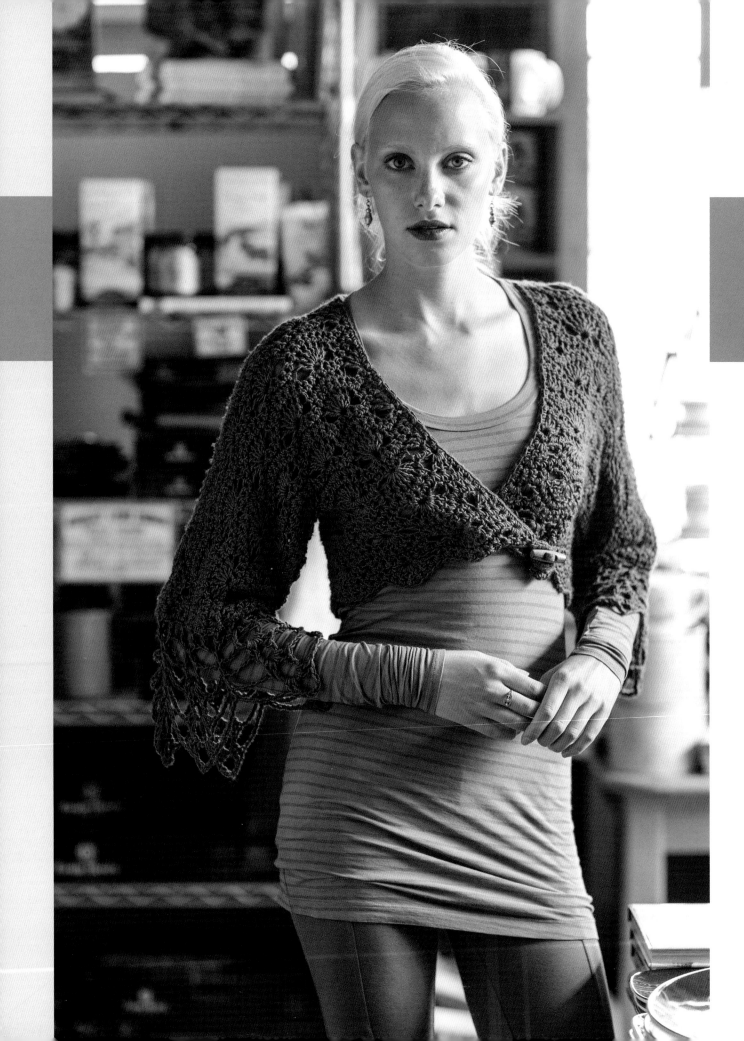

Michelle Ma Belle *shrug*

FINISHED SIZES
XS/S (M/L, 1X/2X). Sample shown is size XS/S.

Bust: 36 (44, 52)" (91.5 [112, 132] cm).

Note: Shrug is designed to be wrapped across the front. It can be wrapped as loosely or as tightly as you want.

Length: 14¾ (16¾, 18¾)" (37.5 [42.5, 47.5] cm).

YARN
DK weight (#3 Light).

Shown here: Knit One Crochet Two Nauika (85% microfiber acrylic,15% nylon; 98 yd [90 m]/1¾ oz [50 g]): # 769 plum; 8 (12, 15) balls.

HOOKS
Sizes L/11 (8 mm) and G/6 (4 mm). Adjust hook size if necessary to obtain the correct gauge. G is used only for the button lp.

NOTIONS
Stitch markers; yarn needle; 1–1½" (2.5–3.8 cm) button; snaps for closure (optional); 1 yd (.9 m) wide satin ribbon (optional); sewing needle; matching sewing thread (optional).

GAUGE
14 sts or 1 patt rep = 4" (10 cm); 4 rows in patt = 2" (5 cm).

Wear this pretty shrug with a skirt or dress, or jeans for a more casual look. The button sets it off, but you could weave a wide satin ribbon through the front corners for a more girly, feminine style. Using a very large hook helps the DK-weight yarn drape well. To make this even dressier, repeat the lace edging from the sleeves at the bottom edge.

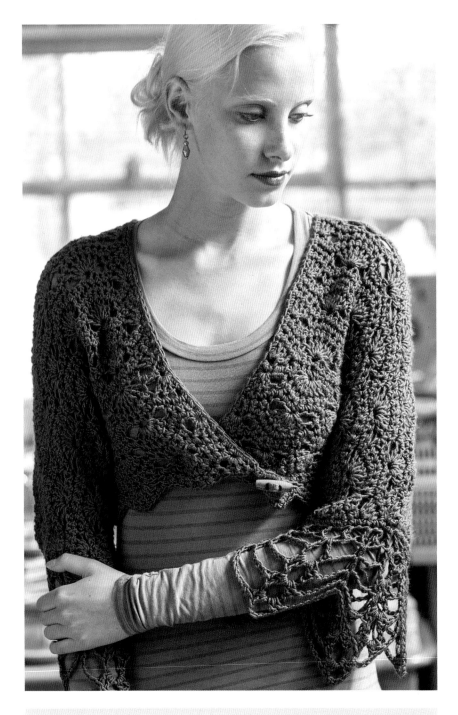

Left Sleeve Front

With larger hook, loosely ch 59 (73, 87).

Row 1: (RS) 3 dc in 4th ch from hook (counts as half shell), *skip next 3 ch, sc in each of next 7 ch, skip next 3 ch**, shell in next ch, rep from * across, ending last rep at **, half shell in last ch, turn—3 (4, 5) shells; 2 half shells.

Row 2: Ch 1, sc in each st across, turn—57 (71, 85) sc.

Row 3: Ch 1, sc in first 4 sc, *skip next 3 sc, shell in next sc, skip next 3 sc**, sc in each of next 7 sc, rep from * across, ending last rep at **, sc in each of last 4 sc, turn—3 (4, 5) shells.

Row 4: Ch 1, sc in each st across, turn—57 (71, 85) sc.

Row 5: Ch 3 (counts as dc here and throughout), 3 dc in first sc, skip next 3 sc, sc in each of next 7 sc, skip next 3 sc**, shell in next sc, rep from * across, ending last rep at **, half shell in last sc, turn—3 (4, 5) shells; 2 half shells.

Rows 6–17 (21, 25): Rep Rows 2–5 (3 [4, 5] times). Fasten off. Set aside.

Right Sleeve Front

Work same as left sleeve front through Row 17 (21, 23).

Do not fasten off.

NOTES

Left and right sleeve fronts are worked separately, and then a ch st is added at the neck to join the sleeve fronts, forming a 4″ (10 cm) neck opening. The back is worked down from the tops of the sleeves to the bottom edge of the sleeve. After seaming the sleeves, the optional lower body of the shrug is worked for 6″ (15 cm) below the sleeve joins. A lace border is then worked on the ends of each sleeve.

STITCH KEY

⬭ = chain (ch)

+ = single crochet (sc)

† = double crochet (dc)

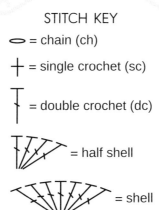 = half shell

= shell

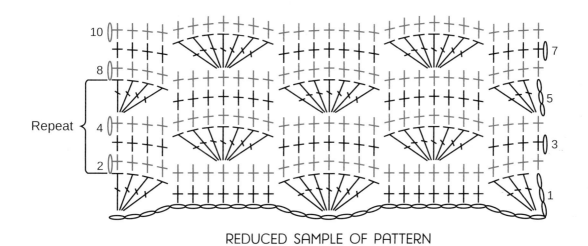

REDUCED SAMPLE OF PATTERN

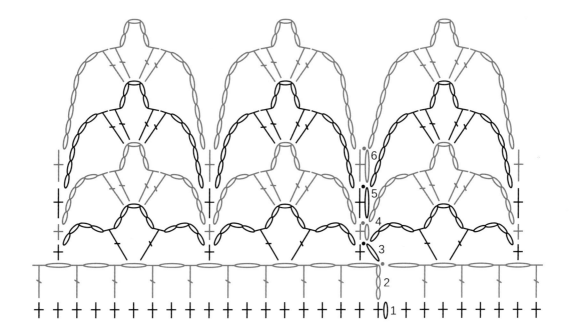

SLEEVE BORDER PATTERN

Back

NOTE: Row 1 will join sleeve fronts with a ch across the back neck edge in preparation to work the back.

Row 1: Ch 1, sc in each st across right sleeve front, ch 13, sc in each st across left Sleeve front, turn—127 (155, 183) sts.

Rows 2–18 (22, 26): Starting with Row 3 of patt, work even in established patt, ending with Row 3 of patt—9 (11, 13) shells. Fasten off.

Sleeve Seams

Fold sleeves with RS tog, matching last row of the back to the bottom of the first row. PM 29 (43, 57) sts from cuff end of each sleeve on the seam edge. Matching sts, sew one sleeve from the cuff edge to the marker on the sleeve. Rep seam on the other sleeve. Turn RS out.

Lower Body (OPTIONAL)

Row 1: With RS facing and bottom of sleeves on top and working across opposite side of foundation ch, with a larger hook, join yarn in first ch on bottom of left sleeve front, sc in each st across to seam, sc in each st across Back, sc in each ch across foundation ch of right sleeve front, turn—239 (295, 351) sc.

NOTE: It is important to have a multiple of 14 sts + 1.

Rows 2–13: Starting with Row 5 of patt, work even in established pattern, ending with Row 4 of patt.

Lace Sleeve Edging

Row 1: With RS facing and a larger hook, join yarn on cuff edge of one sleeve at sleeve seam, ch 1, work 40 (48, 56) sc loosely and evenly around cuff edge of sleeve, join with sl st in first sc around bottom edge of sleeve, sl st to first sc—40 (48, 56) sc.

Row 2: Ch 4 (counts as dc, ch 1), skip next sc, *dc in next sc, ch 1, skip next sc; rep from * around, join with sl st to 3rd ch of beg ch-4—20 (24, 28) ch-1 sps.

Row 3: Ch 1, sc in first ch-1 sp, *ch 4, skip next ch-1 sp, (dc, ch 5, dc) in next ch-1 sp, ch 4, skip next ch-1 sp**, sc in next ch-1 sp; rep from * around, ending last rep at **, join with sl st in first sc—5 (6, 7) ch-5 sps.

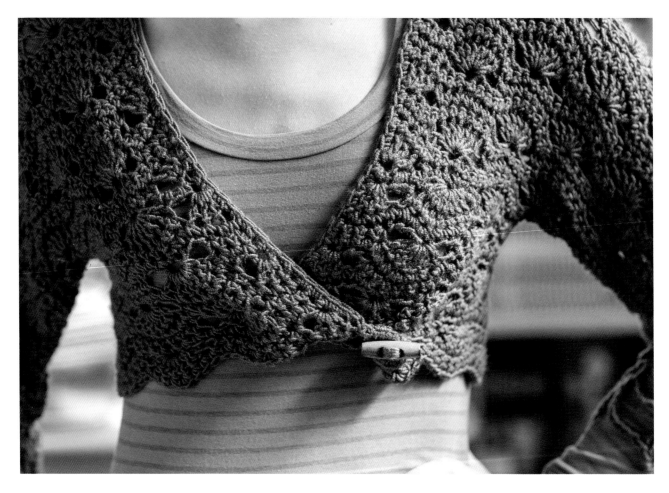

Row 4: Ch 1, sc in first sc, *ch 5, skip next ch-4 lp, (2 dc, ch 5, 2 dc) in next ch-5 lp, ch 5, skip next ch-4 lp**, sc in next sc; rep from * around, ending last rep at **, join with sl st in first sc—5 (6, 7) shells.

Row 5: Ch 1, sc in first sc, *ch 6, skip next ch-5 lp, (2 dc, ch 5, 2 dc) in next ch-5 lp, ch 6, skip next ch-5 lp**, sc in next sc; rep from * around, ending last rep at **, join with sl st in first sc—5 (6, 7) shells.

Row 6: Ch 1, sc in first sc, *ch 7, skip next ch-6 lp, (2 dc, ch 5, 2 dc) in next ch-5 lp, ch 7, skip next ch-6 lp**, sc in next sc; rep from * around, ending last rep at **, join with sl st in first sc—5 (6, 7) shells. Fasten off.

Rep edging on other sleeve edge.

Neck Edging

With RS facing and larger hook, join yarn in the bottom right-hand corner of the right front, ch 10, sl st in the corner for the button lp, ch 1, work sc evenly across the right front edge, across the back neck edge, and down the left front edge to the bottom left-hand corner. Fasten off.

Finishing

BUTTON CLOSURE

With smaller hook, join yarn in bottom right-hand corner of right front, work 12 sc in ch-10 lp, sl st in corner st. Fasten off. Weave in ends.

Sew large button on left front side, opposite button lp, positioning it so that the right front crosses over the left front and fits comfortably.

SNAP CLOSURE (OPTIONAL)

With sewing needle and thread, sew snap to corner of left front and corresponding position on the inside of the right front to secure the corner.

RIBBON CLOSURE (OPTIONAL)

With sewing needle and thread, sew one 18" (45.5 cm) length of ribbon to the bottom right-hand corner of the right front. Overlap the right front over the left front and PM for the 2nd ribbon. Sew another 12" (30.5 cm) length of ribbon to the left front at marker.

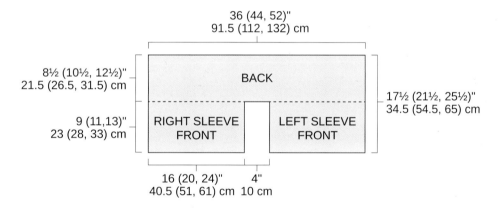

SHRUG BEFORE SEAMING

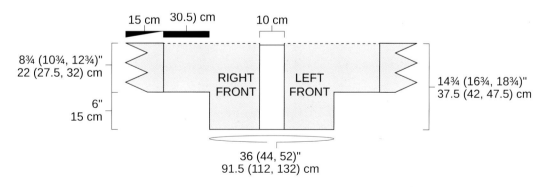

ASSEMBLED SHRUG (WITH OPTIONAL LOWER BODY)

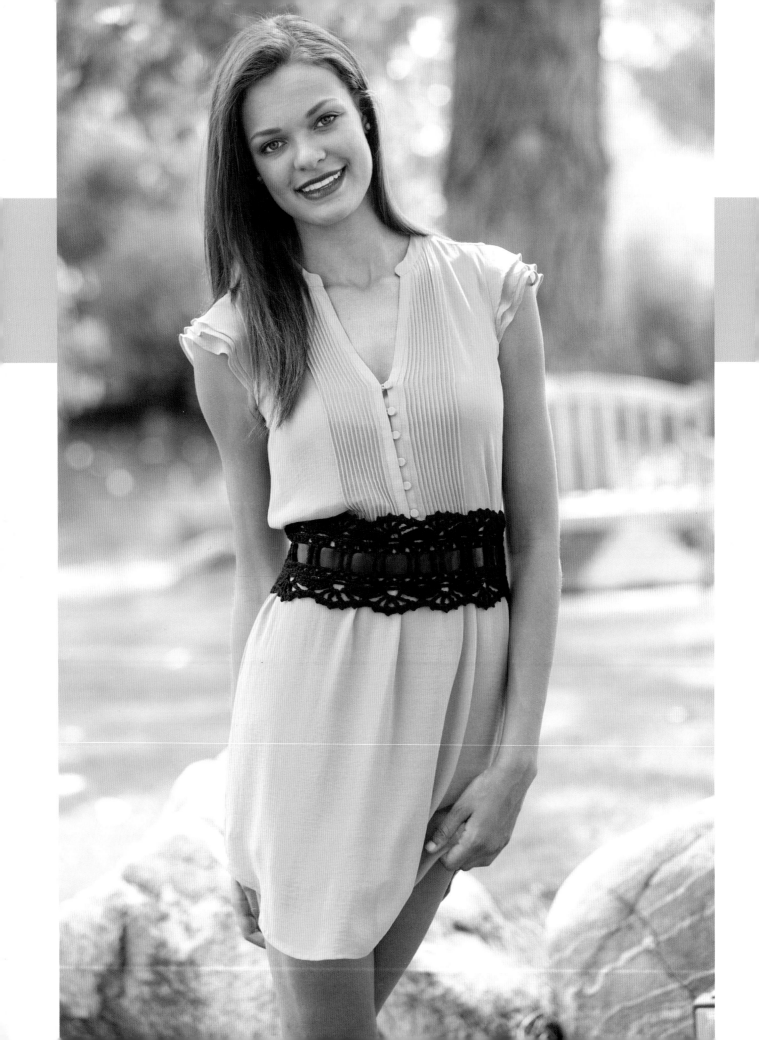

Brigitte
wide belt

FINISHED SIZES
XS/S (M, L, 1X, 2X, 3X).
Sample shown is size XS/S.

5″ (12.5 cm) wide x 27½ (30,
32½, 37½, 42½, 45)″ (70 [76,
82.5, 95, 108, 114.5] cm) long.

YARN
Sportweight (#2 Fine).

Shown here: Red Heart Yarn
Luster Sheen (100% acrylic;
307 yd [281 m]/3½ oz [100
g]): #2 black, 1 (1, 1, 1, 2, 2)
skeins.

HOOK
E/4 (3.5 mm). Adjust hook
size if necessary to obtain the
correct gauge.

NOTIONS
Stitch markers; yarn needle;
2 yd (1.8 m) of ⅞″ (2.2 cm)
wide satin ribbon; 2 hook-and-
eye clasps (optional).

GAUGE
One pattern repeat (12 sts
in Row 1) = 2½″ (6.5 cm).

5 rows of First Side = 2″
(5 cm).

This quick project will put the finishing touch on any plain dress or top. Wear the belt with or without the ribbon, depending on your mood or style. It can be worn with just about any color, and you have the option of weaving any color ribbon through the center. An amazing thing about this yarn is the fact it seems to magically stretch, so go ahead and order dessert!

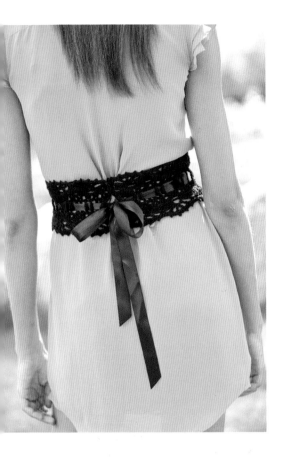

NOTES

Belt can be worn with ends butted up against each other or, if it turns out a little small, with the ribbon tied into a bow in back, even if the ends don't meet.

If your gauge is tight and the belt turned out too small, but you prefer the ends meeting, work some sc or dc rows on each short end of the belt to make the ends meet. Each size will be 2½″ (6.5 cm) larger than the previous size.

Belt is designed to be worn over other clothing. To determine what size to make, put on a dress or top that you would wear the belt with and then measure your waist over the clothing to determine the right belt size to make.

Belt

First side of belt is worked in 1 long strip. Then a row of tr is worked across the base of the first side forming a center row (where the ribbon will be woven through). Second side is worked on the opposite side of the first side, into the sts of the center dtr row, completing the belt.

FIRST SIDE

Ch 136 (148, 160, 172, 184, 196).

Row 1: (RS) V-st in 5th ch from hook, *skip next 2 ch, V-st in next ch, rep from * across to within last 2 ch, skip next ch, dc in last ch, turn—44 (48, 52, 56, 60, 64) V-sts.

Row 2: Ch 5 (counts as dc, ch 2), skip next ch-1 sp, sc bet next 2 dc, *ch 5, skip next 2 ch-1 sps, sc bet next 2 dc; rep from * across to within last ch-1 sp, ch 2, skip next ch-1 sp, skip next dc, dc in top of tch, turn—21 (23, 25, 27, 29, 31) ch-5 sps.

Row 3: Ch 3 (counts as dc here and throughout), half shell in next ch-2 sp, (sc, ch 5, sc) in next ch-5 sp, *shell in next ch-5 sp, (sc, ch 5, sc) in next ch-5 sp, rep from * across to last ch-5 sp, half shell in next ch-2 sp of tch, dc in 3rd ch of tch, turn—10 (11, 12, 13, 14, 15) shells, 2 half shells; 11 (12, 13, 14, 15, 16) ch-5 sps.

STITCH GUIDE

V-stitch (V-st): (Dc, ch 1, dc) in same st or sp.

Half shell: (Dc, [ch 1, dc] 3 times) in same sp.

Shell: (Dc, [ch 1, dc] 6 times) in same sp.

Treble crochet fan (Tr-fan): (Tr, [ch 2, tr] 3 times) in same sp.

Picot: Ch 2, sl st in second ch from hook.

Row 4: Ch 1, sc in first dc, *ch 2, tr-fan. in next ch-5 sp, ch 2, sc in center dc of next shell; rep from * across, ending with last sc in top of tch, turn—11 (12, 13, 14, 15, 16) fans.

Row 5: Ch 1, sc in first sc, [sc in next ch-2 sp, picot, sc in next dc] 4 times, sc in next ch-2 sp**, sc in next sc; rep from * across, ending last rep at **, picot, sc in last sc—45 (49, 53, 57, 61, 65) picots. Fasten off.

CENTER ROW

NOTE: Make sure your dtr sts are tall enough to weave your ribbon through.

With WS facing, working across opposite side of foundation ch, join yarn with sl st in first ch (bottom ch of tch), ch 5 (counts as dtr), dtr (see Glossary) in next ch, *ch 1, skip next ch, dtr in next ch; rep from * across, turn—68 (74, 80, 86, 92, 98) dtr; 66 (72, 78, 84, 90, 96) ch-1 sps. Do not fasten off.

SECOND SIDE

Row 1: Ch 3, skip next ch-1 sp, *V-st in next dtr, skip 2 sts, V-st in next ch-1 sp**, skip next 2 sts; rep from * across, ending last rep at **, skip next dtr, dc in top of tch, turn.

Rows 2–5: Rep Rows 2–5 of first side. Do not fasten off.

FIRST END EDGING

Ch 1, work about 24 sc evenly spaced across short side edge, keeping work flat. Fasten off.

SECOND END EDGING

With RS facing, join yarn with sl st in top right-hand corner of other side edge, ch 1, work about 24 sc evenly spaced across short side edge keeping work flat. Fasten off.

Finishing

Weave in ends. Insert ribbon from back to front in first ch-1 sp between first 2 dtr in Center Row, *skip next ch-1 sp, insert ribbon from front to back in next ch-1 sp**, sk next ch-1 sp, insert ribbon from back to front in next ch-1 sp, rep from * across. Draw ribbon through belt until an even amount of ribbon is on each side. Sew a hook and eye on each short end of the belt above and below the ribbon.

STITCH KEY

= chain (ch)
= slip st (sl st)
= single crochet (sc)
= double crochet (dc)
= treble crochet (tr)
= picot

= V-stitch (V-st)
= half shell
= shell
= treble crochet fan (tr-fan)

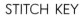
First side

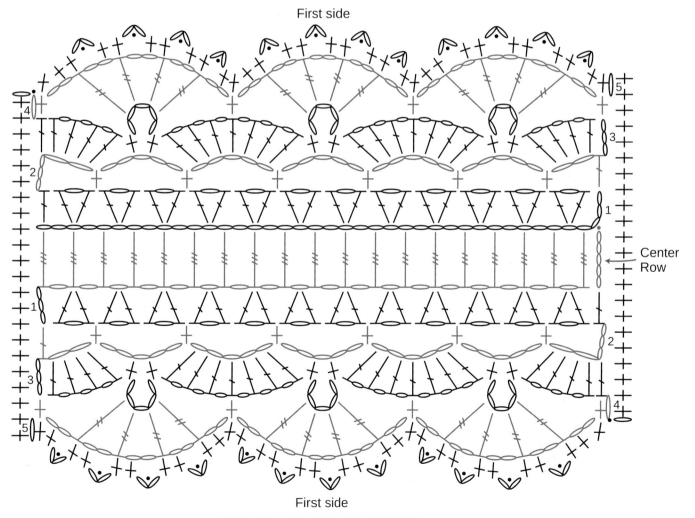

First side

REDUCED SAMPLE OF PATTERN

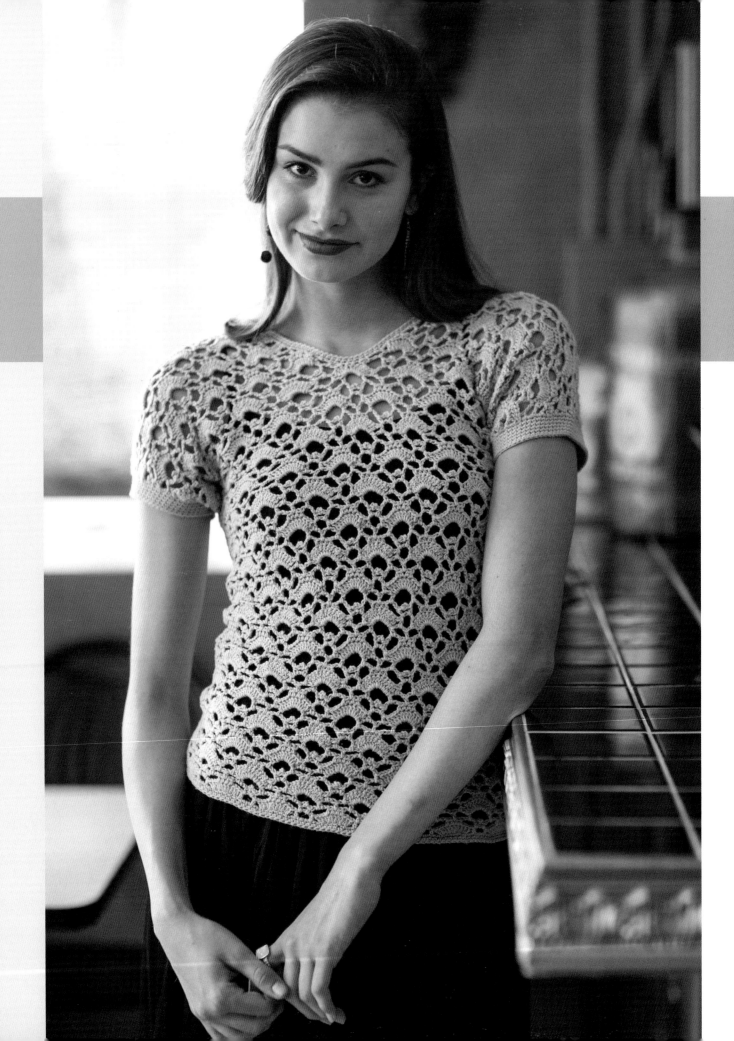

Café au Lait
t-shirt

FINISHED SIZES
S (M, L, 1X, 2X, 3X). Sample shown is size S.

Bust: 32½ (37, 41½, 46, 50½, 55)" (82.5 [94, 105.5, 117, 128.5, 139.5] cm).

Length: 21 (21½, 22½, 22½, 22½, 22½)" (53.5 [54.5, 57, 57, 57, 57] cm).

YARN
Fingering weight (#1 Super Fine).

Shown here: Knit Picks Comfy Fingering (75% pima cotton, 25% acrylic; 218 yd [199 m]/1¾ oz [50 g]): #25759 parchment, 5 (6, 7, 8, 9) balls.

HOOK
Size E/4 (3.5mm). Adjust hook size if necessary to obtain the correct gauge.

NOTIONS
Stitch markers; yarn needle.

GAUGE
1 pattern rep (shell and ch-3 space) = 2¼" (5.5 cm); 6 rows = 2" (5 cm).

*I*f you like open crochet, but don't go for a lot of frills, this basic tee may be just the project for you. But if you prefer a more feminine look, add a pretty border at the sleeve and bottom edges to make this top extra special. Keep it casual by pairing it with jeans or wear it with a skirt to dress it up.

NOTES

Front and back are worked exactly the same beginning at lower edge. Instructions include options for working a longer shirt or longer sleeves.

VARIATIONS

To make longer sleeves, work more ch sts in multiples of 10 at designated place at beginning of sleeve shaping. Before sleeve shaping, body should measure 13½" (34.5 cm). To make a longer T-shirt or a dress, add rows in pattern, ending with Row 4, before working sleeves.

STITCH GUIDE

Picot: Ch 3, sc in third ch from hook.

Picot loop (picot-lp): Hdc in sp, picot, hdc in same sp.

Shell: 10 dc in same sp.

Half shell: 4 dc in same sp.

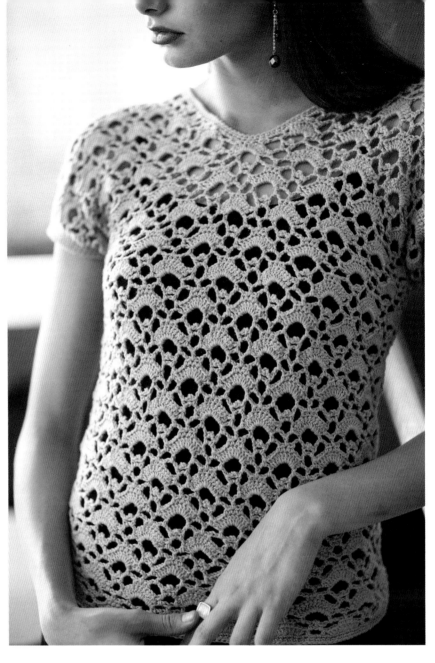

Front/Back (MAKE 2)

Begins at lower edge.

Starting at bottom edge, ch 99 (112, 125, 138, 151, 164).

Row 1: Hdc in 8th ch from hook, (beg ch counts as hdc, ch 3 sp), *skip next 2 ch, 2 dc in each of next 5 ch, skip next 2 ch, hdc in next ch, ch 3, skip next 2 ch, hdc in next ch; rep from * across, turn—7 (8, 9, 10, 11, 12) 10-dc groups.

Row 2: Ch 2 (counts as hdc here and throughout), picot, hdc in next ch-3 sp (starting picot lp made), *ch 3, skip next 4 sts, hdc in each of next 4 dc, ch 3**, picot-lp in next ch-3 sp; rep from * across, ending last rep at **, hdc in last ch-2 sp, picot, hdc in 4th ch of tch—8 (9, 10, 11, 12, 13) picots.

Row 3: Ch 4 (counts as hdc, ch 2), *skip next picot, hdc in next ch-3 sp, ch 3, hdc between center 2 sts of next hdc-group, ch 3, hdc in next ch-3 sp**, ch 4; rep from * across, ending last rep at **, ch 2, hdc in 3rd ch of tch, turn—6 (7, 8, 9,10, 11) ch-4 sps.

Row 4: Ch 3, half shell in next ch-3 sp, *hdc in next ch-3 sp, ch 3, hdc in next ch-3 sp**, shell in next ch-4 sp, rep from * across, ending last rep at **, half shell in last ch-2 sp, dc in 2nd ch of tch, turn—6 (7, 8, 9, 10, 11) shells; 2 half shells.

Row 5: Ch 2 (counts as hdc), hdc in next dc, *ch 3, picot-lp in next ch-3 sp, ch 3, skip next 4 sts**, hdc in each of next 4 dc; rep from * across, ending last rep at **, hdc in last dc, hdc in top of tch, turn—7 (8, 9, 10, 11, 12) picots.

Row 6: Ch 5 (counts as hdc, ch 3), hdc in next ch-3 sp, *ch 4, hdc in next ch-3 sp, ch 3**, hdc between 2 center sts of next hdc-group, ch 3, hdc in next ch-3 sp; rep from * across, ending last rep at **, ch 3, hdc in top of tch, turn—7 (8, 9, 10, 11, 12) ch-4 sps.

Row 7: Ch 4, hdc in next ch-3 sp, *shell in next ch-4 sp, hdc in next ch-3 sp, ch 3**, hdc in next ch-3 sp; rep from * across, ending last rep at

STITCH KEY

⬯ = chain (ch)

• = slip st (sl st)

✛ = single crochet (sc)

T = half double crochet (hdc)

Ŧ = double crochet (dc)

⬲ = picot

⬳ = picot loop (picot-lp)

⤙⤚ = shell

⤙ = half shell

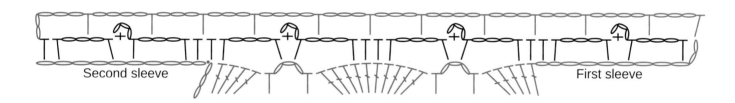

Second sleeve First sleeve

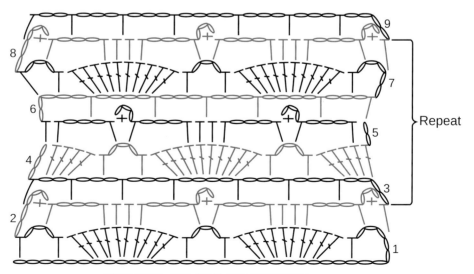

REDUCED SAMPLE OF PATTERN

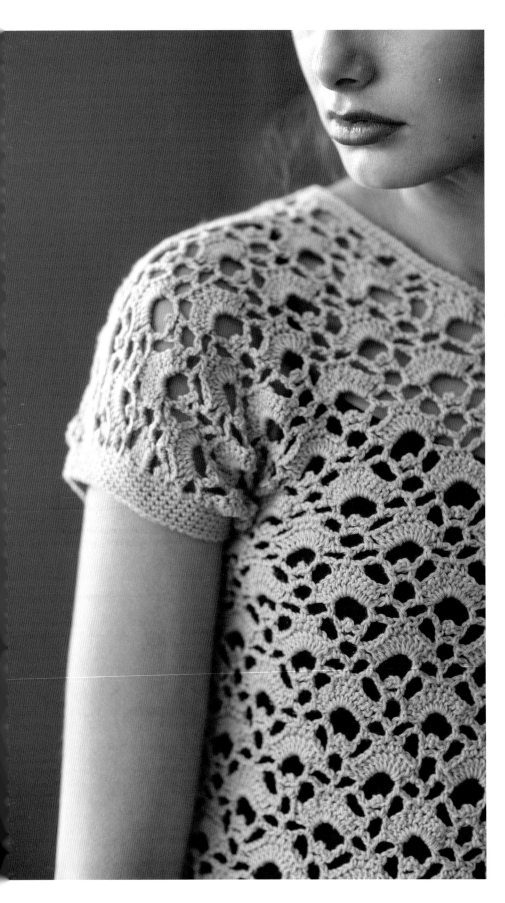

**, hdc in 2nd ch of tch—7 (8, 9, 10, 11, 12) shells.

Rows 8–40: Rep Rows 2–7 (5 times); then rep Rows 2–4.

To make T-shirt shorter or longer, add or subtract rows ending with Row 4 of pattern. Do not fasten off. Drop lp from hook.

SHAPE SLEEVES

Join a separate strand of yarn at the end of last row, ch 10 (10, 10, 10, 10, 20). Fasten off.

NOTE: For 4½" long sleeves, work ch 20 for left sleeve, then follow directions for 3X right sleeve below.

Row 1: Ch 11 (11, 11, 11, 11, 21) for right Sleeve, hdc in 3rd ch from hook, ch 3, skip next 2 ch, hdc in next ch, picot, hdc in next ch, ch 3, skip next 2 ch, hdc in each of next 2 ch, [size 3X only: Hdc in each of next 2 ch, ch 3, skip next 2 ch, hdc in next ch, picot, hdc in next ch, ch 3, skip next 2 ch, hdc in each of next 2 ch], hdc in each of next 2 dc, *ch 3, picot-lp in next ch-3 sp, ch 3, skip next 4 sts**, hdc in each of next 4 dc; rep from * across, ending last rep at **, hdc in last dc, hdc in top of tch, working across added ch, [hdc in each of next 2 ch, ch 3, skip next 2 ch, hdc in next ch, picot, hdc in next ch, ch 3, skip next 2 ch, hdc in each of next 2 ch] 1 (1, 1, 1, 1, 2) twice, turn—9 (10, 11, 12, 13, 16) picots.

YOKE

Starting with Row 6 of pattern, work even in pattern for 9 (6, 9, 6, 9, 6) rows—9 (9, 11, 11, 13, 13) shells; 0 (2, 0, 2, 0, 2) half shells.

FIRST FRONT/SHAPE NECK
Sizes S, L, and 2X only

Row 1: Ch 2, picot, hdc in next ch-3 sp (starting picot lp made), *ch 3, skip next 4 sts, hdc in each of next 4 dc, ch 3, picot-lp in next ch-3 sp; rep from *

4 (5, 6) times, ch 3, skip next 4 sts, hdc in each of next 2 dc, turn, leaving rem sts unworked—5 (6, 8) picots.

Row 2: Ch 3, hdc in next ch-3 sp, ch 4, hdc in next ch-3 sp, work in pattern Row 3 across, turn—4 (5, 6) ch-4 sps.

Row 3: Ch 4, work in pattern Row 4 across until last shell is made, hdc in next ch-3 sp, turn—4 (5, 6) shells; 1 half shell.

Row 4: Ch 3, skip first 4 sts, hdc in each of next 4 dc, work in patt Row 5 across, turn—4 (5, 6) picot-lps.

Row 5: Work in patt Row 6 across to last 4-hdc group, hdc in center of last 4 hdc, ch 3, hdc in last ch-3 sp, turn.

Row 6: Ch 2, hdc in next ch-3 sp, work in patt Row 7 across, turn—4 (5, 6) shells.

Row 7: Work in patt Row 8 across, ending with picot-lp in last ch-3 sp, turn, leaving rem st unworked—5 (6, 7) picot-lps.

Row 8: Ch 4 (counts as hdc, ch 2), hdc in next ch-3 sp, work in patt Row 3 across, turn—3 (4, 5) ch-4 sps.

Row 9: Work in patt Row 4 across until last shell is made, hdc in next ch-3 sp, ch 3, sk next ch-3 sp, hdc in next hdc, turn, leaving rem sts unworked—3 (4, 5) shells; 1 half shell.

Row 10: Ch 3, picot-lp in first ch-3 sp, work in patt Row 5 across, turn—4 (5, 6) picot-lps.

Row 11: Work in patt Row 3 across to last ch-3 sp, ch 2, hdc in top of tch, turn—3 (4, 5) ch-4 sps.

Row 12: Ch 3, half shell in next ch-2 sp, work patt Row 7 across, turn—3 (4, 5) shells; 2 half shells.

Row 13: Work in patt Row 8 across, picot-lp in last ch-3 sp, ch 3, skip next 5 sts, hdc in top of tch, turn—4 (5, 7) picot-lps. Fasten off size S.

Sizes L and 2X only

Row 14: Ch 3, hdc in first ch-3 sp, ch 3, hdc in next ch-3 sp, work in patt Row 3 across, turn—3 (4) ch-4 sps.

Row 15: Work in patt Row 4 across to last ch-3 sp, half shell in next ch-3 sp, dc in top of tch, turn—3 (4) shells; 2 half shells.

Row 16: Ch 2, hdc in next dc, work in patt Row 5 across, turn—4 (5) picot-lps.

Row 17: Work in patt Row 6 across, turn—4 (5) ch-4 sps. Fasten off sizes L and 2X.

Sizes M, 1X, and 3X only

Row 1: Ch 2 (counts as hdc), hdc in next dc, *ch 3, picot-lp in next ch-3 sp, ch 3, skip next 4 sts**, hdc in each of next 4 dc, rep from * 3 (4, 6) times; rep from * to ** once, hdc in each of next 2 dc, turn, leaving rem sts unworked, turn—5 (6, 8) picots.

Row 2: Ch 3, hdc in next ch-3 sp, ch 4, work in pattern Row 6 across, turn—5 (6, 8) ch-4 sps.

Row 3: Work in pattern Row 7 across until last shell is made, hdc in next ch-3 sp, turn—5 (6, 8) shells.

Row 4: Ch 3, skip first 4 sts, hdc in each of next 4 dc, work in patt Row 8 across, turn—5 (6, 8) picot-lps.

Row 5: Work in patt Row 3 across to last 4-hdc group, hdc in center of last 4 hdc, ch 3, hdc in last ch-3 sp, turn—4 (5, 7) ch-4 sps.

Row 6: Ch 2, hdc in next ch-3 sp, work in patt Row 4 across, turn—4 (5, 7) shells; 1 half shell.

Row 7: Work in patt Row 5 across, ending with picot-lp in last ch-3 sp, turn, leaving rem sts unworked—5 (6, 7) picot-lps.

Row 8: Ch 4 (counts as hdc, ch 2), hdc in next ch-3 sp, work in patt Row 6 across, turn—5 (6, 8) ch-4 sps.

Row 9: Work in patt Row 7 across until last shell is made, hdc in next ch-3 sp, ch 3, sk next ch-3 sp, hdc in next hdc, turn, leaving rem sts unworked—5 (6, 8) shells.

Row 10: Ch 3, picot-lp in first ch-3 sp, work in patt Row 8 across, turn—5 (6, 8) picot-lps.

Row 11: Work in patt Row 3 across to last ch-3 sp, ch 2, hdc in top of tch, turn—4 (5, 7) ch-4 sps.

Row 12: Work in patt Row 4 across, turn—4 (5, 7) shells; 2 half shells.

Row 13: Work in patt Row 5 across, turn—4 (5, 7) picot-lps.

Row 14: Ch 3, hdc in first ch-3 sp, ch 3, hdc in next ch-3 sp, work in patt Row 6 across, turn—4 (5, 7) ch-4 sps.

Row 15: Work in patt Row 7 across to last ch-3 sp, half shell in next ch-3

3¾ (5, 5, 6, 7, 8¼)"
9.5 (12.5, 12.5, 15, 18, 21) cm

4½ (6¾, 6¾, 6¾, 6¾, 6¾)"
11.5 (17, 17, 17, 17, 17) cm

3 (3, 3, 3, 5¼)"
7.5 (7.5, 7.5, 7.5, 7.5, 13.5) cm

7½ (8, 9, 9, 9, 9)"
19 (20.5, 23, 23, 23, 23) cm

4½ (5½, 5½, 6½, 5½, 6½)"
11.5 (14, 14, 16.5, 14, 16.5) cm

13½"
34.5 cm

FRONT
&
BACK

16¼ (18½, 20¾, 23, 25¼, 27½)"
41.5 (47, 52.5, 58.5, 64, 70) cm

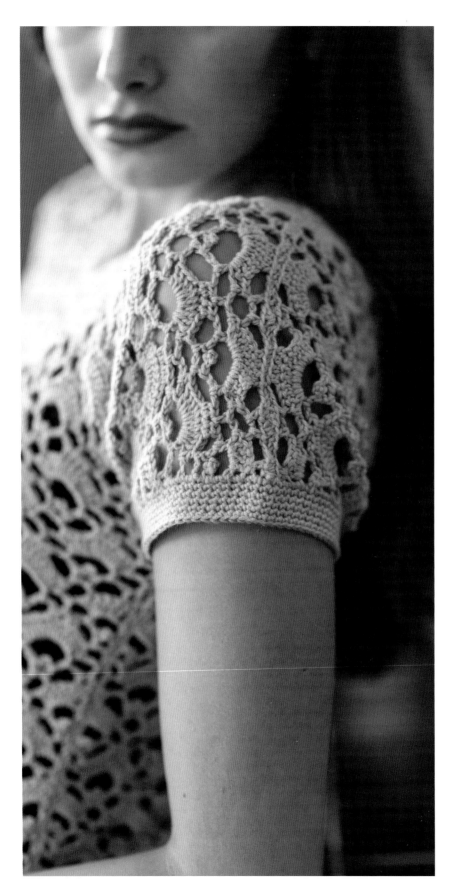

sp, dc in top of tch, turn—4 (5, 7) shells; 1 half shell.

Row 16: Ch 2, hdc in next dc, work in patt Row 8 across, turn—4 (5, 7) picot-lps.

Row 17: Work in patt Row 6 across, turn—3 (4, 6) ch-4 sps. Fasten off size M.

Sizes 1X and 3X only
Work 3 more rows evenly in established pattern. Fasten off sizes 1X and 3X.

SECOND FRONT
Sizes S, L, and 2X only
Row 1: With RS facing, rejoin yarn in first dc to the left of Row 1 of first front, ch 2 (counts as hdc, hdc in next dc, *ch 3, picot-lp in next ch-3 sp, ch 3, skip next 4 sts, hdc in each of next 4 dc; rep from * 4 (5, 6) times, ch 3, hdc in next ch-3 sp, picot, hdc in 2nd ch of tch, turn—5 (6, 8) picots.

Row 2: Work in pattern Row 3 across to last ch-3 sp, hdc in last ch-3 sp, dc in top of tch, turn—4 (5, 6) ch-4 sps.

Row 3: Ch 2, shell in next ch-4 sp, work in pattern Row 4 across, turn—4 (5, 6) shells; 1 half shell.

Row 4: Work in patt Row 5 across to last ch-3 sp, skip next 5 sts, hdc in each of next 4 sts, skip next 3 dc, dc in top of tch, turn—4 (5, 6) picot-lps.

Row 5: Ch 5 (counts as hdc, ch 3, hdc in center of next 4 hdc, work in patt Row 6 across, turn.

Row 6: Work in patt Row 7 across to last ch-3 sp, hdc in last ch-3 sp, hdc in 2nd ch of tch, turn—4 (5, 6) shells.

Row 7: Ch 3, picot lp in next ch-3 sp, work in patt Row 8 across—5 (6, 7) picot-lps.

Row 8: Work in patt Row 3 across to last ch-3 sp, hdc in last ch-3 sp, ch 2, hdc in top of tch, turn—3 (4, 5) ch-4 sps.

Row 9: Ch 3, hdc in next hdc, ch 3, hdc in next ch-3 sp, work in patt Row 4 across, turn—3 (4, 5) shells; 1 half shell.

Row 10: Work in patt Row 5 across to last ch-3 sp, picot lp in last ch-3 sp, dc in top of tch, turn—4 (5, 6) picot-lps.

Row 11: Ch 4 (counts as hdc, ch 2), hdc in next ch-3 sp, work in patt Row 3 across, turn—3 (4, 5) ch-4 sps.

Row 12: Work in patt Row 7 across to last ch-3 sp, hdc in last ch-3 sp, half shell in next ch-2 sp, dc in 2nd ch of tch, turn—3 (4, 5) shells; 2 half shells.

Row 13: Ch 2, hdc in next dc, work in patt Row 8 across, turn—4 (5, 7) picot-lps. Fasten off size S.

Sizes L and 2X only

Row 14: Work in patt Row 3 across to last ch-3 sp, hdc in last ch-3 sp, dc in top of tch, turn—3 (4) ch-4 sps.

Row 15: Ch 3, half shell in next ch-3 sp, hdc in next ch-3 sp, work in patt Row 4 across, turn—3 (4) shells; 2 half shells.

Row 16: Work in patt Row 5 across, turn—4 (5) picot-lps.

Row 17: Work in patt Row 6 across, turn—4 (5) ch-4 sps. Fasten off sizes L and 2X.

Sizes M, 1X, and 3X only

Row 1: With RS facing, rejoin yarn in first dc to the left of Row 1 of first front, ch 2 (counts as hdc, hdc in next dc, *ch 3, picot-lp in next ch-3 sp, ch 3, skip next 4 sts, hdc in each of next 4 dc; rep from * 3 (4, 6) times, ch 3, picot-lp in next ch-3 sp, ch 3, skip next 5 sts, hdc in next dc, hdc in top of tch, turn—5 (6, 8) picots.

Row 2: Work in pattern Row 6 across to last ch-3 sp, hdc in last ch-3 sp, hdc in top of tch, turn—5 (6, 8) ch-4 sps.

Row 3: Ch 2, shell in next ch-4 sp, work in pattern Row 7 across, turn—5 (6, 8) shells.

Row 4: Work in patt Row 8 across to last shell, skip next 5 sts, hdc in each of next 4 dc, skip next 3 sts, dc in top of tch, turn—5 (6, 8) picot-lps.

Row 5: Ch 5 (counts as hdc, ch 3), hdc in center of 4 hdc, work in patt Row 3 across, turn—4 (5, 7) ch-4 sps.

Row 6: Work in patt Row 4 across to last ch-3 sp, hdc in last ch-3 sp, hdc in 2nd ch of tch, turn—4 (5, 7) shells; 1 half shell.

Row 7: Ch 3, picot-lp in next ch-3 sp, work in patt Row 5 across, turn—5 (6, 7) picot-lps.

Row 8: Work in patt Row 6 across to last ch-3 sp, hdc in last ch-3 sp, ch 2, hdc in top of tch, turn—5 (6, 8) ch-4 sps.

Row 9: Ch 3, skip next ch-2 sp, hdc in next hdc, ch 3, hdc in next ch-3 sp, work in patt Row 7 across, turn—5 (6, 8) shells.

Row 10: Work in patt Row 8 across to last ch-3 sp, picot-lp in last ch-3 sp, dc in top of tch, turn—5 (6, 8) picot-lps.

Row 11: Ch 4 (counts as hdc, ch 2), hdc in next ch-3 sp, work in patt Row 3 across, turn—4 (5, 7) ch-4 sps.

Row 12: Work in patt Row 4 across, turn—4 (5, 7) shells; 2 half shells.

Row 13: Work in patt Row 5 across, turn—4 (5, 7) picot-lps.

Row 14: Work in patt Row 6 across to last ch-3 sp, hdc in last ch-3 sp, hdc in top of tch, turn —4 (5, 7) ch-4 sps.

Row 15: Ch 3, half shell in next ch-3 sp, work in patt Row 7 across, turn—4 (5, 7) shells; 1 half shell.

Row 16: Work in patt Row 8 across to last ch-3 sp, picot-lp in last ch-3 sp, skip next 4 sts, hdc in next dc, hdc in top of tch, turn—4 (5, 7) picot-lps.

Row 17: Work in patt Row 6 across, turn—3 (4, 6) ch-4 sps. Fasten off size M.

Sizes 1X and 3X only

Work 3 more rows evenly in established pattern. Fasten off sizes 1X and 3X.

Finishing

ASSEMBLY

With RS together, matching sts, sew side and underarm seam. Sew shoulder seams.

LOWER EDGING

With RS facing, join yarn with sl st in one side seam, ch 1, sc evenly around, keeping work flat, join with sl st in first sc. Fasten off.

Note: For a wider band, continue working rnds of sc, without joining until desired length, join with sl st in next sc.

NECK EDGING

Rnd 1: With RS facing, join yarn with sl st in one shoulder seam, ch 1, sc evenly around neck opening, join with sl st in first sc.

Rnd 2: Ch 1, sc in each sc, working sc3tog (see Glossary) at center of V-neck, join with sl st in first sc. Fasten off. For a wider Neck Edging, rep Rnd 2 until edging is desired width.

SLEEVE EDGING

Rnd 1: With RS facing, join yarn with sl st in seam at center of underarm, ch 1, sc evenly around Sleeve, join with sl st in first sc.

Rnd 2: Ch 1, sc in each sc around, join with sl st in first sc.

Rep Rnd 2 until band measures ¾" (2 cm) or to desired length. Fasten off.

Weave in ends. Steam block.

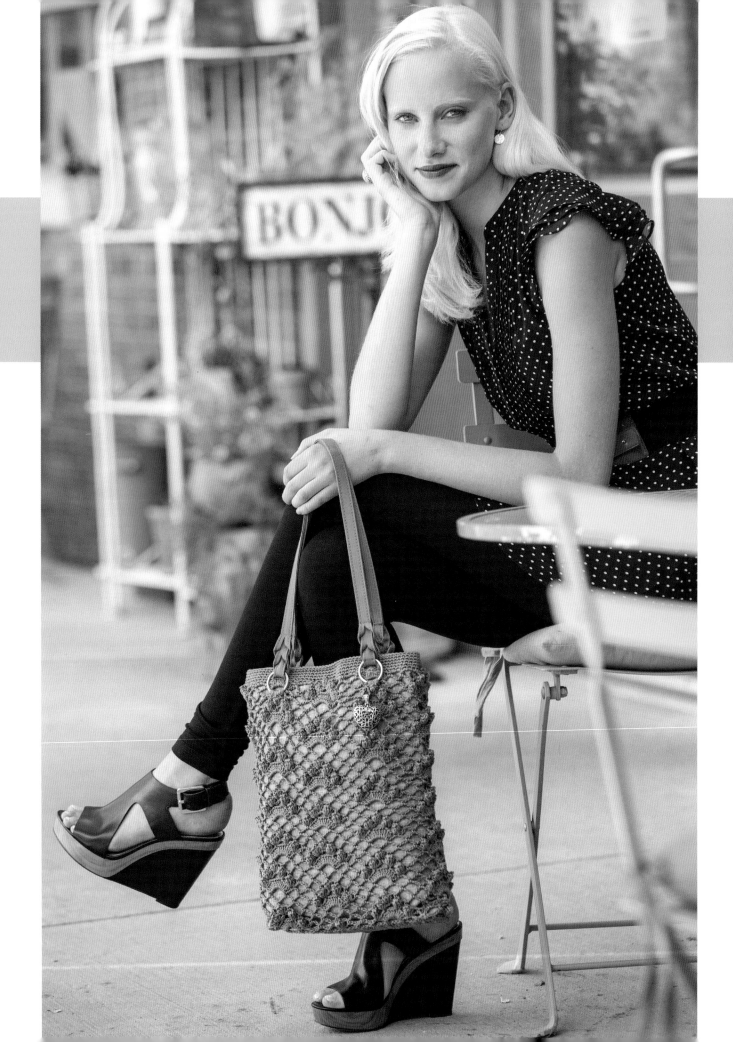

FINISHED SIZE
Shoulder Bag: 14″ (35.5 cm) tall x 11″ (28 cm) wide, excluding handles.

Larger Beach Bag/Carry-On: 15″ (38 cm) tall x 22″ (56 cm) wide.

Handles: 11″ (28 cm) from top of bag.

YARN
Sportweight (#2 Fine).

Shown here: Tahki Cotton Classic Lite (100% mercerized cotton; 146 yd [134 m]/1¾ oz [50 g]): #4725 deep leaf green, 5 skeins.

HOOK
Size F/5 (3.75 mm) *or* G/6 (4 mm). Gauge is not critical with this project.

Note: I used the size F hook, but I crochet more loosely than most people.

NOTIONS
1 yd (.9 m) fabric for lining (optional; see Notes).

Sewing needle; matching sewing thread; yarn needle; leather tote handles, 24″ (61 cm) long (Jo-Ann Fabrics and Craft Stores).

GAUGE
1 shell with 5 pop sts at top = 2¼″ (5.5 cm) wide

One pattern repeat = 5¾″ (14.5 cm); 6 rows = 2¼″ (5.5 cm).

Bottom = 1¾″ (4.5 cm) x 10½″ (26.5 cm).

Daytime in Paris
shoulder bag

*J*f you like texture, you'll love this bag. But if you don't enjoy making popcorn stitches or just prefer a smoother surface, all you have to do is work a 3dc-cluster stitch in place of the popcorns. This fun project can be used as a shoulder bag or tote, and I've added easy instructions for making it larger (twice the size) to be used as a beach bag or carry-on.

NOTES

Sample uses ½ yd (.5 m) each of 2 different fabrics—a printed fabric for the inside lining and a solid-color fabric to show through the front of the bag. You could also use a quilted fabric printed on both sides for the lining instead of 2 fabrics and stabilizer.

If making a shoulder bag, you'll need 2 yd (1.8 m) of total fabric and ½ yd (.5 m) of stabilizer (optional), such as Pellon or Peltex, depending on how stiff you want your bag to be. Fusible is best because you can adhere it to the fabric with an iron. If making a beach bag or carry-on, you'll need 1 yd (.9 m) of stabilizer.

If you would like less texture or don't like working pop sts, you can replace the pops with 3-dc clusters.

If you are adding the lining, make sure you sew the pocket to the inside lining before sewing the front, back, and side pieces together.

You will always have a ch-2 before and after each pop st.

When working into pops, always work sc in ch-1 sp behind pop—not in a dc.

Shoulder Bag

BAG BOTTOM

Ch 8.

Row 1: Dc in 3rd ch from hook (tch counts as first dc), dc in each ch across, turn—7 dc.

Row 2: Ch 2 (counts as dc here and throughout), skip first dc, dc in each dc across, turn—7 dc.

Rep Row 2 until work measures 10½" (26.5 cm) from beg, or 28 rows. Do not fasten off.

BODY OF BAG

NOTE: Body is worked in rounds without turning.

Foundation Rnd (RS): Ch 1, * work 47 sc evenly spaced across long edge of bottom, 2 sc in next corner st, 5 sc across short edge of bottom, 2 sc in next corner st; rep from * around, join with sl st in first sc—112 sc.

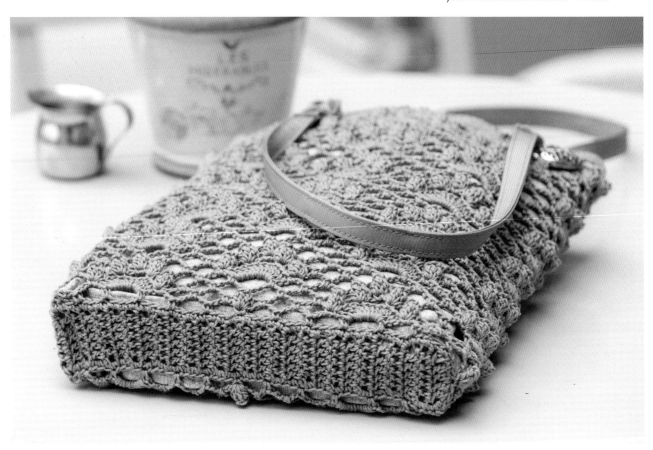

STITCH GUIDE

Beginning popcorn (beg pop): Ch 3 (counts as dc), 4 dc in designated st, remove loop from hook, insert hook from front to back in top of beg ch-3, insert hook in dropped lp, draw dropped lp through top of first st, ch 1 to close.

Popcorn (pop): 5 dc in designated st, remove loop from hook, insert hook from front to back in top of first dc made, insert hook in dropped lp, draw dropped lp through top of first st, ch 1 to close.

Shell: 11 dc in same ch-5 lp.

STITCH KEY

⬭ = chain (ch)

• = slip stitch (sl st)

+ = single crochet (sc)

T = double crochet (dc)

🪧 = beginning popcorn (beg pop)

🪧 = popcorn (pop)

🌰 = shell

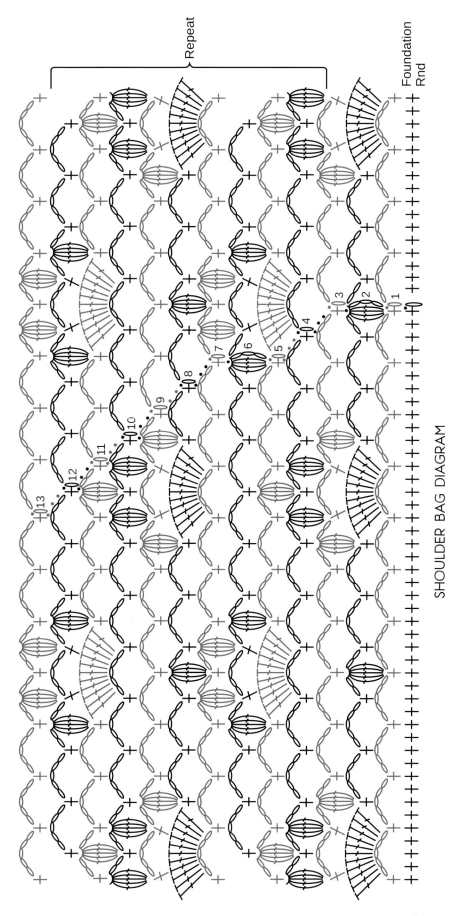

Rnd 1: Ch 1, sc in first sc, ch 5, skip next 3 sc, *sc in next sc, ch 5, skip next 3 sc; rep from * around, sl st in first sc—28 ch-5 lps.

Rnd 2: Beg pop in first sc, *ch 2, sc in next ch-5 lp, (ch 5, sc) in each of next 2 ch-5 lps, shell in next ch-5 lp, sc in next ch-5 lp, (ch 5, sc) in each of next 2 ch-5 lps, ch 2**, pop in next sc, rep from * around, ending last rep at **, join with sl st in first beg pop—4 shells; 4 pops.

Rnd 3: Ch 1, *sc in pop, (ch 5, sc) in each of next 2 ch-5 lps, ch 2, pop in next sc, ch 2, skip next 3 dc, sc in next dc, ch 5, skip next 3 dc, sc in next dc, ch 2, pop in next sc, ch 2, (sc, ch 5) in each of next 2 ch-5 lps; rep from *

around, join with sl st in first sc.

Rnd 4: Sl st to center of first ch-5 lp, ch 1, sc in same ch-5 lp, *ch 5, sc in next ch-5 lp, ch 5, sc in next pop, [ch 2, pop in next sc, ch 2, sc in next pop] twice, (ch 5, sc) in each of next 3 ch-5 sps, rep from * around, omitting last sc, join with sl st in first sc.

Rnd 5: Sl st to center of first ch-5 lp, ch 1, sc in same ch-5 lp, *ch 5, sc in next ch-5 lp, ch 5, sc in next pop, ch 2, pop in next sc, ch 2, sc in next pop, (ch 5, sc) in each of next 2 ch-5 lps, shell in next ch-5 lp (shell should be directly above pop 3 rows below)**, sc in next ch-5 lp; rep from * around, ending last rep at **, join with sl st in first sc.

Rnd 6: Beg pop in first sc, *ch 2, (sc, ch 5) in each of next 2 ch-5 lps, sc in next pop, (ch 5, sc) in each of next 2 ch-5 lps, ch 2, pop in next sc, ch 2, skip next 3 dc, sc in next dc, ch 5, skip next 3 dc, sc in next dc, ch 2**, pop in next sc; rep from * around, ending last rep at **, join with sl st in first sc.

Rnd 7: Ch 1, sc in first pop, *(ch 5, sc) in each of next 4 ch-5 sps, ch 5, sc in next pop, ch 2, pop in next sc, ch 2, sc in next ch-5 sp, ch 2, pop in next sc, ch 2**, sc in next pop; rep from * around, ending last rep at **, join with sl st in first sc.

Rnd 8: Sl st to center of first ch-5 lp, ch 1, sc in same ch-5 lp, ch 5, sc in next ch-5 lp, *shell in next ch-5 lp, (sc, ch 5) in each of next 2 ch-5 lps, ch 5, sc in next pop, ch 2, pop in next sc, ch 2, sc in next pop**, (ch 5, sc) in each of next 2 ch-5 lps; rep from * around, ending last rep at **, ch 5, join with sl st in first sc.

Rnd 9: Sl st to center of first ch-5 lp, ch 1, sc in same ch-5 lp, *ch 2, pop in next sc, ch 2, skip next 3 dc, sc in next dc, ch 5, skip next 3 dc, sc in next dc, ch 2, pop in next sc, ch 2, (sc, ch 5) in each of next 2 ch-5 lps, sc in next pop, (ch 5, sc) in each of next 2 ch-5 lps; rep from * around, omitting last sc, join with sl st in first sc.

Rnd 10: Sl st to next pop, ch 1, *sc in pop, [ch 2, pop in next sc, ch 2, sc in next pop] twice, (ch 5, sc) in each of next 4 ch-5 sps, ch 5; rep from * around, join with sl st in first sc.

Rnd 11: Sl st to next pop, ch 1, *sc in pop, ch 2, pop in next sc, ch 2, sc in next pop, (ch 5, sc) in each of next 2 ch-5 lps, shell in next ch-5 lp, (sc, ch 5) in each of next 2 ch-5 lps; rep from * around, join with sl st in first sc.

Rnd 12: Sl st to next pop, ch 1, *sc in pop, (ch 5, sc) in each of next 2 ch-5 lps, ch 2, pop in next sc, ch 2, skip next 3 dc, sc in next dc, ch 5, skip next 3 dc, sc in next dc, ch 2, pop in next sc, ch 2, (sc, ch

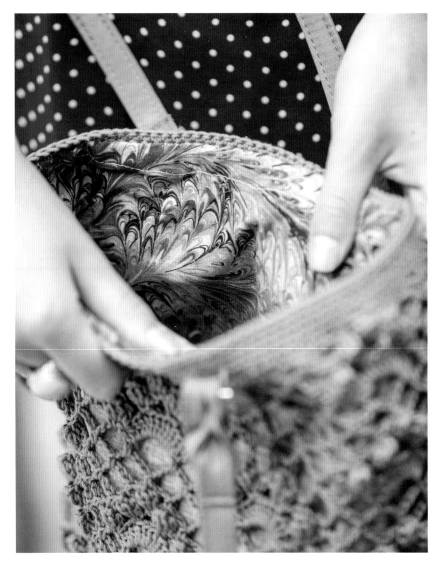

5) in each of next 2 ch-5 lps; rep from * around, join with sl st in first sc.

Rnds 13–35: Rep Rnds 4–12 (twice), then rep Rnds 4–8.

TOP EDGING

Rnd 1: Ch 1, sc evenly around (keeping work flat), join with sl st in first sc.

Rnds 2–5: Ch 1, sc in each sc around, join with sl st in first sc. Fasten off. Weave in ends.

Larger Beach Bag/ Carry-On

Work same as shoulder bag with the following exceptions:

BAG BOTTOM

Work same as shoulder bag bottom until piece measures 21" (53.5 cm) or 56 rows.

BODY OF BAG

Foundation Rnd: Ch 1, work 103 sc evenly spaced across long edge of bottom, 2 sc in next corner st, 5 sc across short edge of bottom, 2 sc in next corner st; rep from * around, join with sl st in first sc—224 sc.

Work remainder of pattern same as shoulder bag until body of bag measures 14" (35.5 cm) tall without edging, or to desired height. Work top edging same as shoulder bag.

Optional Lining

NOTE: Bag has a double lining so RS of fabric shows through the front as well as the inside.

Measure each side of the bag and add a seam allowance of about ½" (1.3 cm) on all sides. For the inside lining, cut out a front and back piece, two sides, and a Bottom panel.

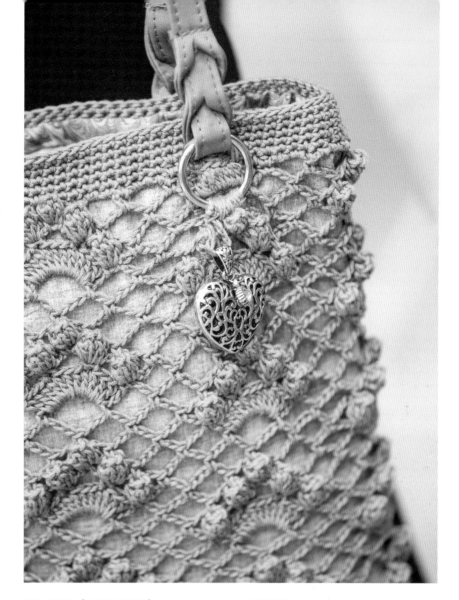

POCKET (OPTIONAL)

NOTE: You need to do this with one thickness of inside lining fabric before sewing lining pieces together.

Pocket has double fabric to avoid frayed edges. Cut 2 squares of fabric 5½" (14 cm) x 6½" (16.5 cm). Press all 4 edges under ½" (1.3 cm) to WS on both pocket pieces. With WS together, pin both pocket pieces to each other and then pin the pocket where desired to the side of the lining that will be showing on the inside of the bag. Stitch in place with machine or by hand, close to the edges, leaving the top edge free for the pocket opening. If you want 2 pockets inside the bag, rep this process on the other inside lining piece.

BOTTOM

Matching seams, pin and sew the bottom edges to the bottom edges of body, one at a time, leaving ½" (1.3 cm) opening on all corners.

OUTSIDE LINING

If you want a double lining with contrasting fabric showing through the lace on the outside, repeat the steps above. Pin both linings with WS together at the top edges and sew about ⅛" (3mm) to ¼" (6mm) below the folded top edge.

Place lining inside the bag, making sure the sides of the lining are at the sides of the bag. Hand or machine stitch lining to the bag at the top edge.

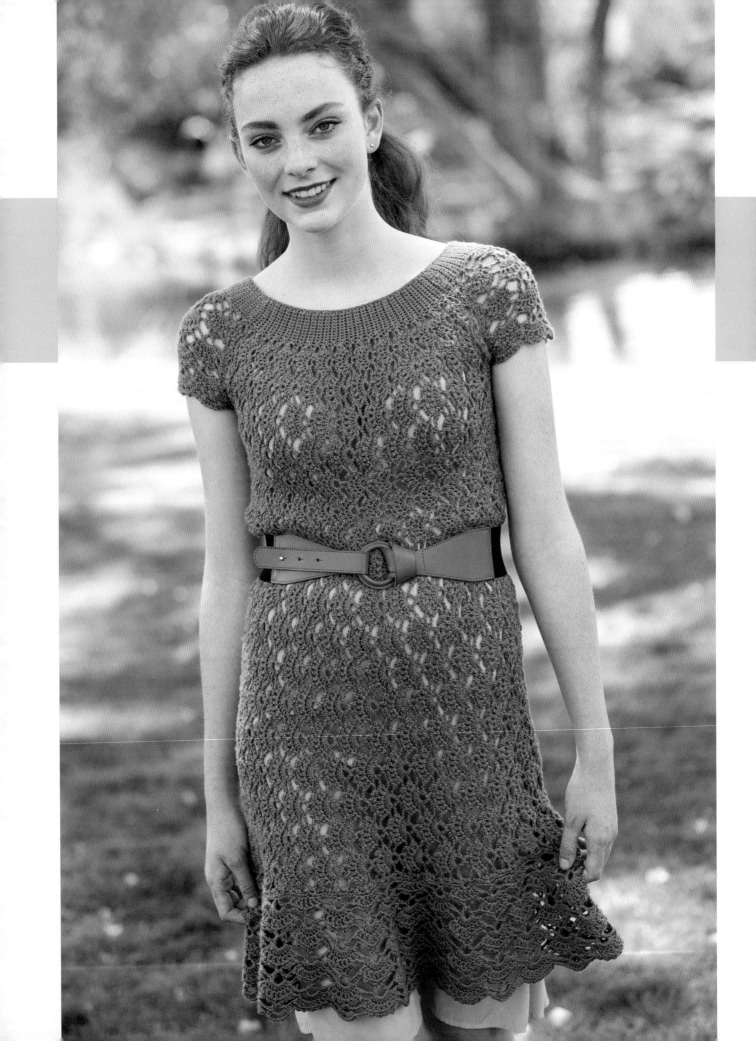

Ooh Là Là flared dress

FINISHED SIZES
S (M, L, 1X, 2X, 3X). Sample shown is size S.

Bust: 34 (37, 40, 43, 48, 51)″ (86.5 [94, 101.5, 109, 122, 129.5] cm).

Waist: 31 (34, 36, 39, 44, 46)″ (79 [86.5, 91.5, 99, 112, 117] cm).

Length: 32″ (81.5 cm) from front neck edge to hem.

Note: Instructions are given for lengthening the dress.

YARN
Fingering weight (#1 Super Fine).

Shown here: Cascade Heritage Silk Fingering (85% superwash merino wool; 15% mulberry silk; 437 yd [400 m]/3½ oz [100 g]): #5627 jade, 4 (4, 4, 5, 6, 6) hanks.

HOOK
Size G/6 (4mm). Adjust hook size if necessary to obtain the correct gauge.

NOTIONS
Stitch markers; yarn needle.

GAUGE
Working in Body patt (with dc's), one patt rep (shell, ch 3, V-st, ch 3) = 3¼″ (8.5 cm); 8 rows = 3½″ (9 cm).

Working in Waist patt (with hdc's), one patt rep (Shell, ch 3, V-st, ch 3) = 2½″ (6.5 cm); 8 rows = 2½″ (6.5 cm).

In Ribbing patt, 7 sc and 7 rows = 1″ (2.5 cm).

This charming dress is worked in a fingering yarn, but don't let that scare you off. It's much easier to work with thinner yarns than you think, and the great drape you will get is worth it. The versatile pattern includes options to turn it into a straight dress without the flare, a top, a sleeveless dress, a maxi dress, and to add longer sleeves. It uses my Graduated Stitch Method (GSM; see page 152) for effortless shaping.

STITCH KEY

⬭ = chain (ch)

✚ = single crochet (sc)

T = half double crochet (hdc)

⊤ = double crochet (dc)

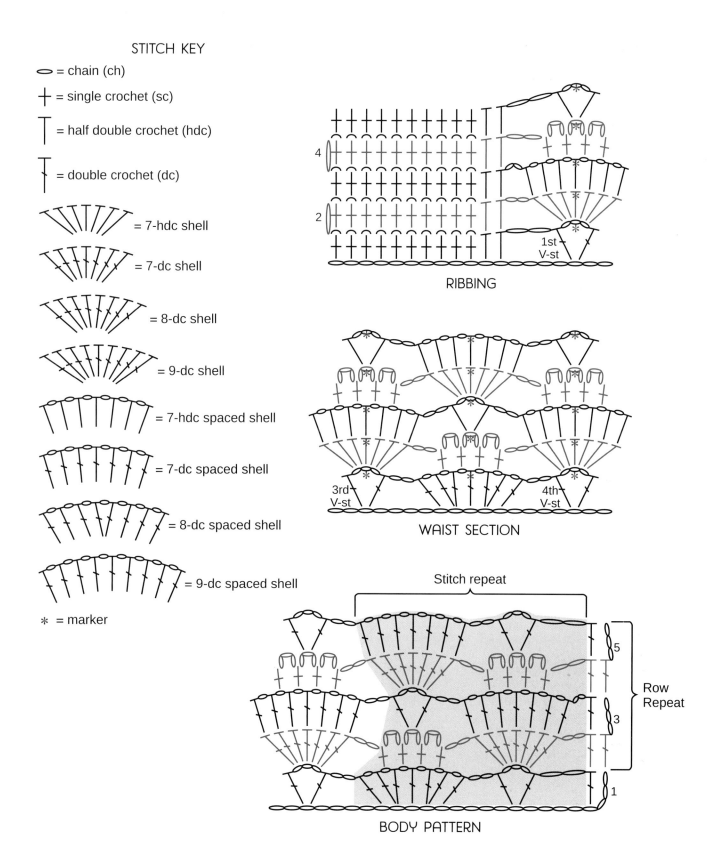

= 7-hdc shell

= 7-dc shell

= 8-dc shell

= 9-dc shell

= 7-hdc spaced shell

= 7-dc spaced shell

= 8-dc spaced shell

= 9-dc spaced shell

✳ = marker

RIBBING

1st V-st

WAIST SECTION

3rd V-st 4th V-st

Stitch repeat

Row Repeat

BODY PATTERN

Row 2: Ch 1, sc in blo of each of first 10 sc, hdc in each of next 2 hdc, ch 2, skip next ch-2 sp, * 7-dc shell in next V-st, ch 2**, skip next 2 sps, (sc, ch 3) in each of next 3 ch-1 sps, sc in next ch-1 sp, ch 2, skip next 2 sps, rep from * across, ending last rep at **, dc in each of last 2 sts, turn—9 shells.

NOTE: At end of next row (Row 3), counting from neck edge, the 3rd and 4th shells will be worked with hdc where markers were placed (see diagram).

Row 3: Ch 3 (counts as dc here and throughout), dc in next dc, ch 2, skip next ch-2 sp, *(dc, ch 1) in each of next 6 dc, dc in next dc (spaced shell made), ch 2**, skip next 2 sps, V-st in next ch-3 sp, ch 2, skip next 2 sps, rep from * across, ending last rep at **, hdc in each of next 2 hdc, sc in blo of each of last 10 sc, turn—9 spaced shells.

NOTE: Beg at neck end first, 3rd and 4th spaced shells will be worked with hdc, where markers were placed (see diagram).

Row 4: Ch 1, sc in blo of each of first 10 sc, hdc in each of next 2 hdc, *ch 2, skip next 2 sps, (sc, ch 3) in each of next 3 ch-1 sps, sc in next ch-1 sp, ch 2, skip next 2 sps**, shell in next V-st, rep from * across, ending last rep at **, dc in each of last 2 sts, turn—8 shells.

Row 5: Ch 3, dc in next dc, *ch 2, skip next 2 sps, V-st in next ch-3 sp, ch 2**, skip next 2 sps, (dc, ch 1) in each of next 6 dc, dc in next dc (spaced shell made); rep from * across, ending last rep at **, sk next ch-2 sp, hdc in each of next 2 hdc, sc in blo of each of last 10 sc, turn—8 spaced shells.

Rows 6–50 (54, 58, 62, 70, 74): Rep Rows 2–5 (11 [12, 13, 14, 16, 17] times); then rep Row 2.

NOTE: If front piece is too small (from hip to hip), add more rows. If piece is too wide, delete rows to fit. This is the amazing thing about working vertical rows—you can get a custom fit by adding or deleting rows.

Assembly

PM 6½ (7, 7½, 8, 8, 8)" (16.5 [18, 19, 20.5, 20.5, 20.5] cm) below neck edge on each side of front and back for armhole. With RS together, place front and back tog, match sts and place safety pins to hold in place. Starting at bottom edge, sew side seams to markers.

Sleeve (MAKE 2)

Ribbing at top of sleeve will be worked separately. Sleeve is then worked across long edge of ribbing in horizontal rows. Cap sleeve will resemble a raglan sleeve.

NECK RIBBING

Row 1: Ch 11, sc in 2nd ch from hook, sc in each ch across, turn—10 sc.

Row 2: Ch 1, sc in blo of each sc across, turn—10 sc.

NOTE: Make sure the short ends of the band measure the same as the band on the front and back piece. They will be sewn together at the ends.

Rows 3–41 (41, 48, 48, 54, 54): Rep Row 2. Do not fasten off.

CAP SLEEVE

Set-up Row: Turn to work across long edge of Ribbing, ch 1, work 39 (39, 53, 53, 67, 67) sc evenly spaced across long edge of Ribbing, turn—39 (39, 53, 53, 67, 67) sc.

Row 1: Ch 3 (counts as dc here and throughout), dc in next sc, ch 2, skip next 2 sc, *V-st in next sc, ch 2**, skip next 4 sc, [dc in next sc, ch 1, (dc, ch 1, dc) in next sc] twice, ch 1, dc in next

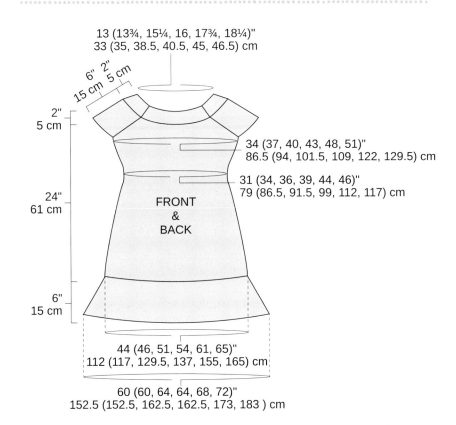

13 (13¾, 15¼, 16, 17¾, 18¼)"
33 (35, 38.5, 40.5, 45, 46.5) cm

6" 2"
15 cm 5 cm

2"
5 cm

2"
5 cm

24"
61 cm

FRONT
&
BACK

34 (37, 40, 43, 48, 51)"
86.5 (94, 101.5, 109, 122, 129.5) cm

31 (34, 36, 39, 44, 46)"
79 (86.5, 91.5, 99, 112, 117) cm

6"
15 cm

44 (46, 51, 54, 61, 65)"
112 (117, 129.5, 137, 155, 165) cm

60 (60, 64, 64, 68, 72)"
152.5 (152.5, 162.5, 162.5, 173, 183) cm

STITCH KEY

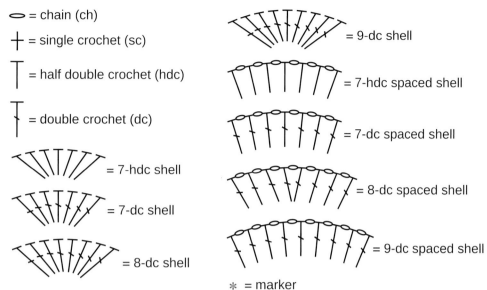

- ⬭ = chain (ch)
- ✝ = single crochet (sc)
- ⊤ = half double crochet (hdc)
- ⊤ = double crochet (dc)
- = 7-hdc shell
- = 7-dc shell
- = 8-dc shell
- = 9-dc shell
- = 7-hdc spaced shell
- = 7-dc spaced shell
- = 8-dc spaced shell
- = 9-dc spaced shell
- ✳ = marker

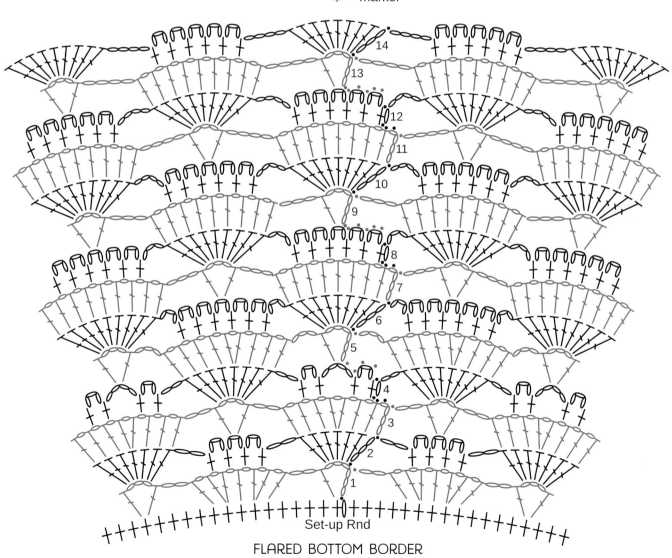

Set-up Rnd

FLARED BOTTOM BORDER

sc (spaced shell made), skip next 4 sts, rep from * across, ending last rep at **, ch 2, skip next 2 sc, dc in each of last 2 sts, turn—3 (3, 4, 4, 5, 5) V-st; 2 (2, 3, 3, 4, 4) spaced shells.

Row 2: Ch 3, dc in next dc, ch 2, skip next ch-2 sp, * 7-dc shell in next V-st, ch 2**, skip next 2 sps, (sc, ch 3) in each of next 3 ch-1 sps, sc in next ch-1 sp, ch 2, skip next 2 sps, rep from * across, ending last rep at **, dc in each of last 2 sts, turn—3 (3, 4, 4, 5) shells.

Row 3: Ch 3, dc in next dc, *ch 2, skip next ch-2 sp, (dc, ch 1) in each of next 6 dc, dc in next dc (spaced shell made), ch 2**, skip next 2 sps, V-st in next ch-3 sp, rep from * across, ending last rep at **, dc in each of last 2 sts, turn—3 (3, 4, 4, 5) spaced shells.

Row 4: Ch 3, dc in next dc, *ch 2, skip next 2 sps, (sc, ch 3) in each of next 3 ch-1 sps, sc in next ch-1 sp, ch 2, skip next ch-2 sp**, 7-dc shell in next V-st, rep from * across, ending last rep at **, dc in each of last 2 sts, turn—2 (2, 3, 3, 4) shells.

Row 5: Ch 3, dc in next dc, *ch 2, skip next 2 sps, V-st in next ch-3 sp, ch 2**, skip next 2 sps, (dc, ch 1) in each of next 6 dc, dc in next dc (spaced shell made), rep from * across, ending last rep at **, dc in each of last 2 sts, turn—2 (2, 3, 3, 4) spaced shells.

Rows 6–14: Rep Rows 2–5 (twice), then rep Row 2. Fasten off.

Steam block Sleeves. With WS tog, pin side edge of one sleeve to side of one armhole opening, matching sts across ribbing and adjusting length of sleeve to fit in rem armhole opening. Sew sides of sleeves in place along armhole opening. Rep on other side of same sleeve. Sew other sleeve in same manner.

TIP: *After sewing sleeves to the dress front and back, you may find the opening at the neck edge is too loose. You can fix that with one of the following 3 options:*

1. *Work a rnd of sts around top edge of ribbing, working: *sc in each of next 2 row-end sts, sc2tog over next 2 row-end sts; rep from * around or decrease as frequently as desired.*

2. *Work a rnd of sc in every other row-end st around top edge of ribbing.*

3. *Use bead elastic and sc around edge encasing elastic with sts. Pull elastic to fit neck before securing it with a knot.*

FOR LONGER SLEEVES

After sleeves are sewn to armhole opening on dress, turn dress RS out so bottom edge of sleeve is facing. At underarm seam, attach yarn and cont to work in rnds following patt st as established until sleeve is desired length. Fasten off.

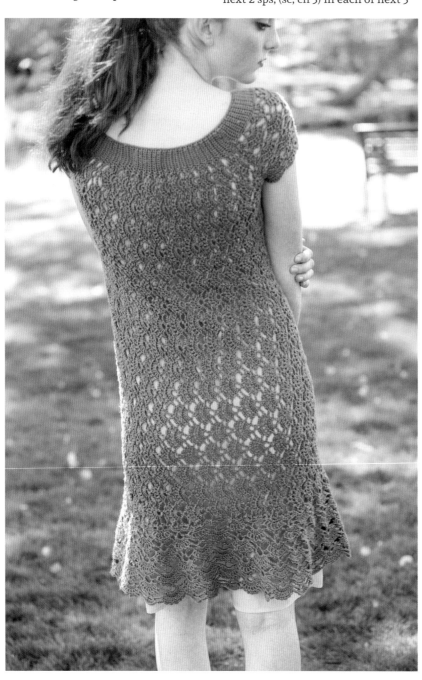

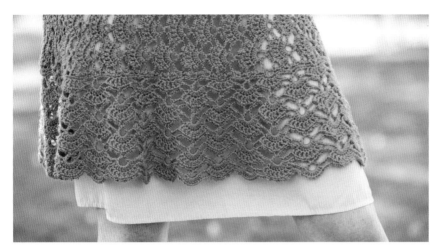

Flared Bottom Border

NOTE: Starting with Rnd 3, you will be adding sts to each shell and spaced shell to make the border flare.

Set-up Rnd: Starting at one side seam, place 15 (15, 16, 16, 17, 18) markers evenly spaced around bottom edge of dress. With RS facing, join yarn in marked side seam, ch 1, work 14 sc evenly spaced across to next marker; rep from * around, join with sl st in first sc—210 (210, 224, 224, 238, 252) sc.

Rnd 1: Ch 6 (counts as dc, ch 3), dc in same sp (counts as V-st), *ch 2, skip next 4 sc, [dc in next sc, ch 1, (dc, ch 1, dc) in next sc] twice, ch 1, dc in next sc (spaced shell made), skip next 4 sts**, V-st in next sc; rep from * around, ending last rep at **, join with sl st in 3rd ch of beg ch-6—15 (15, 16, 16, 17, 18) spaced shells; 15 (15, 16, 16, 17, 18) V-sts.

Rnd 2: Sl st in next ch-3 sp, ch 3, 6 dc in same sp, *ch 2, skip next 2 sps, (sc, ch 3) in each of next 3 ch-1 sps, sc in next ch-1 sp, ch 2, skip next ch-2 sp**; rep from * around, ending last rep at **, join with sl st in top of beg ch-3—15 (15, 16, 16, 17, 18) shells.

Rnd 3: Ch 4, (counts as dc, ch 1), dc in next dc, (dc, ch 1) in each of next 2 dc, (dc, ch 1, dc) in next dc, ch 1, (dc, ch 1) in each of next 2 dc, dc in next dc (8-dc spaced shell made), *ch 2, skip next 2 sps, V-st in next ch-3 sp, ch 2, skip next ch-2 sp**, (dc, ch 1) in each of next 3 dc, (dc, ch 1, dc) in next dc, ch 1, (dc, ch 1) in each of next 2 dc, dc in next dc (8-dc spaced shell made); rep from * around, ending last rep at **, join with sl st in 3rd ch of beg ch-4—15 (15, 16, 16, 17, 18) 8-dc spaced shells.

Rnd 4: Sl st in each of next 2 ch-1 sps, ch 1, sc in same sp, ch 3, sc in next ch-1 sp, ch 4, skip next ch-1 sp, sc in next ch-1 sp, ch 3, sc in next ch-1 sp, *ch 2, skip next 2 sps, 8 dc in next V-st, ch 2, skip next 2 sps**, sc in next ch-1 sp, ch 3, sc in next ch-1 sp, ch 4, skip next ch-1 sp, sc in next ch-1 sp, ch 3, sc in next ch-1 sp; rep from * around, ending last rep at **, join with sl st in first sc—15 (15, 16, 16, 17, 18) 8-dc shells.

Rnd 5: Sl st across to center ch-4 sp, ch 6 (counts as dc, ch 3), *ch 3, skip next 2 sps, (dc, ch 1) in each of next 3 dc, (dc, ch 1, dc) in next dc, ch 1, (dc, ch 1) in each of next 2 dc, dc in next dc (8-dc spaced shell made), ch 3, skip next 2 sps**, V-st in next ch-3 sp; rep from * around, ending last rep at **, join with sl st in 3rd ch of beg ch-6—15 (15, 16, 16, 17, 18) 8-dc spaced shells.

Rnd 6: Sl st in next ch-3 sp, ch 3, 8 dc in same sp, *ch 3, skip next 2 sps, (sc, ch 3) in each of next 6 ch-1 sps, skip next 2 sps**, 9 dc in next V-st; rep from * around, ending last rep at **, join with sl st in top of beg ch-3—15 (15, 16, 16, 17, 18) 9-dc shells.

Rnd 7: Ch 4, (counts as dc, ch 1), (dc, ch 1) in each of next 7 dc, dc in next dc (9-dc spaced shell made), *ch 3, skip next 3 sps, V-st in next ch-3 sp, ch 3, skip next 3 sps**, (dc, ch 1) in each of next 8 dc, dc in next dc (9-dc spaced shell made); rep from * around, ending last rep at **, join with sl st in 3rd ch of beg ch-4—15 (15, 16, 16, 17, 18) 9-dc spaced shells.

Rnd 8: Sl st in each of next 2 ch-1 sps, ch 1, sc in same sp, (ch 3, sc) in each of next 5 ch-1 sps, *ch 3, skip next 2 sps, 9 dc in next V-st, ch 3, skip next 2 sps**, sc in next ch-1 sp, (ch 3, sc) in each of next 5 ch-1 sps; rep from * around, ending last rep at **, join with sl st in first sc—15 (15, 16, 16, 17, 18) 9-dc shells.

Rnd 9: Sl st across to center ch-3 sp, ch 6 (counts as dc, ch 3), *ch 3, skip next 3 sps, (dc, ch 1) in each of next 8 dc, dc in next dc (9-dc spaced shell made), ch 3, skip next 3 sps**, V-st in next ch-3 sp; rep from * around, ending last rep at **, join with sl st in 3rd ch of beg ch-6—15 (15, 16, 16, 17, 18) 9-dc spaced shells.

Rnd 10: Sl st in next ch-3 sp, ch 3, 8 dc in same sp, *ch 4, skip next 2 sps, (sc, ch 3) in each of next 5 ch-1 sps, sc in next ch-1 sp, ch 4, skip next 2 sps**, 9 dc in next V-st; rep from * around, ending last rep at **, join with sl st in top of beg ch-3—15 (15, 16, 16, 17, 18) 9-dc shells.

Rnd 11: Ch 4, (counts as dc, ch 1), (dc, ch 1) in each of next 7 dc, dc in next dc (9-dc spaced shell made), *ch 4, skip next 3 sps, V-st in next ch-3 sp, ch 3, skip next 3 sps**, (dc, ch 1) in each of next 8 dc, dc in next dc (9-dc spaced shell made); rep from * around, ending last rep at **, join with sl st in 3rd ch of beg ch-4—15 (15, 16, 16, 17, 18) 9-dc spaced shells.

Rnds 12–14: Rep Rnds 8–10 of Border. Fasten off. To lengthen dress, rep Rnds 11–14 for desired length.

Finishing

Weave in ends and steam block dress if necessary.

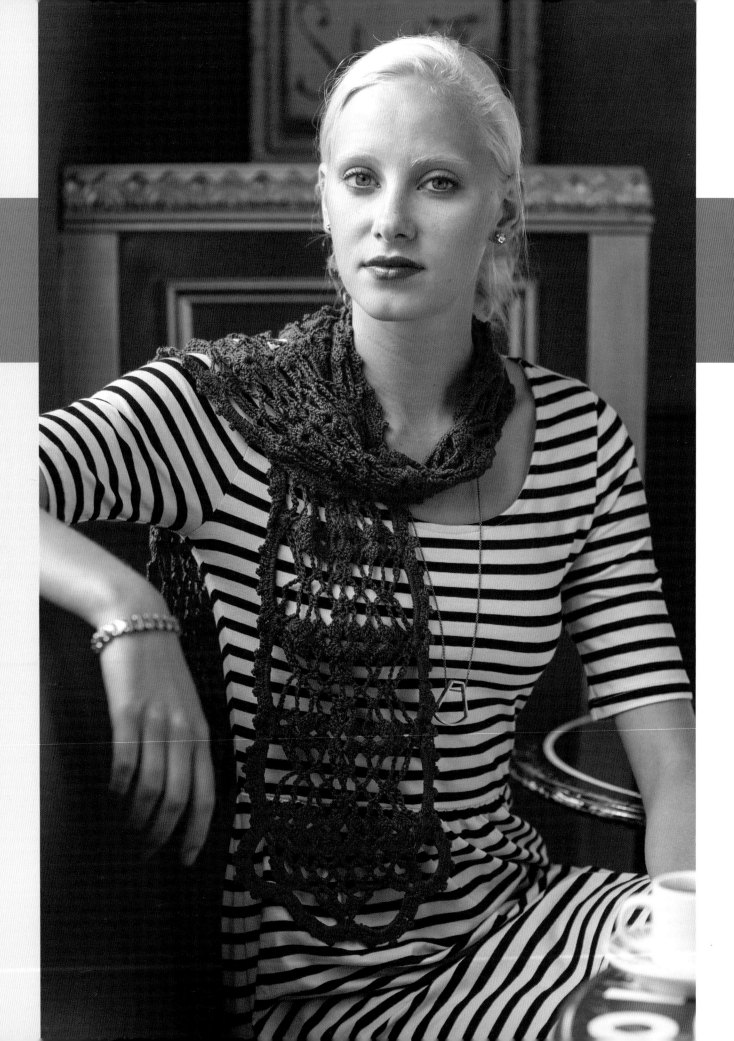

Ma Chérie scarf

FINISHED SIZE
7″ (18 cm) wide x 59″ (150 cm) long.

YARN
DK weight (#3 Light).

Shown here: Louisa Harding Mulberry (100% silk; 136 yd [124 m]/1¾ oz [50 g]): #35 raspberry, 3 balls.

HOOK
Size F/5 (3.75 mm). Adjust hook size if necessary to obtain the correct gauge.

NOTIONS
Yarn needle.

GAUGE
One pattern repeat on first side (ch-3 sp, ch-5 sp, ch-3 sp, shell in Row 2) = 3″ (7.5 cm); Rows 1–4 on first side = 2½ (6.5 cm).

If you love luxury yarns with a sheen, you'll love this beautiful silk yarn that is so easy to work with. And your fingers will thank you. Wearing it wrapped around your neck as a cowl shows off the lacy arched border. It can also be tied with a knot in front or off to the side or worn around the shoulders as a wrap.

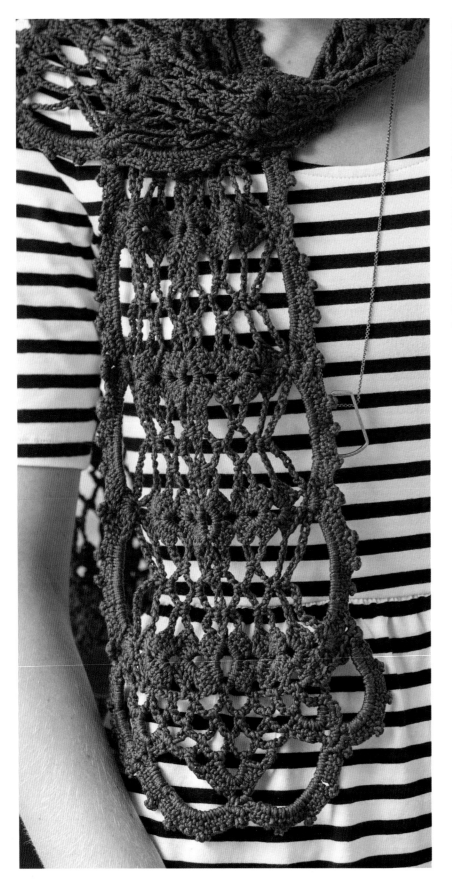

STITCH GUIDE

Shell: (4 dc, ch 3, 4 dc) in
same st or sp.

Picot: Ch 4, sl st in 4th ch
from hook.

Scarf

FIRST SIDE

Foundation Row: (WS) *Ch 4, tr in
4th ch from hook, rep from * 51 times,
or for desired length work a multiple
of 3 + 1 lps—52 lps.

Row 1: Ch 3 (counts as dc here and
throughout), working across ch side
of Foundation Row, shell in next ch-3
sp, *ch 3, sc in next ch-3 sp, ch 5, sc in
next ch-3 sp, ch 3, shell in next ch-3 lp;
rep from * across to last ch-3 lp, dc in
last ch, turn—18 shells.

Row 2: Ch 3, shell in next ch-3 sp, *ch
5, skip next ch-3 sp, sc in next ch-5 sp,
ch 5, skip next ch-3 sp, shell in next
ch-3 sp; rep from * across to last ch-3
sp, skip next 4 dc, dc in top of tch,
turn.

Row 3: Ch 3, shell in next ch-3 sp, *ch
3, sc in next ch-5 sp, ch 5, sc in next
ch-5 sp, ch 3, shell in next ch-3 sp; rep
from * across to last ch-3 sp, dc in top
of tch, turn.

Row 4: Rep Row 2.

Row 5: Ch 1, sc in first dc, ch 4, sc in
next ch-3 sp, *ch 9, skip next ch-5 sp,
sc in next sc, ch 9, skip next ch-5 sp,
sc in next ch-3 sp; rep from * across to
last ch-3 sp, ch 4, sc in top of tch, turn.

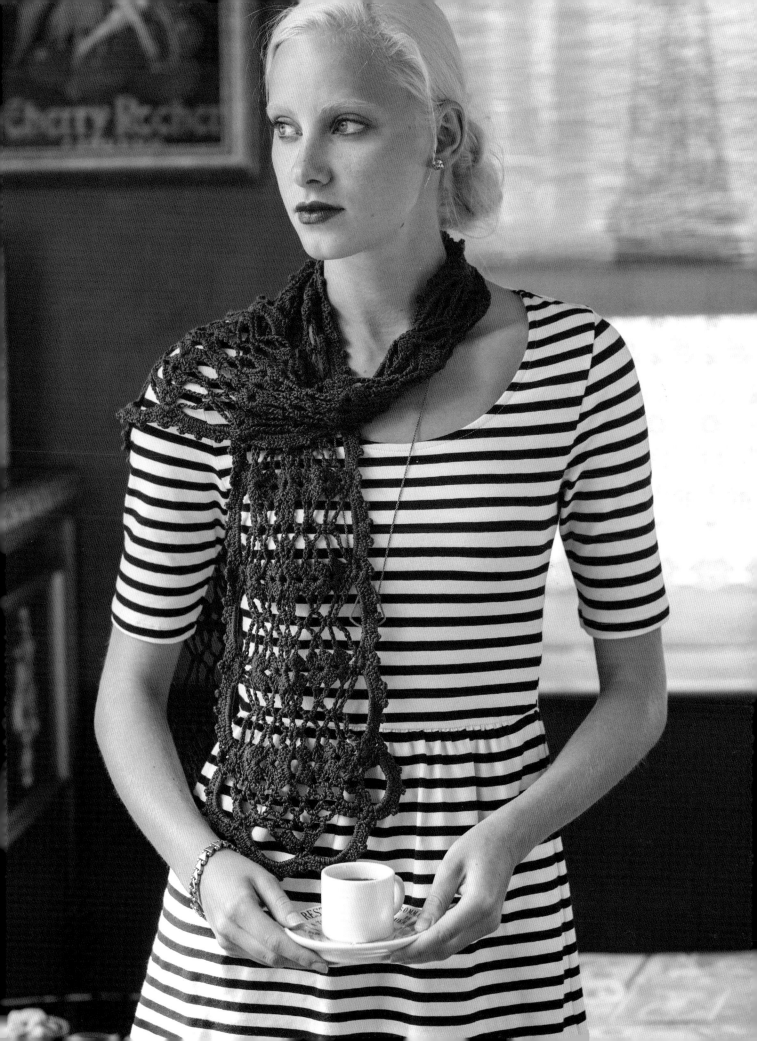

Row 6: Ch 3, skip next ch-4 sp, shell in next sc, *ch 9, skip next 2 ch-9 lps, shell in next sc; rep from * across to last sc, skip next ch-4 sp, dc in last sc, turn.

Row 7: Ch 4 (counts as hdc, ch 2), (sc, picot, sc) in next ch-3 sp, *(4 dc, [picot, 4 dc] 3 times in next ch-9 lp, (sc, picot, sc) in next ch-3 sp; rep from * across to last ch-3 sp, ch 2, skip next 4 dc, hdc in top of tch. Fasten off.

SECOND SIDE

Rotate scarf to work across the opposite side of the Foundation Row.

Row 1: With RS facing, join yarn with sl st in ch at base of first tr, working in tr side of Foundation Row, ch 3, shell in lp formed by next tr, *ch 3, sc in next lp, ch 5, sc in next lp, ch 3, shell in next lp; rep from * across to last lp, dc in top of last tr, turn—18 shells.

Rows 2–7: Rep Rows 2–7 of First Side. Do not fasten off.

FIRST SCARF END

Row 1: With RS facing, working across left short end of scarf, join yarn with sl st in row-end tch in Row 6 of First Side on short edge of scarf, ch 1, sc in same sp, skip next sc row-end, (ch 6, sc) in each of next 3 dc row-ends, ch 6, skip next dc row-end, sc in end of Foundation Row, ch 6, skip next dc row-end, (sc, ch 6) in each of next 3 dc row-ends, skip next sc row-end, sc in next dc row-end, turn leaving rem row unworked—8 ch-6 lps.

Row 2: Sl st to center of next ch-6 lp, ch 1, sc in same sp, (ch 5, sc) in each of next 7 lps, turn—7 ch-5 lps.

Row 3: Shell in first ch-5 sp, sc in next sp, (ch 5, sc) in each of next 4 ch-5 sps, shell in last ch-5 sp, sc in ch-5 sp at end of Row 2, turn—4 ch-5 sps with 1 shell on each end. Fasten off.

Row 4: With WS facing, join yarn with sl st in first ch-5 sp in Row 3, ch 1, sc in same sp, (ch 5, sc) in each of next 3 ch-5 sps, turn—3 ch-5 sps.

Row 5: Sl st to center of first ch-5 sp, ch 1, sc in same sp, shell in next ch-5 sp, sc in last ch-5 sp, do not turn—1 shell. Fasten off.

Row 6: With RS facing, join yarn with sl st in ch-2 sp at end of Row 7 of first side of scarf, *ch 13, (sc, ch 3, sc) in ch-3 sp in center of next shell in Row 3 of scarf end, rep from * twice, ch 13, sl st in ch-2 sp at end of Row 7 of second side of scarf, do not turn—4 ch-13 lps. Fasten off.

Row 7: With RS facing, join yarn with sl st in sc to the left of last picot in Row 7 of first side of scarf, ch 1, *(4 dc, [picot, 4 dc] 3 times) in next ch-13 lp**, (sc, picot, sc) in next ch-3, rep from * twice, rep from * to ** once, ch 1, sl st in sc to the right of next picot in Row 7 of second side of scarf, do not turn. Fasten off.

SECOND SCARF END

Row 1: With RS facing, working across right short end of scarf, join yarn with sl st in row-end tch in Row 6 of second side on short edge of scarf, ch 1, sc in same sp, skip next sc row-end, (ch 6, sc) in each of next 3 dc row-ends, ch 6, skip next dc row-end, sc in end of Foundation Row, ch 6, skip next dc row-end, (sc, ch 6) in each of next 3 dc row-ends, skip next sc row-end, sc in next dc row-end, turn leaving rem row unworked—8 ch-6 lps.

Rows 2–7: Rep Rows 2–7 of first scarf end.

Finishing

Weave in the ends and block the scarf, pinning out the points of the picots and rounding out the arches.

STITCH KEY

⊖ = chain (ch)

• = slip stitch (sl st)

✚ = single crochet (sc)

T = half double crochet (hdc)

╪ = double crochet (dc)

╪ = treble crochet (tr)

⬥ = picot

⬤ = shell

First scarf end

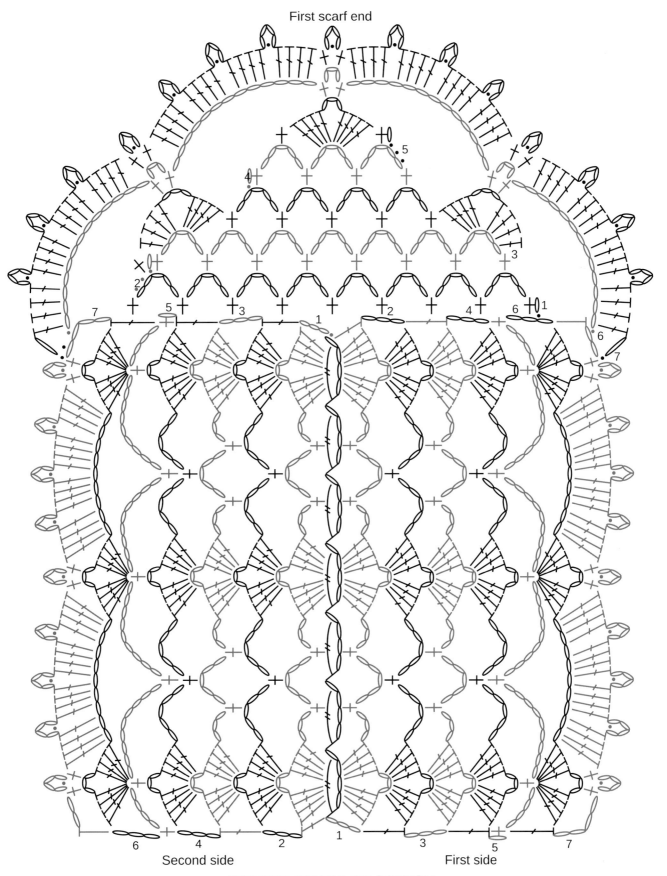

Second side First side

REDUCED SAMPLE OF PATTERN

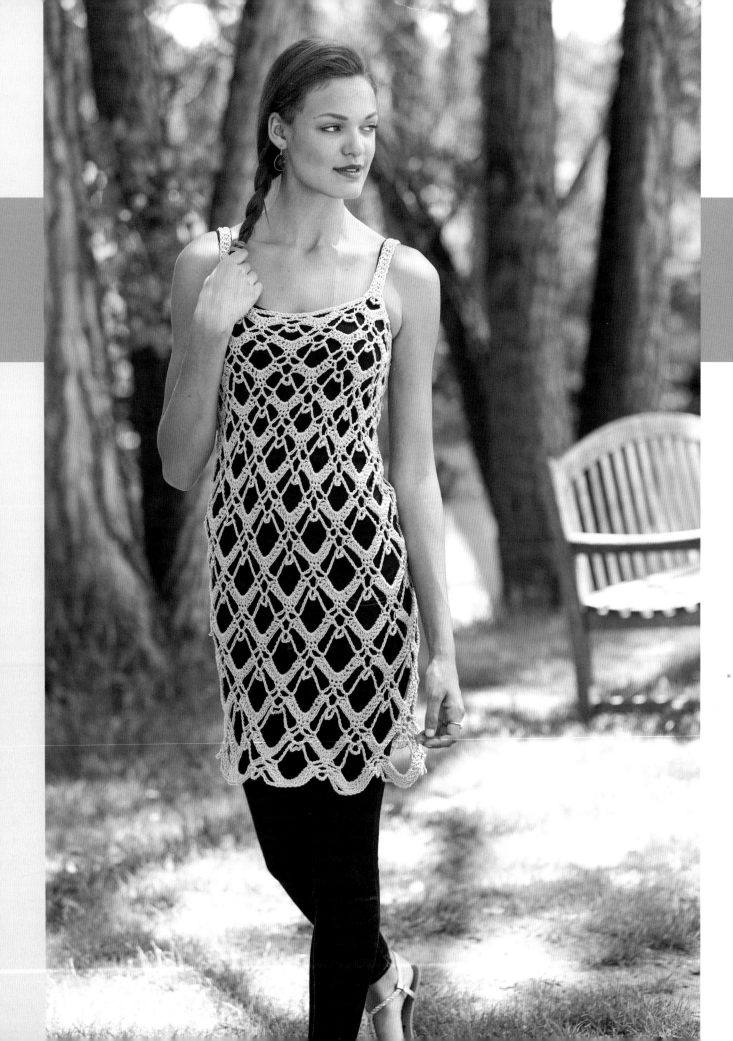

Dominique dress overlay

This top-down dress can be worn over a tank and leggings or another dress and would also make a fantastic beach cover-up. Or add a belt for another look. The pattern is fairly easy and works up quickly. The instructions include options for turning it into a cropped top, a skirt, or a tunic.

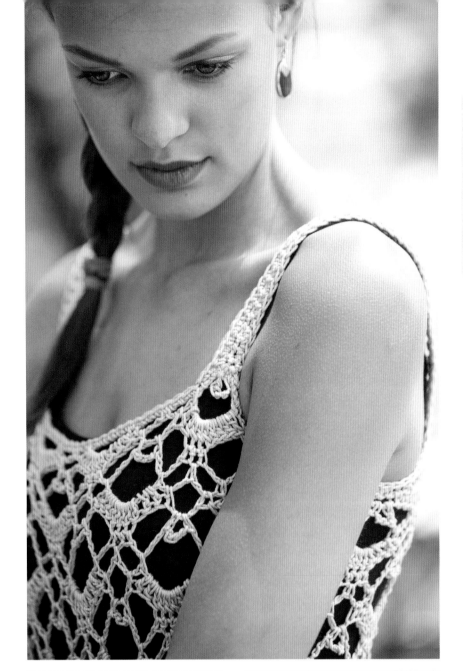

STITCH KEY

⬭ = chain (ch)

• = slip st (sl st)

✝ = single crochet (sc)

Ⳁ = half double crochet (hdc)

Ⳁ = double crochet (dc)

⋌ = single crochet 2 together (sc2tog)

= half shell

= 9-dc shell

= 11-dc shell

= 13-dc shell

NOTES

Rows 1–13 are worked without joining to create an opening in the back. The rows are then connected and worked in rounds. The dress gradually gets wider toward the bottom, which is achieved by adding extra sts to the shells on specific rows as it is worked downward.

VARIATIONS

To make this into a crop top, work through Rnd 20, then fasten off.

To shorten it into a tunic, work through Rnd 26, then fasten off.

To make a skirt from this pattern, starting with Row 1, work to desired length using the top area opening in back for your waist. Eliminate straps.

Dress

Yoke is worked in rows (leaving an opening in back). Remainder of dress is worked in rounds.

Ch 114 (125, 136, 158, 169, 180).

Row 1: Sc in 2nd ch from hook, sc in next ch, *ch 3, skip next 2 sc, sc in next sc, ch 6, skip next 4 sc, sc in next sc, ch 3, skip next 2 sc, sc in next sc; rep from * across to last ch, sc in last ch, turn—10 (11, 12, 14, 15, 16) ch-6 sps.

Row 2: Ch 2 (counts as hdc here and throughout), hdc in next sc, ch 1, *sc in next ch-3 sp, 9 dc in ch-6 sp, sc in next ch-3 sp, ch 3; rep from * across to last ch-3 sp, sc in last ch-3 sp, ch 1, hdc in each of last 2 sc, turn—10 (11, 12, 14, 15, 16) shells.

Row 3: Ch 1, sc in each of first 2 hdc, *ch 5, sc in center 3 dc of next shell, ch 5**, (sc, ch 5, sc) in next ch-3 sp; rep from * across, ending last rep at **, sc in each of last 2 sts, turn—10 (11, 12, 14, 15, 16) groups of 3 sc.

Row 4: Ch 3 (counts as dc here and throughout), dc in next sc, ch 3, *sc in next ch-5, ch 3, skip next sc, sc in next sc, ch 3, sc in next ch-5**, ch 6, skip next ch-5; rep from * across, ending last rep at **, ch 3, dc in each of last 2 sc, turn—9 (10, 11, 13, 14, 15) ch-6 sps.

Row 5: Ch 3, dc in next dc, 4 dc in

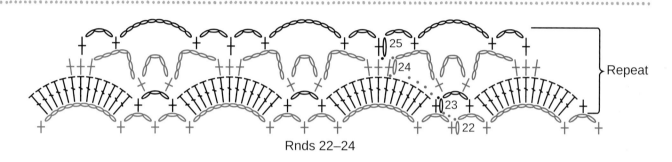

Rnds 22–24

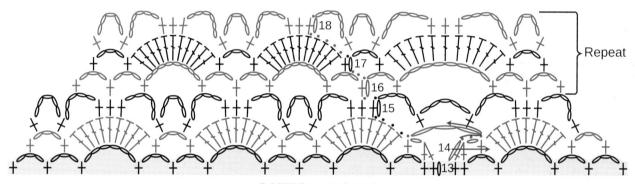

PATTERN IN RNDS
Rnds 14–18

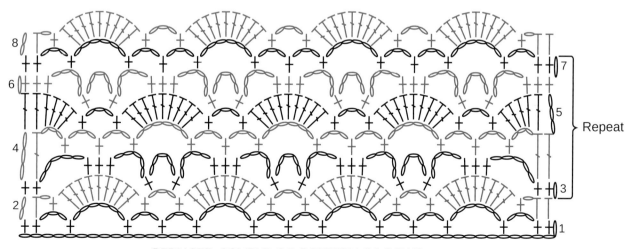

REDUCED SAMPLE OF PATTERN IN ROWS

next ch-3 sp, *sc in next ch-3 sp, ch 3, sc in next ch-3 sp**, 9 dc in next ch-6 sp, rep from * across, ending last rep at **, 4 dc in last ch-3 sp, dc in each of last 2 sts, turn—9 (10, 11, 13, 14, 15) shells; 2 half shells.

Row 6: Ch 1, sc in each of first 3 dc, *ch 5, (sc, ch 5, sc) in next ch-3 sp, ch 5**, sc in center 3 dc of next shell; rep from * across, ending last rep at **, skip next 3 dc, sc in each of last 3 sts, turn—10 (11, 12, 14, 15, 16) groups of 3 sc.

Row 7: Ch 1, sc in each of first 2 sc, *ch 3, sc in ch-5 sp, ch 6, skip next ch-5 sp, sc in next ch-5 sp, ch 3, skip next sc, sc in next sc; rep from * across, sc in last sc, turn—10 (11, 12, 14, 15, 16) ch-6 sps.

Rows 8–13: Rep Rows 2–7.

NOTE: Work now progresses in joined rnds.

Rnd 14: (WS) Ch 1, sc2tog over first 2 sc, ch 1, *sc in next ch-3 sp, 9 dc in ch-6 sp, sc in next ch-3 sp, ch 3; rep from * across to last ch-3 sp, sc in last ch-3 sp, ch 1, sc2tog over last 2 sc, join with sl st in first sc2tog, sl st to next sc, turn, ch 3, skip next 4 sts, sl st in next sc—10 (11, 12, 14, 15, 16) shells.

Rnd 15: Sl st in each of next 5 sts, ch 1, sc in each of first 3 sts, *ch 5, (sc, ch 5, sc) in next ch-3 sp, ch 5**, sc in center 3 dc of next shell; rep from * around, ending last rep at **, join with sl st in first sc—10 (11, 12, 14, 15, 16) groups of 3 sc.

Rnd 16: Sl st in next sc, ch 1, sc in same st, *ch 3, sc in next ch-5, ch 8, skip next ch-5, sc in next ch-5 sp, ch 3**, skip next sc, sc in next sc; rep from * around, ending last rep at **, join with sl st in first sc—10 (11, 12, 14, 15, 16) ch-8 sps.

Rnd 17: Sl st to center of next ch-3 sp, ch 1, sc in same sp, 11 dc in next ch-6 sp, sc in next ch-3 sp, ch 3**, sc in next ch-3 sp; rep from * across, ending last rep at **, join with sl st in first sc—10 (11, 12, 14, 15, 16) 11-dc shells.

Rnd 18: Sl st in each of next 5 sts, ch 1, sc in each of first 3 st, *ch 6, (sc, ch 5, sc) in next ch-3 sp, ch 6**, sc in center 3 dc of next shell; rep from * around, ending last rep at **, join with sl st in first sc, turn—10 (11, 12, 14, 15, 16) groups of 3 sc.

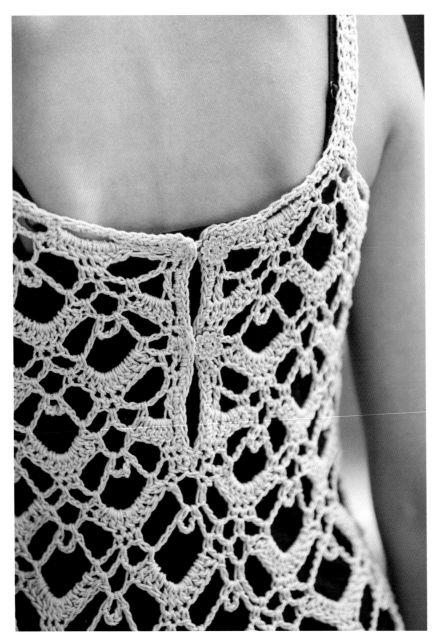

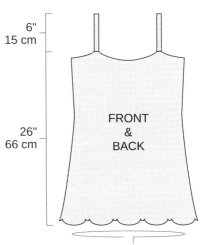

6"
15 cm

26"
66 cm

FRONT
&
BACK

32½ (35¾, 39, 45½, 48¾, 52)"
82.5 (90.5, 99, 115.5, 124, 132) cm

Rnd 19: Sl st in next sc, ch 1, sc in same st, *ch 3, sc in next ch-6, ch 8, skip next ch-5, sc in next ch-6 sp, ch 3**, skip next sc, sc in next sc; rep from * around, ending last rep at **, join with sl st in first sc—10 (11, 12, 14, 15, 16) ch-8 sps.

Rnd 20: Sl st to center of next ch-3 sp, ch 1, sc in same sp, 11 dc in next ch-6 sp, sc in next ch-3 sp, ch 3**, sc in next ch-3 sp; rep from * across, ending last rep at **, join with sl st in first sc—10 (11, 12, 14, 15, 16) 11-dc shells.

Rnd 21: Rep Rnd 18.

Rnd 22: Sl st in next sc, ch 1, sc in same st, *ch 3, sc in next ch-6, ch 10, skip next ch-5, sc in next ch-6 sp, ch 3**, skip next sc, sc in next sc; rep from * around, ending last rep at **, join with sl st in first sc—10 (11, 12, 14, 15, 16) ch-10 sps.

Rnd 23: Sl st to center of next ch-3 sp, ch 1, sc in same sp, 13 dc in next ch-6 sp, sc in next ch-3 sp, ch 3**, sc in next ch-3 sp; rep from * across, ending last rep at **, join with sl st in first sc—10 (11, 12, 14, 15, 16) 13-dc shells.

Rnd 24: Sl st in each of next 6 sts, ch 1, sc in each of first 3 sts, *ch 7, (sc, ch 5, sc) in next ch-3 sp, ch 7**, sc in center 3 dc of next shell; rep from * around, ending last rep at **, join with sl st in first sc—10 (11, 12, 14, 15, 16) groups of 3 sc.

Rnd 25: Sl st in next sc, ch 1, sc in same st, *ch 3, sc in next ch-7, ch 10, skip next ch-5, sc in next ch-7 sp, ch 3**, skip next sc, sc in next sc; rep from * around, ending last rep at **, join with sl st in first sc—10 (11, 12, 14, 15, 16) ch-10 sps.

Change to size J/10 (6 mm) hook.

NOTE: For a straighter dress, keep working with the I/9 (5.5 mm) hook.

Rnds 26–42: Rep Rnds 23–25 (5 times); then rep Rows 23–24. Fasten off.

TOP EDGE

With RS facing and an I-9/(95.5 mm) hook, join yarn with a sl st in first st

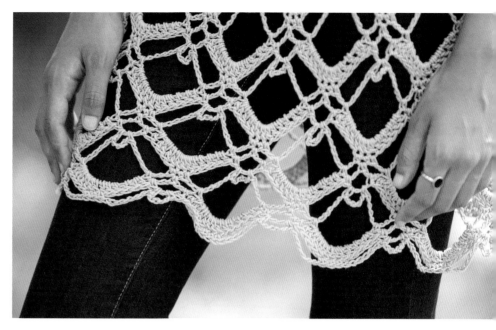

to the left of bottom of slit, ch 1, sc evenly across left side of slit, 3 sc in corner st, sc evenly across back left neck edge, front neck edge, and back right neck edge to next corner, 3 sc in corner at top of slit, sc evenly down right side of slit, sc2tog at base of slit, join with sl st in first sc. Fasten off.

Straps

Try dress on to decide where you want the straps. PM at 4 places on band (2 in front and 2 in back) indicating placement for straps.

Row 1: Beg on back, join yarn with sl st in sc at right of marker, ch 1, sc in same st, sc in next sc, turn.

Row 2: Ch 1, sc in each of next 2 sc, turn.

Rows 3–26: Rep Row 2. Add or delete rows as needed to make the strap the desired length. Keep in mind the strap will stretch. With WS tog, sew end of strap to corresponding marked position on front. Rep for the strap on the other side.

NOTE: You can leave straps as they are or work sc along each side edge to make straps wider and sturdier.

STRAP EDGING

Rnd 1: With RS facing, join yarn with sl st 2 sts to the right of left strap on back, sc in next st, hdc in inside corner at base of strap, sc along side edge to front, hdc in inside corner at base of strap, sc in next st, sl st in next st. Fasten off. Rep for the strap edging on the other edge of the same strap. Work the other strap in the same manner. Weave in the ends.

Finishing

BUTTONS

Pm for button placement at 2 sps along the edge of the opening in the back. Sew buttons onto the dress with the sewing needle and thread.

LOOPS

Place markers on the other side of the back opening at the underside of the edge, opposite the buttons, about ⅓" (.8 cm) from the edge, join yarn with sl st at marker, ch 8 (more or less depending on the button size), sl st in same place as join. Fasten off. Rep for other marker.

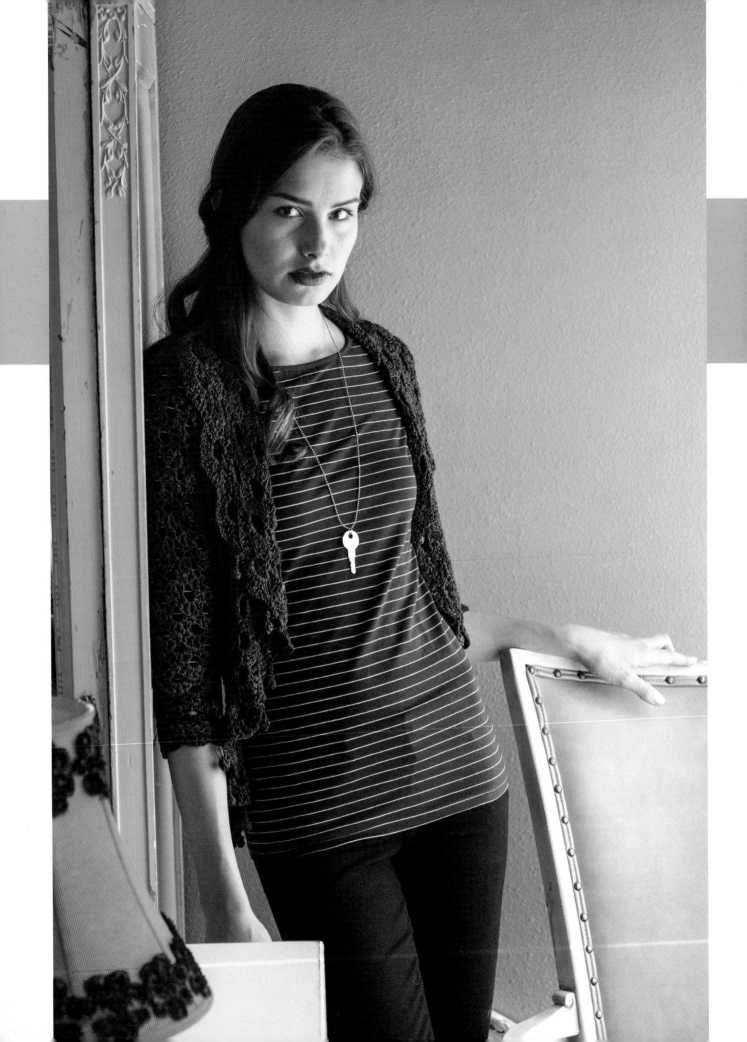

Boutique *bolero*

FINISHED SIZES
S (M, L, 1X, 2X). Sample shown is size S.

24 (27, 30, 33, 36)″ (61 [68.5, 76, 84, 91.5] cm) across back from one armhole to the other.

YARN
Sportweight (#2 Fine).

Shown here: Be Sweet Bamboo Sport (100% hand-dyed bamboo; 110 yd [101 m]/1¾ oz [50 g]): #671 garnet, 7 (8, 9, 10, 11) balls.

HOOK
Size H/8 (5 mm). Adjust hook size if necessary to obtain the correct gauge.

NOTIONS
Stitch markers; yarn needle.

GAUGE
In Body patt, 1 repeat (4-dc shell, sc) = 1½″ (3.8 cm); 6 rows = 4″ (10 cm).

*Y*ou'll love the feel of the soft bamboo yarn as it's gliding across your fingers, and the subtle changes in color create a unique and interesting fabric. Leave off the added sleeves for cap sleeves. Wear it open or add a pretty brooch for closure.

NOTES

Body of bolero is worked in a rectangle, then a flared border is added to the top and bottom edges. Piece will be folded in half across the middle of the body. Side seams will be sewn with space on each side for an armhole opening. Sleeves are worked into armholes in joined rnds. The three-quarter length sleeves, shown, can be lengthened by adding more rnds.

STITCH GUIDE

4 double crochet shell (4-dc shell): ([Dc, ch 1] 3 times, dc) in next st or sp.

5 double crochet shell (5-dc shell): ([Dc, ch 1] 4 times, dc) in next st.

6 double crochet shell (6-dc shell): ([Dc, ch 1] 5 times, dc) in next st.

7 treble crochet shell (7-tr shell): ([Tr, ch 1] 6 times, dc) in next sp.

Single crochet spike (sc spike): Working over ch-sp in previous row, sc in next corresponding st or sp 2 rows below. You will be working a sc around 2 rows.

5 double crochet cluster (5-dc cluster): [Yo, insert hook in next st, yo, draw up a lp, yo, draw yarn through 2 lps on hook] 5 times in same st, yo, draw yarn through 6 lps on hook.

Body

Loosely ch 98 (110, 122, 134, 146).

Row 1: (WS) Sc in 2nd ch from hook, ch 1, skip next ch, *sc in next ch, ch 3, skip next ch, sc in next ch**, ch 3, skip next 3 ch; rep from * across, ending last rep at **, ch 1, skip next ch, sc in last ch, turn—31 (35, 39, 43, 47) ch-3 sps.

NOTE: After first row is worked, piece should measure about 24 (27, 30, 33, 36)" (61 [68.5, 76, 84, 91.5] cm)

across. When the bolero is complete, this width will span the back from armhole to armhole. If the piece does not fit comfortably across the back without stretching after Row 2, you may want to make a different size.

Row 2: Ch 1, sc in first sc, *4-dc shell in next ch-3 sp**, sc spike over next ch-3 sp in next corresponding ch on foundation ch; rep from * across, ending last rep at **, sc in last sc, turn—16 (18, 20, 22, 24) shells.

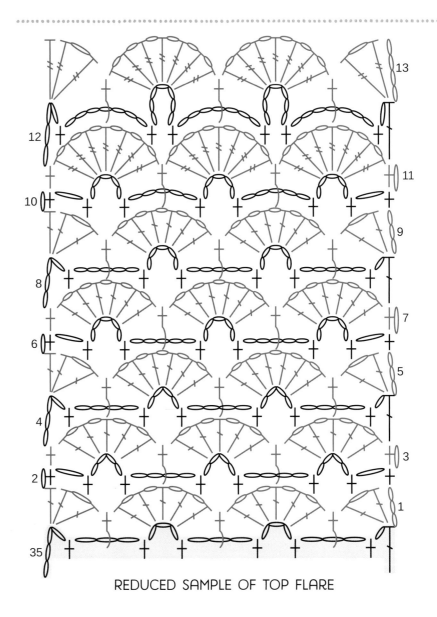

REDUCED SAMPLE OF TOP FLARE

Row 3: Ch 4 (counts as dc, ch 1, here and throughout), sc in next ch-1 sp (first ch-1 sp of shell), *ch 3, skip next ch-1 sp, sc in next ch-1 sp (last ch-1 sp of shell)**, ch 3, sc in next ch-1 sp (first ch-1 sp of next shell); rep from * across, ending last rep at **, ch 1, dc in last sc, turn—31 (35, 39, 43, 47) ch-3 sps.

Row 4: Ch 3 (counts as dc here and throughout), (dc, ch 1, dc) in first dc (half shell made), *sc spike over next ch-3 sp and into ch-1 sp 2 rows below**, 4-dc shell in next ch-3 sp, rep from * across, ending last rep at **, (dc, ch 1, 2 dc) in 3rd ch of tch, turn—15 (17, 19, 21, 23) shells; 2 half shells.

Row 5: Ch 1, sc in first dc, ch 1, *sc in next ch-1 sp, ch 3, sc in next ch-1 sp**, ch 3, skip ch-1 sp; rep from * across, ending last rep at **, ch 1, sc in top of tch, turn—31 (35, 39, 43, 47) ch-3 sps.

Row 6: Ch 1, sc in first sc, *4-dc shell in next ch-3 sp**, sc spike over next ch-3 sp and into ch-1 sp 2 rows below; rep from * across, ending last rep at **, sc in last sc, turn—16 (18, 20, 22, 24) shells.

Rep Rows 3–6 until piece measures 23½" (59.5 cm) from beg, ending with Row 3 of patt. For a longer body, add more rows in patt, ending with Row 3 of patt. With 6" (15 cm) of flare on each end of Body, the length in back will be 35½" (90 cm). Top flare border will be folded over to form a collar, leaving a back measurement of 29½" (75 cm). Consider that when deciding whether to add more rows to the body.

STITCH KEY

◠ = chain (ch)

• = slip st (sl st)

+ = single crochet (sc)

+ = single crochet spike (sc spike)

⊤ = double crochet (dc)

⊤ = treble crochet (tr)

= 4 double crochet shell (4-dc shell)

= 5 double crochet shell (5-dc shell)

= 6 double crochet shell (6-dc shell)

= 7 treble crochet shell (7-tr shell)

REDUCED SAMPLE OF BODY PATTERN

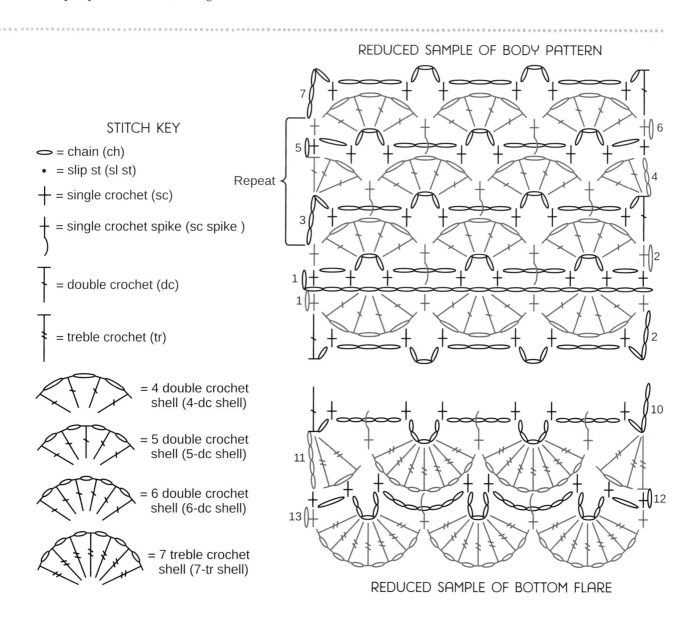

Repeat

REDUCED SAMPLE OF BOTTOM FLARE

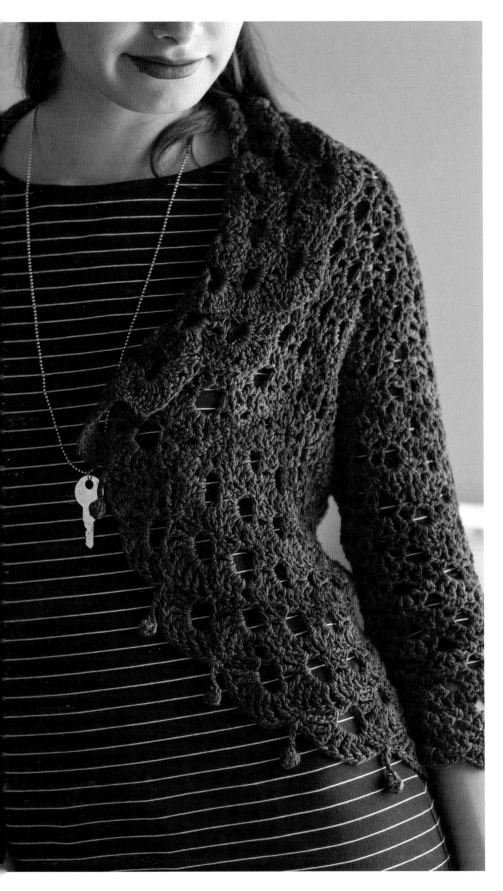

TOP FLARE

NOTE: Flare is worked in similar pattern to body but modified with larger shells to cause the rows to flare out. The top flare will be about 6" (15 cm) deep and will form the collar. After working the flares, try the bolero on to determine if the flares are wide enough.

Row 1: Ch 3 (counts as dc here and throughout), (dc, ch 1, dc) in first dc (half shell made), *sc spike over next ch-3 sp and into ch-1 sp 2 rows below**, 5-dc shell in next ch-3 sp, rep from * across, ending last rep at **, (dc, ch 1, 2 dc) in 3rd ch of tch, turn—15 (17, 19, 21, 23) 5-dc shells; 2 half shells. PM at beg and each end of row to indicate beg of flare.

Row 2: Ch 1, sc in first dc, ch 1, *sc in next ch-1 sp, ch 4, sc in next ch-1 sp**, ch 4, skip next 2 ch-1 sps; rep from * across, ending last rep at **, ch 1, sc in top of tch, turn—31 (35, 39, 43, 47) ch-4 sps.

Row 3: Ch 1, sc in first sc, *5-dc shell in next ch-3 sp**, sc spike over next ch-4 sp and into ch-1 sp 2 rows below; rep from * across, ending last rep at **, sc in last sc, turn—16 (18, 20, 22, 24) 5-dc shells.

Row 4: Ch 4, sc in next ch-1 sp, *ch 4, skip next 2 ch-1 sps, sc in next ch-1 sp**, ch 4, sc in next ch-1 sp; rep from * across, ending last rep at **, ch 1, dc in last sc, turn—31 (35, 39, 43, 47) ch-4 sps.

Row 5: Ch 3, (dc, ch 1, dc) in first dc (half shell made), *sc spike over next ch-4 sp and into center dc 2 rows below**, 6-dc shell in next ch-3 sp, rep from * across, ending last rep at **, (dc, ch 1, 2 dc) in 3rd ch of tch, turn—15 (17, 19, 21, 23) 6-dc shells; 2 half shells.

Row 6: Ch 1, sc in first dc, ch 1, *sc in next ch-1 sp, ch 5, sc in next ch-1 sp**, ch 5, skip next 3 ch-1 sps; rep from * across, ending last rep at **, ch 1, sc

in top of tch, turn—31 (35, 39, 43, 47) ch-5 sps.

Row 7: Ch 1, sc in first sc, *6-dc shell in next ch-3 sp**, sc spike over next ch-5 sp and into ch-1 sp 2 rows below; rep from * across, ending last rep at **, sc in last sc, turn—16 (18, 20, 22, 24) 6-dc shells.

Row 8: Ch 4 (counts as dc, ch 1, here and throughout), sc in next ch-1 sp, *ch 5, skip next 3 ch-1 sps, sc in next ch-1 sp**, ch 5, sc in next ch-1 sp; rep from * across, ending last rep at **, ch 1, dc in last sc, turn—31 (35, 39, 43, 47) ch-5 sps.

Row 9: Ch 3, (dc, ch 1, dc) in first dc (half shell made), *sc spike over next ch-5 sp and into ch-1 sp 2 rows below**, 6-dc shell in next ch-3 sp, rep from * across, ending last rep at **, (dc, ch 1, 2 dc) in 3rd ch of tch, turn—15 (17, 19, 21, 23) 6-dc shells; 2 half shells.

Row 10: Ch 1, sc in first dc, ch 1, *sc in next ch-1 sp, ch 5, sc in next ch-1 sp**, ch 5, skip next 3 ch-1 sps; rep from * across, ending last rep at **, ch 1, sc in top of tch, turn—31 (35, 39, 43, 47) ch-5 sps.

Row 11: Ch 1, sc in first sc, *7-tr shell in next ch-3 sp**, sc spike over next ch-5 sp and into ch-1 sp 2 rows below; rep from * across, ending last rep at **, sc in last sc, turn—16 (18, 20, 22, 24) 7-tr shells.

Row 12: Ch 4 (counts as dc, ch 1, here and throughout), sc in next ch-1 sp, *ch 7, skip next 4 ch-1 sps, sc in next ch-1 sp**, ch 7, sc in next ch-1 sp; rep from * across, ending last rep at **, ch 1, dc in last sc, turn—31 (35, 39, 43, 47) ch-7 sps.

Row 13: Ch 4 (counts as tr), (tr, ch 1, tr) in first dc (half shell made), *sc spike over next ch-7 sp and into center tr 2 rows below**, 7-tr shell in next ch-3 sp, rep from * across, ending last rep at **, (tr, ch 1, 2 tr) in 3rd ch of tch, turn—15 (17, 19, 21, 23) 7-tr shells; 2 half shells. Fasten off.

BOTTOM FLARE

Row 1: With RS facing, working across opposite side of foundation ch, join yarn with sl st in first ch, ch 1, sc in first ch, skip next ch, *4-dc shell in next ch-3 sp directly above 4-dc shell in Row 2 of body, skip next 2 ch, sc in next ch (ch at base of spike st from Row 2 of body); rep from * across, ending with last sc in last ch, turn—16 (18, 20, 22, 24) 4-dc shells.

Row 2: Ch 4 (counts as dc, ch 1, here and throughout), sc in next ch-1 sp

(first ch-1 sp of shell), *ch 3, skip next ch-1 sp, sc in next ch-1 sp (last ch-1 sp of shell)**, ch 3, sc in next ch-1 sp (first ch-1 sp of next shell); rep from * across, ending last rep at **, ch 1, dc in last sc, turn—31 (35, 39, 43, 47) ch-3 sps.

Rows 3–10: Rep Rows 1–8 of top flare.

Row 11: Ch 4, (tr, ch 1, tr) in first dc (half shell made), *sc spike over next ch-5 sp and into ch-1 sp 2 rows below**, 7-tr shell in next ch-5 sp, rep

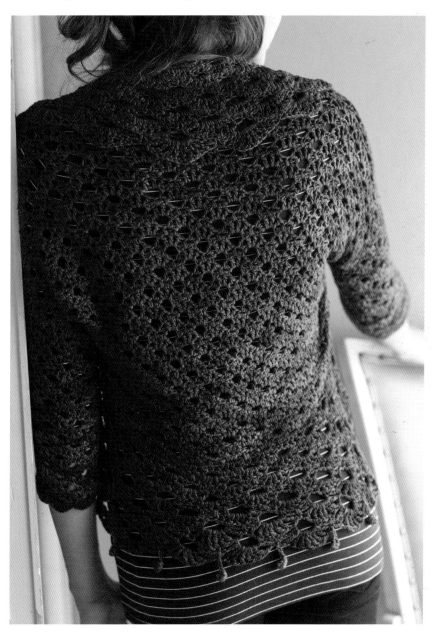

from * across, ending last rep at **, (tr, ch 1, 2 tr) in 3rd ch of tch, turn—15 (17, 19, 21, 23) 7-tr shells; 2 half shells.

Row 12: Ch 1, sc in first tr, ch 1, *sc in next ch-1 sp, ch 5, sc in next ch-1 sp**, ch 7, skip next 4 ch-1 sps, rep from * across, ending last rep at **, ch 1, sc in top of tch, turn—16 (18, 20, 22, 24) ch-5 sps; 15 (17, 19, 21, 23) ch-7 sps.

Row 13: Ch 1, sc in first sc, *7-tr shell in next ch-5 sp**, sc spike over next ch-7 sp and into center tr 2 rows below; rep from * across, ending last rep at **, sc in last sc, turn—16 (18, 20, 22, 24) 7-tr shells. Fasten off.

Assembly

Fold piece in half crosswise, with WS on outside.

NOTE: Flared ends will be at the bottom when the piece is facing you and lying flat. Last row and first row of body should meet at the sides, and the sides of the flares should match up (see diagram).

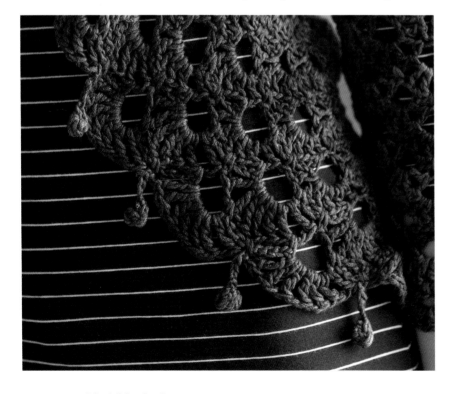

Place a marker 6½ (7, 7½, 8, 8½)" (16.5 [18, 19, 20.5, 21.5] cm) below the fold on either side and on the front and back of the body for armholes. Beg at the bottom short edge of the flare, sew the side seams to the markers.

Sleeves

Turn bolero RS out.

NOTE: If you do not want your sleeves to be snug and would rather have them open and loose, do not work decreases in any rnds.

Rnd 1: With bottom of armhole opening and side seam facing, join yarn in first sp at right of seam, ch 1, sc in same sp (PM to indicate beg of rnd), ch 3, crossing over seam skip about ⅔" (1.7 cm) from first sc, *sc in armhole edge, ch 3, skip about ⅔" (1.7 cm) from previous sc; rep from * around, working a total of 20 (20, 22, 22, 24) ch-3 sps, join with sl st in first sc—20 (20, 22, 22, 24) ch-3 sps.

Rnd 2: Ch 1, sc spike over next ch-3 sp into sp at side seam on edge of

armhole, PM in first st, *4-dc shell in next ch-3 sp, sc spike over next ch-3 into corresponding place on armhole edge, rep from * around, join with sl st in first sc—10 (10, 11, 11, 12) shells; 10 (10, 11, 11, 12) sc spikes.

Rnd 3: Sl st over to first ch-1 sp of next shell, ch 1, sc in same sp, PM in first st, *ch 3, skip next ch-1 sp, sc in last ch-1 sp of shell, ch 3**, sc in next ch-1 sp; rep from * around, ending last rep at **, join with sl st in first sc—20 (20, 22, 22, 24) ch-3 sps.

Rnd 4 (dec): Ch 1, *sc spike over next ch-3 sp into ch-1 sp 2 rnds below, PM in first st, shell in next ch-3 sp, rep from * 8 (8, 9, 9, 10) times, sc2tog over last 2 ch-3 sps, join with sl st in first sc—9 (9, 10, 10, 11) shells; 9 (9, 10, 10, 11) sc.

Rnd 5: Sl st over to first ch-1 sp of next shell, ch 1, sc in same sp, PM in first st, *ch 3, skip next ch-1 sp, sc in last ch-1 sp of shell, ch 3**, sc in next ch-1 sp; rep from * around, ending last rep at **, join with sl st in first sc—18 (18, 20, 20, 22) ch-3 sps.

Rnd 6: Ch 1, *sc-spike st over next ch-3 sp into ch-1 sp 2 rows below, PM in first st, shell in next ch-3 sp; rep from * around, join with sl st in first sc—9 (9, 10, 10, 11) shells and 9 (9, 10, 10, 11) sc spikes.

Rnd 7: Rep Rnd 5—18 (18, 20, 20, 22) ch-3 sps.

Rnd 8 (dec): Ch 1, *sc spike over next ch-3 sp into ch-1 sp 2 rnds below, PM in first st, shell in next ch-3 sp, rep from * 7 (7, 8, 8, 9) times, sc2tog over last 2 ch-3 sps, join with sl st in first sc—8 (8, 9, 9, 10) shells; 8 (8, 9, 9, 10) sc spikes.

Rnd 9: Rep Rnd 5—16 (16, 18, 18, 20) ch-3 sps.

Rnd 10: Rep Rnd 6—8 (8, 9, 9, 10) shells; 8 (8, 9, 9, 10) sc spikes.

Rnd 11: Rep Rnd 5—16 (16, 18, 18, 20) ch-3 sps.

Try bolero on before next rnd to see whether or not you need to work

remaining rnds and if you need to keep decreasing. If sleeve fits the way you like after Rnd 11, keep working same as the last 2 rnds, without decreases until Sleeve is desired length.

Rnd 12 (dec): Ch 1, *sc spike over next ch-3 sp into ch-1 sp 2 rnds below, PM in first st, shell in next ch-3 sp, rep from * 6 (6, 7, 7, 8) times, sc2tog over last 2 ch-3 sps, join with sl st in first sc—7 (7, 8, 8, 9) shells; 7 (7, 8, 8, 9) sc spikes.

NOTE: Rnd 12 will be the last dec rnd unless you desire to work sleeves to fit more snugly.

Rep Rows 5–6 until sleeve measures 12" (30.5 cm) from beginning, or for desired length. Fasten off.

Rep sleeve in other armhole.

Hanging Teardrops

There should be 32 (36, 40, 44, 48) shells around the outer flared edge. Locate sc at center top of the bolero (between 2 shells). Count 7 (8, 9, 10, 11) sc to either side of center sc. Place a marker in each of those 2 sc. Leave top 13 (15, 17, 19, 21) sc without teardrops. Starting in marked sc on left side of collar, work 1 hanging teardrop in each sc around the bottom of the bolero to the other marked sc on the right side of the collar as follows:

Hanging Teardrop: With RS facing, join yarn in first marked sc, ch 6, work (5-dc cluster, ch 1 tightly, sl st tightly) in 3rd ch from hook, cluster should appear as a ball. Fasten off. Rep hanging teardrop in each sc around the bottom of the bolero to the next marked sc.

Finishing

Weave in ends. Block if desired.

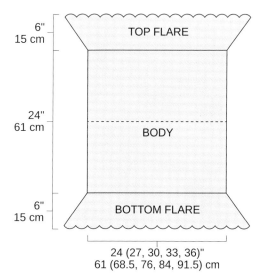

BEFORE FOLDING AND SEAMING

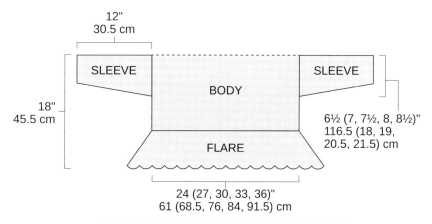

AFTER SEAMING AND ADDING SLEEVES

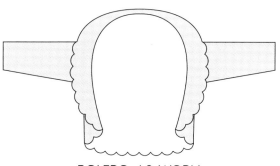

BOLERO AS WORN

Open up body to form back. Front flare folds back to form collar.

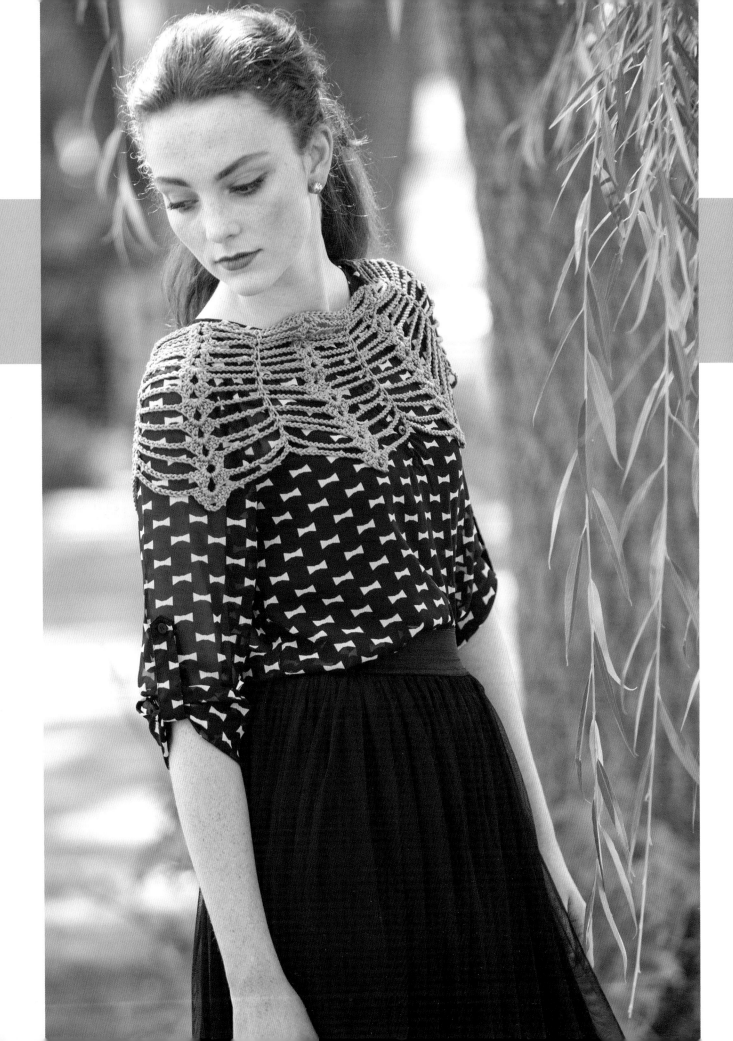

Walk in the Park
capelet

*I*f you're a beginner or like openwork that isn't too fancy, this easy capelet is for you. It looks great over a solid or even patterned top.

FINISHED SIZES
S/M (L/1X, 2X/3X). Sample shown is size S/M.

Top edge: 28 (32, 36)″ (71 [81.5, 91.5] cm) in circumference. Length: 8½″ (21.5 cm).

YARN
DK weight (#3 Light).

Shown here: Patons Grace (100% mercerized cotton; 136 yd [124 m]/1¾ oz [50 g]): #62322 viola, 2 (3, 4) skeins.

HOOK
Sizes I/9 (5.5 mm). Adjust hook size if necessary to obtain the correct gauge.

NOTIONS
Stitch markers; yarn needle.

GAUGE
16 sc in Row 1 and one pattern rep in Row 2 = 4″ (10 cm). Rnds 2–7 (6 rows of 2-dc shells) = 4″ (10 cm).

STITCH GUIDE

**Two Double Crochet Shell
(2-dc shell):** (2 dc, ch 2, 2 dc)
in same st or sp.

**Treble Double Crochet Shell
(3-dc shell):** (3 dc, ch 2, 3 dc)
in same sp.

**Four Double Crochet Shell
(4-dc shell):** (4 dc, ch 3, 4 dc)
in same sp.

Capelet

Ch 96 (112, 128), join into a ring with sl
st in first ch.

Rnd 1 (RS): Ch 1, sc in each ch
around, join with sl st in first sc,
turn—96 (112, 128) sc.

Rnd 2: Ch 1, sc in first sc, *ch 7, skip
next 7 sc, 2-dc shell in next sc, ch 7, skip
next 7 sc**, sc in next sc, rep from *
around, ending last rep at **, join with
sl st in first sc, turn—6 (7, 8) shells.

Rnd 3: Ch 1, sc in first sc, *ch 7, skip
next ch-7 sp, 2-dc shell in next shell,
ch 7, skip next ch-7 sp**, sc in next sc,
rep from * around, ending last rep at
**, join with sl st in first sc, turn.

Rnd 4: Rep Rnd 3.

Rnds 5–7: Ch 1, sc in first sc, *ch 8,
skip next ch-7 sp, 2-dc shell in next
shell, ch 8, skip next ch-7 sp**, sc in
next sc, rep from * around, ending
last rep at **, join with sl st in first
sc, turn.

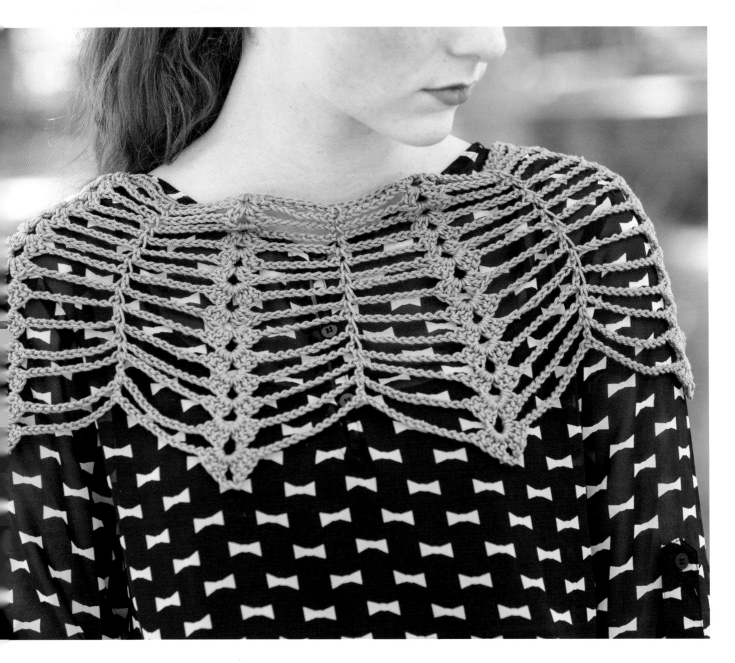

STITCH KEY

- ◯ = chain (ch)
- • = slip st (sl st)
- ✝ = single crochet (sc)
- ⊤ = double crochet (dc)
- ⟨shell⟩ = 2-dc shell
- ⟨shell⟩ = 3-dc shell
- ⟨shell⟩ = 4-dc shell

Rnds 8–9: Ch 1, sc in first sc, *ch 9, skip ch-8 sp, 3-dc shell in next shell, ch 9, skip ch-8 sp**, sc in next sc, rep from * across, rep from * around, ending last rep at **, join with sl st in first sc, turn.

Rnd 10: Ch 1, sc in first sc, *ch 9, skip ch-9 sp, 3-dc shell in next shell, ch 9, skip ch-9 sp**, sc in next sc, rep from * around, ending last rep at **, join with sl st in first sc, turn—6 (7, 8) sc; 6 (7, 8) shells.

Rnds 11–13: *Ch 10, skip next ch-9 sp, 3-dc shell in next shell, ch 10**, skip next ch-9 sp, sc in next sc, rep from * around, ending last rep at **, join with sl st in first sc.

Rnds 14–15: *Ch 12, skip next ch-sp, 4-dc shell in next shell, ch 12, skip next ch-sp**, sc in next sc, rep from * rep from * around, ending last rep at **, join with sl st in first sc. Fasten off.

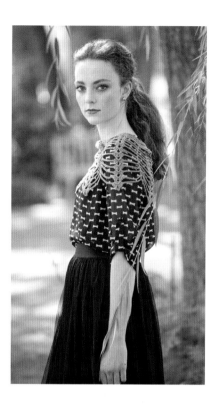

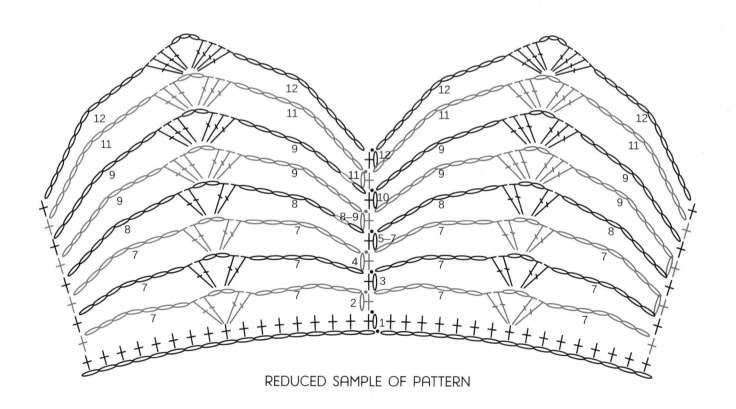

REDUCED SAMPLE OF PATTERN

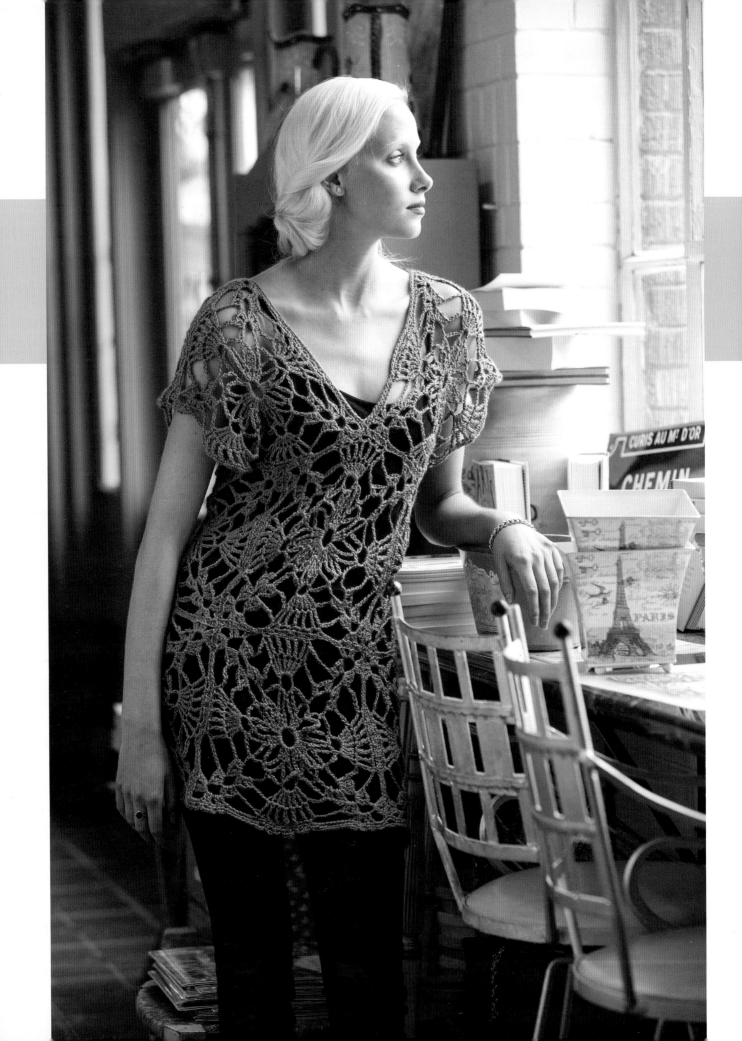

Magnifique
modular tunic

FINISHED SIZES
XS (S, M, L/1X, 2X/3X).
Sample shown is size S.

Bust: 34 (36, 38, 42, 57)″ (86.5 [91.5, 96.5, 106.5, 145] cm).

Length: 25½ (27, 28½, 31½, 38)″ (65 [68.5, 72.5, 80, 96.5] cm).

YARN
DK weight (#3 Light).

Shown here: Caron Simply Soft Light (100% acrylic; 330 yd [302 m]/3 oz [85 g]): #0008 riviera, 3 (3, 4, 5, 5) skeins.

HOOKS
Size H/8 (5 mm) for size XS.

Size I/9 (5.5 mm) for size S.

Size J/10 (6 mm) for sizes M and 2X/3X.

Size L/11 (8 mm) for size L/1X.

Adjust hook size if necessary to obtain the correct gauge.

NOTIONS
Stitch markers; yarn needle.

GAUGE
Size XS: 1 square = 8½″ (21.5 cm)

Sizes S: 1 square = 9″ (23 cm)

Sizes M and 2X/3X: 1 square = 9½″ (24 cm)

Size L/1X: 1 square = 10½″ (26.5 cm)

This clever design is made up of lacy squares you can crochet on the go and then sew together. Depending on how many squares you stitch and how you arrange them, you can create a sleeveless tunic, a shorter top, a longer beach tunic, a sleeved tunic, or even a poncho!

NOTES

Tunic is created by sewing squares together. See diagrams.

Square (MAKE 12 [12, 12, 12, 22])

Ch 10, sl st to first ch to form a ring. Do not turn rnds.

Row 1: (RS) Ch 3 (counts as dc here and throughout), 2 dc in ring, [ch 9, 3 dc] 7 times in ring, ch 4, dtr in top of beg ch-3—24 dc.

Row 2: Ch 1, sc around post of dtr, *ch 6, skip next dc, sc in next dc, ch 6, sc in next ch-9 sp; rep from * around, join with sl st in first sc—16 ch-6 sps.

Row 3: Sl st in next ch-6 sp, ch 1, sc in same ch-6 sp, *(ch 5, sc) in each of next 2 ch-6 sp, ch 11, sc in next ch-6 sp, ch 5**, sc in next ch-6 sp, rep from * around, ending last rep

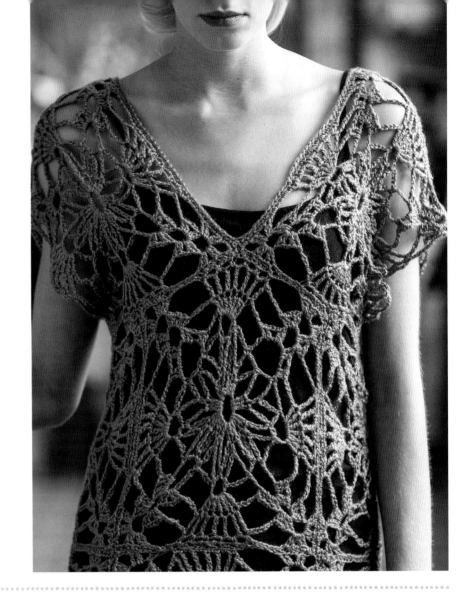

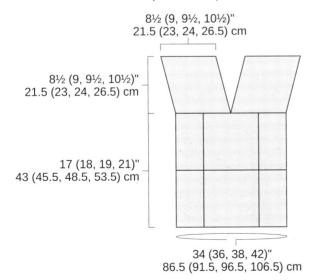

SIZES XS–L/1X
Requires 12 squares

8½ (9, 9½, 10½)"
21.5 (23, 24, 26.5) cm

8½ (9, 9½, 10½)"
21.5 (23, 24, 26.5) cm

17 (18, 19, 21)"
43 (45.5, 48.5, 53.5) cm

34 (36, 38, 42)"
86.5 (91.5, 96.5, 106.5) cm

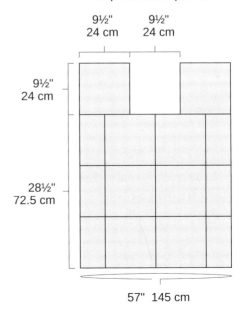

SIZE 2X/3X VARIATION
Requires 22 squares

9½"
24 cm 9½"
24 cm

9½"
24 cm

28½"
72.5 cm

57" 145 cm

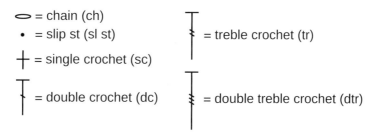

◯ = chain (ch)

• = slip st (sl st)

╀ = single crochet (sc)

╤ = treble crochet (tr)

╁ = double crochet (dc)

╪ = double treble crochet (dtr)

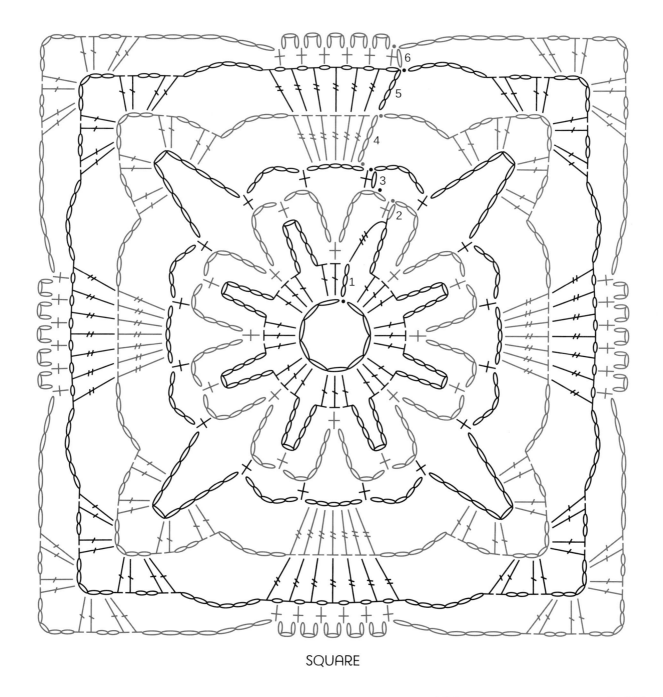

SQUARE

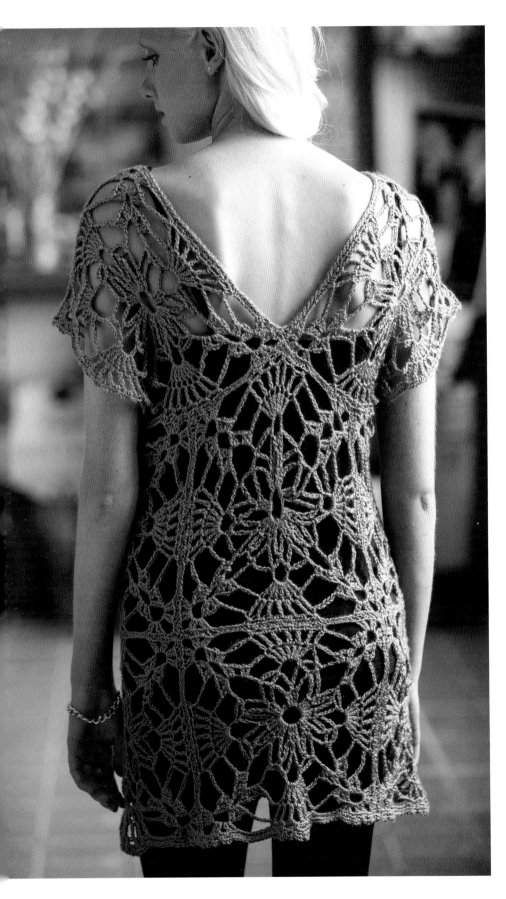

at **, join with sl st in first sc—4 ch-11 sps; 12 ch-5 sps.

Row 4: Sl st in next ch-5 lp (center lp of the 3 ch-5 lps on first side), ch 4 (counts as tr), 6 tr in same ch-5 lp, *ch 5, (2 dc, ch 2, 2 dc, ch 5, 2 dc, ch 2, 2 dc) in next ch-11 sp, ch 5, skip next ch-5 sp and next ch-2 sp **, 7 tr in next ch-5 sp; rep from * around, ending last rep at **, join with sl st in top of beg ch-4.

Row 5: Ch 5 (counts as tr, ch 1), *(tr, ch 1) in each of next 5 tr, tr in next tr, ch 6, skip next ch-5 sp and next ch-2 sp**, (2 dc, ch 2, 2 dc, ch 5, 2 dc, ch 2, 2 dc) in next ch-5 sp, ch 6; rep from * around, ending last rep at **, join with sl st in 4th ch of beg ch-5.

Row 6: Ch 1, starting in same sp, *(sc, ch 3), in each of first 5 ch-1 sps, sc in next ch-1 sp, ch 7, skip next ch-6 sp and next ch-2 sp, (2 dc, ch 2, 2 dc, ch 5, 2 dc, ch 2, 2 dc) in next ch-5 sp, ch 7; rep from * around, join with sl st in first sc. Fasten off.

Finishing

SEAMS
With RS tog, match up the stitches. Using a needle and yarn, sew the squares tog following the diagram.

EDGING
Place a marker at each end of each fan and at the beg of each shell section at each corner of each Square round.

Rnd 1: With RS facing and using an H/8 (5 mm) hook, join yarn to any st on bottom edge, ch 1, *sc evenly across to next marker, work 17 sc evenly spaced across to next marker; rep from * around, join with sl st in first sc. Move markers up to corresponding sc's.

Rnd 2: Ch 1, *sc in each sc across to next marker, sc in next sc, (ch 3, skip next sc, sc in next sc) 8 times across to next marker; rep from * around, join with sl st in first sc. Fasten off.

NECK EDGING
Rnd 1: With RS facing and using an H/8 (5 mm) hook, join yarn to any st on the neck edge, ch 1, sc evenly around the edge, decreasing with sc2tog or skipping sts if needed to tighten the neck edge and to keep the sleeves from falling off the shoulders. Fasten off. Weave in the ends. Block as needed.

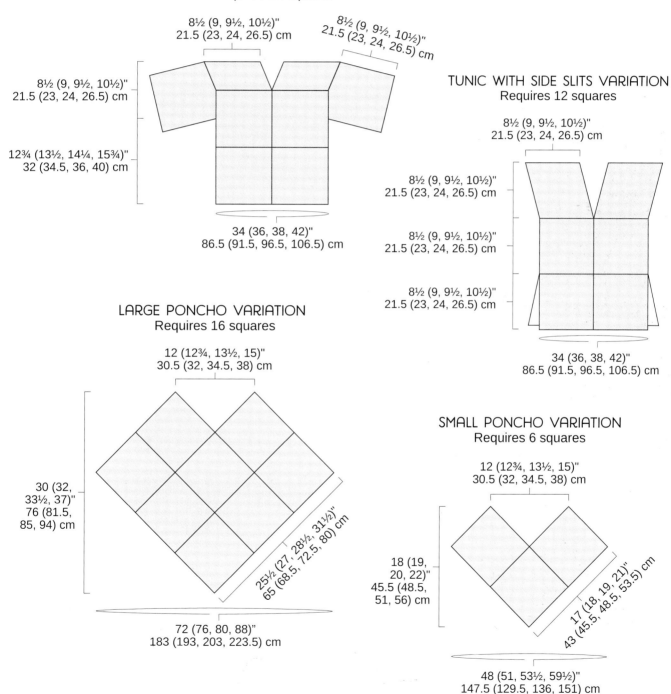

TUNIC WITH SLEEVES VARIATION
Requires 14 squares

8½ (9, 9½, 10½)"
21.5 (23, 24, 26.5) cm

8½ (9, 9½, 10½)"
21.5 (23, 24, 26.5) cm

8½ (9, 9½, 10½)"
21.5 (23, 24, 26.5) cm

12¾ (13½, 14¼, 15¾)"
32 (34.5, 36, 40) cm

34 (36, 38, 42)"
86.5 (91.5, 96.5, 106.5) cm

TUNIC WITH SIDE SLITS VARIATION
Requires 12 squares

8½ (9, 9½, 10½)"
21.5 (23, 24, 26.5) cm

8½ (9, 9½, 10½)"
21.5 (23, 24, 26.5) cm

8½ (9, 9½, 10½)"
21.5 (23, 24, 26.5) cm

8½ (9, 9½, 10½)"
21.5 (23, 24, 26.5) cm

34 (36, 38, 42)"
86.5 (91.5, 96.5, 106.5) cm

LARGE PONCHO VARIATION
Requires 16 squares

12 (12¾, 13½, 15)"
30.5 (32, 34.5, 38) cm

30 (32, 33½, 37)"
76 (81.5, 85, 94) cm

25½ (27, 28½, 31½)"
65 (68.5, 72.5, 80) cm

72 (76, 80, 88)"
183 (193, 203, 223.5) cm

SMALL PONCHO VARIATION
Requires 6 squares

12 (12¾, 13½, 15)"
30.5 (32, 34.5, 38) cm

18 (19, 20, 22)"
45.5 (48.5, 51, 56) cm

17 (18, 19, 21)"
43 (45.5, 48.5, 53.5) cm

48 (51, 53½, 59½)"
147.5 (129.5, 136, 151) cm

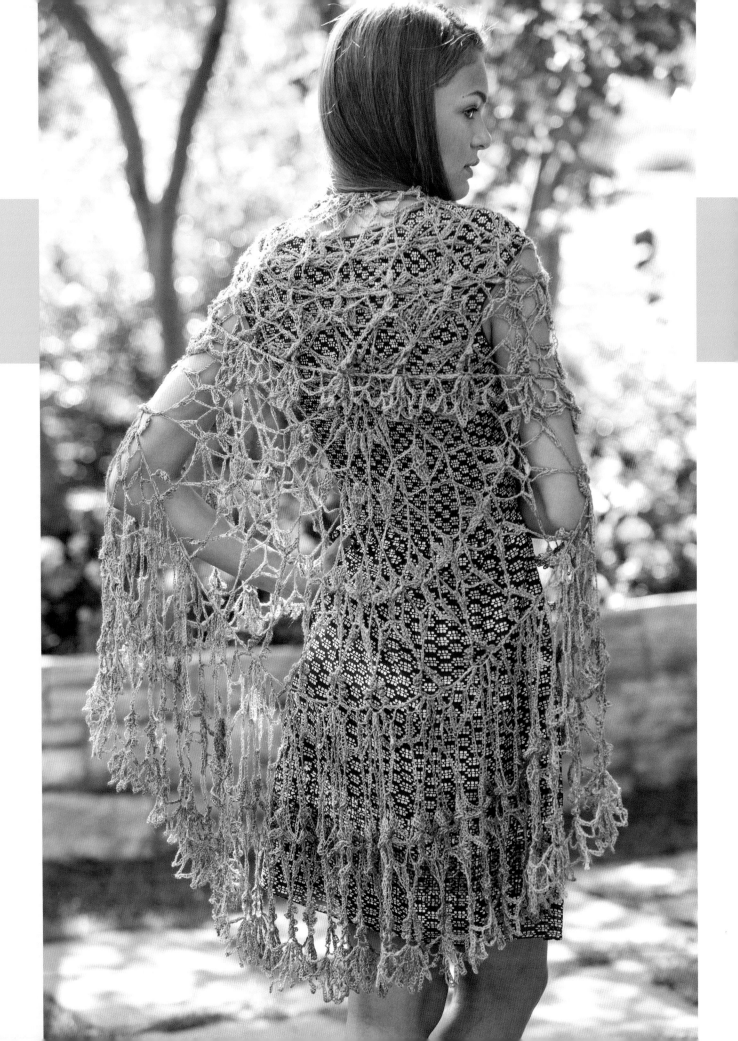

Parisian Gardens
circular shawl

···

FINISHED SIZE
55″ (140 cm) in diameter.

YARN
Laceweight (#0).

Shown here: Malabrigo Silk-
paca Lace (70% baby alpaca,
30% silk; 420 yd [384 m]/1¾
oz [50 g]): #809 solis, 3 hanks.

HOOK
Size G/6 (4mm). Adjust hook
size if necessary to obtain the
correct gauge.

NOTIONS
Yarn needle; stitch markers.

GAUGE
Rnds 1–2 = 3″ (7.5 cm) in
diameter.

*U*sing a laceweight yarn creates a light-as-a-feather shawl, and the very open stitch pattern makes it a surprisingly quick project. To increase your options, you can wear the shawl as a scarf or even a cowl!

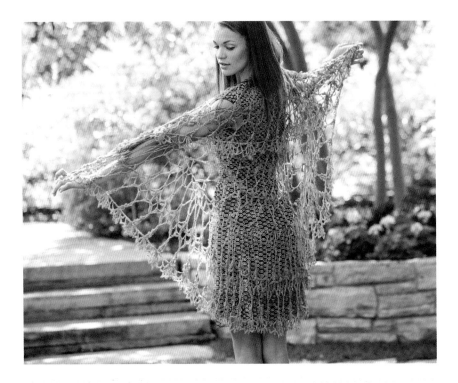

STITCH GUIDE

2 treble cluster (2-tr cl): [Yo (2 times), insert hook in next st, yo, draw yarn through st, (yo, draw yarn through 2 lps on hook) 2 times] twice in same st, yo, draw yarn through 3 lps on hook.

2 double treble cluster (2-dtr cl): [Yo (3 times), insert hook in next st, yo, draw yarn through st, (yo, draw yarn through 2 lps on hook) 3 times] twice in same st, yo, draw yarn through 3 lps on hook.

3 double treble cluster (3-dtr cl): [Yo (3 times), insert hook in next st, yo, draw yarn through st, (yo, draw yarn through 2 lps on hook) 3 times] 3 times in same st, yo, draw yarn through 4 lps on hook.

Double treble 4 together (dtr4tog): [Yo (3 times), insert hook in next st, yo, draw yarn through st, (yo, draw yarn through 2 lps on hook) 3 times] 4 times, yo, draw yarn through 5 lps on hook.

Partial double treble crochet (partial dtr): Yo (3 times), insert hook in designated st, yo, draw yarn through st, (yo, draw yarn through 2 lps on hook) 3 times (2 lps rem on hook).

Double treble 8 together (dtr8tog): Work 2 partial dtr in 6th ch from hook (3 lps rem on hook), skip designated number of sts, work partial dtr in each of next 3 ch (6 lps rem on hook), skip designated number of sts, work partial dtr in each of next 3 ch (9 lps rem on hook), yo, draw yarn through 9 lps on hook.

Triple treble crochet (tr tr): Yo (4 times), insert hook in next st, yo, draw yarn through st, yo, [draw through 2 lps on hook] 5 times.

Quadruple treble crochet (quad tr): Yo (5 times), insert hook in next st, yo, draw yarn through st, yo, [draw through 2 lps on hook] 6 times.

Shawl

Ch 2, sl st in 2nd ch from hook forming a ring.

Rnd 1: Ch 5 (counts as tr, ch 1), (tr, ch 1) 11 times in ring, sl st in 4th ch of beg ch-5—12 tr; 12 ch-1 sps.

Rnd 2: Sl st in next ch-1 sp, ch 4, tr in first ch-1 sp (counts as 2-tr cl), (2-tr cl, ch 3) in each ch-1 sp around, join with sl st in tr-cl—12 ch-3 sps.

Rnd 3: Sl st over to first ch-3 sp, ch 5, dtr in same sp (counts as 2-dtr cl), ch 5, sl st in same sp, ch 5, 2-dtr cl in same sp, ch 10, *(2 dtr-cl, ch 5, sl st, ch 5, 2 dtr-cl) in next ch-3 sp, ch 10, rep from * around, join with sl st to top of beg 2-dtr cl—24 clusters; 12 ch-10 sps.

Rnd 4: Ch 1, turn, sl st to center of first ch-10 sp, turn, *ch 14, (sl st, ch 10, sl st) in 5th ch of next ch-10, rep from * around, ending with sl st in first sl st—12 ch-14 sps; 12 ch-10 sps.

Rnd 5: Ch 11 (counts as dc, ch 8), *4 dtr in 7th ch of next ch-14 sp, ch 8**, dc in 5th ch of next ch-10 sp, ch 8; rep from * around, ending last rep at **, sl st to 3rd ch of beg ch-11—12 4-dtr groups, 24 ch-8 lps.

NOTES

This pattern requires stitches that are very long, but if you have never worked any stitch longer than a triple crochet, you'll soon find that it's the long stitches that make the open lace work up quickly. Gauge and yarn weight is not as important as it is with any other wearable crochet. If you prefer a much smaller shawl, all you have to do is use a smaller hook.

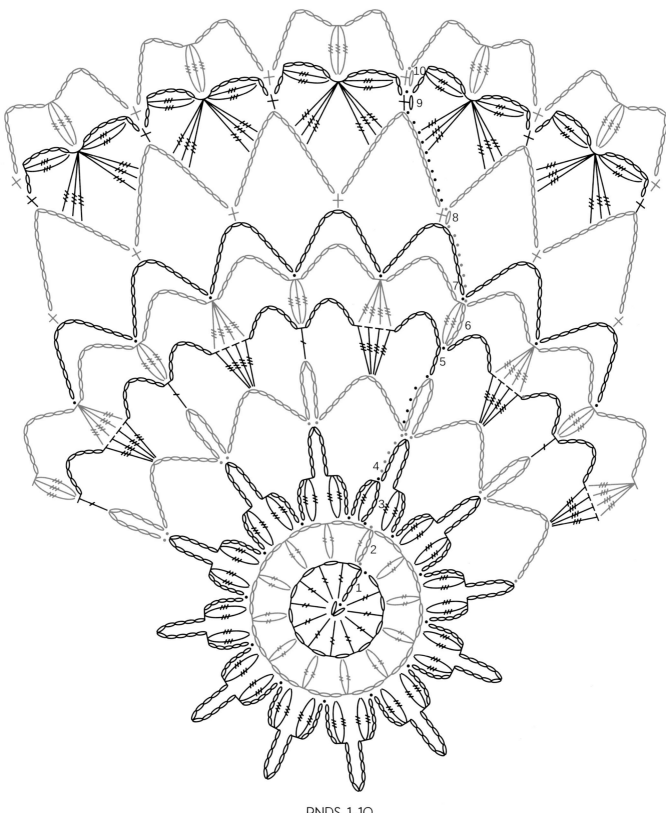

RNDS 1–10
(See stitch key on page 138.)

STITCH KEY

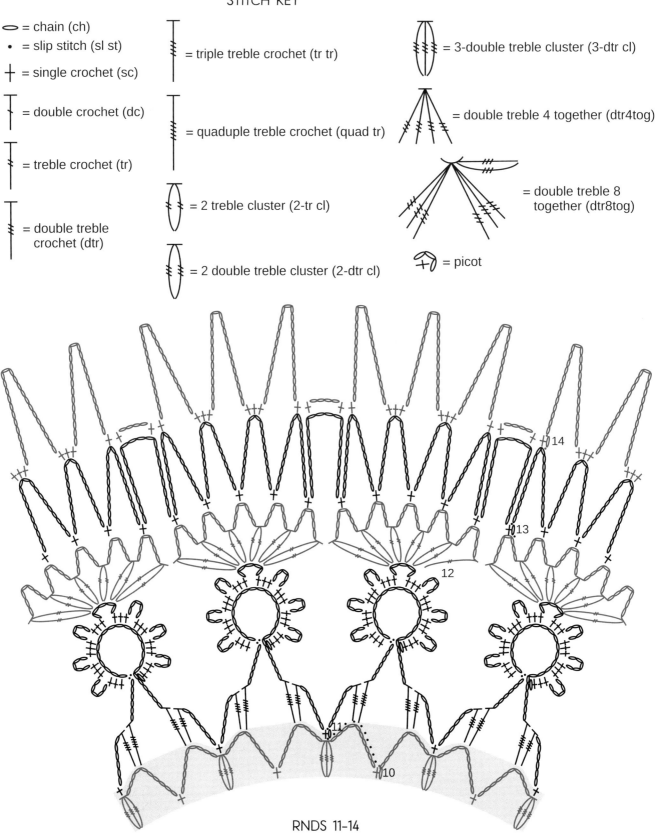

⬭ = chain (ch)

• = slip stitch (sl st)

✛ = single crochet (sc)

╪ = double crochet (dc)

╪ = treble crochet (tr)

╪ = double treble crochet (dtr)

╪ = triple treble crochet (tr tr)

╪ = quaduple treble crochet (quad tr)

⬭ = 2 treble cluster (2-tr cl)

⬭ = 2 double treble cluster (2-dtr cl)

= 3-double treble cluster (3-dtr cl)

= double treble 4 together (dtr4tog)

= double treble 8 together (dtr8tog)

= picot

RNDS 11–14

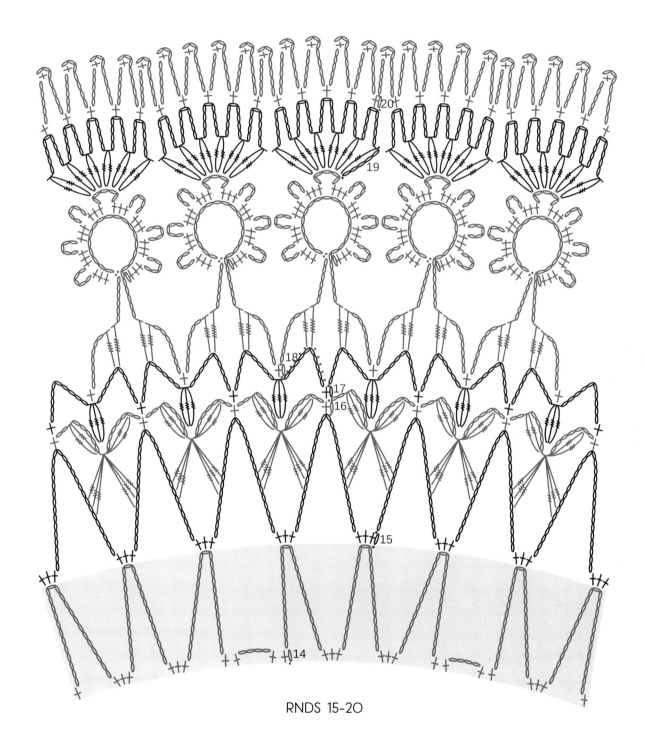

RNDS 15-20

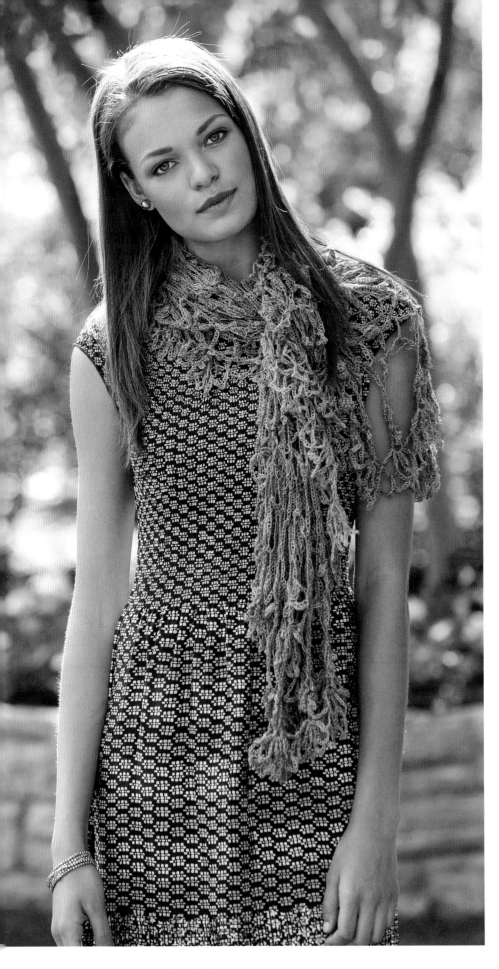

Rnd 6: Ch 5, 2-dtr cl in same sp (counts as 3-dtr cl), *ch 10, skip next ch-8 lp, dtr4tog over next 4 dtr, ch 10, skip next ch-8 lp**, 3-dtr cl in next dc; rep from * around, ending last rep at **, join with sl st in top of beg 3-dtr cl—24 ch-10 lps.

Rnd 7: *Ch 15, skip next ch-10 lp, sl st in top of next cl; rep from * around, ending with sl st in top of first cl—24 ch-15 lps.

Rnd 8: Sl st to center ch of first ch-15 sp, ch 1, sc in same ch, ch 20, *sc in center ch of next ch-15 lp, ch 20; rep from * around, join with sl st in first sc—24 ch-20 lps.

Rnd 9: Sl st to 10th ch of first ch-20 lp, ch 1, sc in same ch, *ch 7, work 2 partial dtr in 6th ch from hook, skip next 3 ch, work partial dtr each of next 3 ch, skip next 5 ch of next ch-20 lp, work partial dtr in each of next 3 ch, yo, draw yarn through 9 lps on hook (dtr8tog made), ch 5, 2-dtr cl in top of last cl, ch 2**, sc in 10th ch of next ch-20 lp; rep from * around, ending last rep at **, join with sl st in first sc—24 dtr8tog.

Rnd 10: Ch 1, sc in first sc, *ch 10, 3-dtr cl in next dtr8tog, ch 10**, sc in next sc; rep from * around, join with sl st in first sc—48 ch-10 lps.

Rnd 11: Sl st in each st to next cl, ch 1, sc in first cl, *ch 7, (tr tr, quad tr) in next ch-10 lp, ch 25, sl st in 20th ch from hook (ring formed), ch 1, turn so that ring is to your left, (3 sc, [ch 5, 3 sc] 7 times) in ring, sl st in first sl st, ch 6, (quad tr, tr tr) in next ch-10 lp, ch 7**, sc in top of next cl; rep from * around, join with sl st in first sc—24 oval rings with 7 ch-5 sps in each oval ring. Fasten off.

Rnd 12: With RS facing, join yarn with sl st in center ch-5 sp on any oval ring, ch 5, tr in 5th ch from hook (counts as 2-tr cl), [ch 7, 2 tr-cl] 5 times in same ch-5 sp (first fan made), *(2-tr cl, [ch 7, 2 tr-cl] 5 times

in next ch-5 sp (fan made), rep from * around, join with sl st in top of first 2-tr cl—24 fans; 120 ch-7 lps. Fasten off.

Rnd 13: With RS facing, join yarn with sl st in last ch-7 lp of any fan, ch 1, sc in same lp, ch 20, (sc, ch 20) in each ch-7 lp around, join with sl st in first sc—120 ch-20 lps. Fasten off.

Rnd 14: With RS facing, join yarn with sl st in last ch-20 lp, sc in same sp, *(sc, ch 4, sc) in next ch-20 lp, sc in next ch-20 lp, (ch 25, 3 sc) in each of next 2 ch-20 lps, ch 25**, sc in next ch-20 lp, rep from * around, ending last rep at **, join with sl st in first sc—72 ch-25 lps; 24 ch-4 sps. Fasten off.

Rnd 15: With RS facing, join yarn with sl st in center of any ch-25 lp, ch 1, (3 sc, ch 30) in each ch-5 lp around, join with sl st in first sc—72 ch-30 lps. Fasten off.

Rnd 16: With RS facing, join yarn with sl st in 15th ch of any ch-30

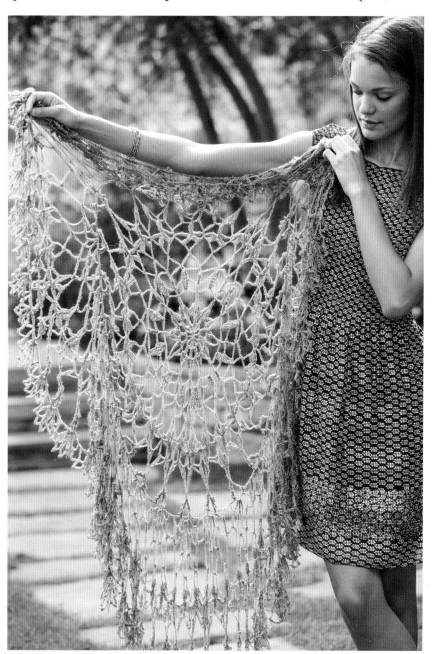

lp, ch 1, sc in same ch, *ch 7, work 2 partial dtr in 6th ch from hook, skip next 7 ch, work partial dtr each of next 3 ch, skip next 5 ch of next ch-30 lp, work partial dtr in each of next 3 ch, yo, draw yarn through 9 lps on hook (dtr8tog made), ch 5, 2-dtr cl in top of last cl, ch 2**, sc in 15th ch of next ch-30 lp; rep from * around, ending last rep at **, join with sl st in first sc—72 dtr8tog.

Rnd 17: Ch 1, sc in first sc, *ch 10, 3-dtr cl in next dtr8tog, ch 10**, sc in next sc; rep from * around, ending last rep at **, join with sl st in first sc—72 ch-10 lps.

Rnd 18: Sl st in each st to next cl, ch 1, sc in first cl, *ch 7, (tr tr, quad tr) in next ch-10 lp, ch 25, sl st in 20th ch from hook (ring formed), ch 1, turn so that ring is to your left, (3 sc, [ch 5, 3 sc] 7 times) in ring, sl st in first sl st, ch 6, (quad tr, tr tr) in next ch-10 lp, ch 7**, sc in top of next cl; rep from * around, join with sl st in first sc—72 oval rings with 7 ch-5 sps in each oval ring. Fasten off.

Rnd 19: With RS facing, join yarn with sl st in center ch-5 sp on any oval ring, ch 5, tr in 5th ch from hook (counts as 2-tr cl), [ch 9, 2 tr-cl] 5 times in same ch-5 sp (first fan made), *(2-tr cl, [ch 9, 2 tr-cl] 5 times in next ch-5 sp, rep from * around, join with sl st in top of first 2-tr cl—72 fans; 120 ch-7 lps. Fasten off.

Rnd 20: Sl st to center of first ch-7 lp, sc in center of ch-7 lp, *ch 4, picot, ch 5**, sc in next ch-7 lp; rep from * around, ending last rep at **, join with sl st in first sc. Fasten off.

Finishing

Weave in ends and block the shawl, pinning out the points.

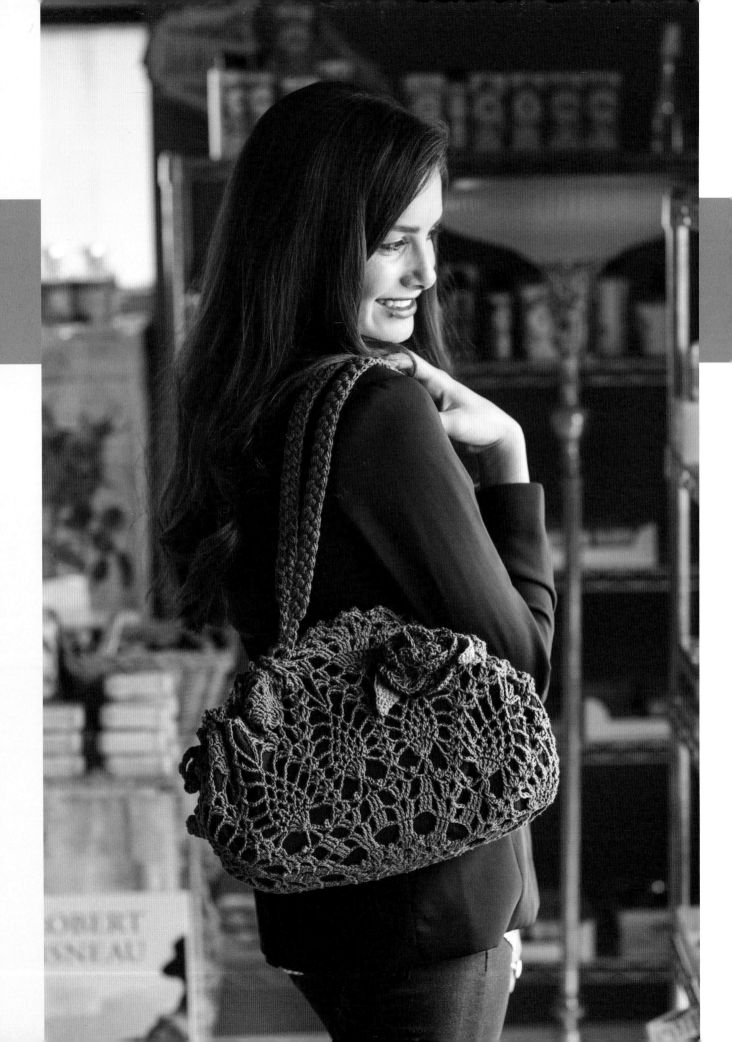

FINISHED SIZES
13″ (33 cm) wide x 9″ (23 cm) tall, excluding handles.

Handles: 12″ (30.5 cm) from top of bag.

Note: To make a larger bag, use a thicker yarn and larger hook.

YARN
Sportweight (#2 Fine).

Shown here: SMC Catania Sport (100% cotton; 137 yd [125 m]/1¾ oz [50 g]): #240 hyacinth (A), 3 skeins.

Laceweight (#0 Lace).

Shown here: DMC Senso Wool Cotton Crochet Thread (for leaf) (70% cotton, 30% wool; 100 yd [91 m]: color #1304 green (B), 1 ball.

HOOK
Size E/4 (3.5 mm). Adjust hook size if necessary to obtain the correct gauge.

NOTIONS
1½ yd (1.4 m) fabric for lining (optional). Sample uses ¾ yd (.7 m) each of 2 different fabrics—a printed fabric for the inside lining and a solid-color fabric to show through the front of the bag. (See Tip on page 144.)

¾ yd (.7 m) stabilizer (optional), such as Pellon or Peltex, depending on how stiff you want the bag to be. Fusible is best because you can adhere it to the fabric with an iron.

Sewing needle; matching sewing thread; large snap for closure; stitch markers; yarn needle.

GAUGE
First 3 rnds = 3″ (7.5 cm) in diameter.

Doily = 22″ (56 cm) in diameter, lying flat (before blocking).

La Fleur
doily bag

This feminine lace bag will surely be a conversation piece everywhere you go. Just a warning though—your friends may request one for themselves! It looks more difficult than it really is and is a fun project. If you prefer a larger bag, use a worsted-weight yarn and a larger hook; for a smaller bag, try a thinner yarn or thread and a smaller hook.

Doily

Begins at center of doily (bottom of bag).

With A, ch 8, join with sl st to form a ring

Row 1: (RS) Ch 3 (counts as dc here and throughout), 23 dc in ring, sl st to first dc—24 dc.

Row 2: Ch 4 (counts as dc, ch 1), (dc, ch 1) in each dc around, join with sl st in 4th ch of beg ch-4—24 ch-1 sps.

Row 3: Sl st in next ch-1 sp, ch 3 (counts as dc here and throughout), 2 dc in same ch-1 sp, ch 2, skip next ch-1 sp, *3 dc in next ch-1 sp, ch 2, skip next ch-1 sp, rep from * around, join with sl st in top of beg ch-3—36 dc; 12 ch-2 sps.

Row 4: Sl st in next dc, ch 3, (dc, ch 2, 2 dc) in same sp, *ch 1, (2 dc, ch 2, 2 dc) in center dc of next 3-dc group; rep from * around, sc in top of beg ch-3—12 shells.

Rnd 5: Ch 4 (counts as tr here and throughout), 2 tr in same sp, *ch 3, (sc, picot, sc) in next ch-2 sp, ch 3**, 3 tr in next ch-1 sp; rep from * around, ending last rep at **, join with sl st in top of beg ch-4—36 tr.

Rnd 6: Ch 4, tr in each of next 2 tr, ch 7, *tr in each of next 3 tr, ch 7; rep from * around, join with sl st in top of beg ch-4—36 tr and 12 ch-7 sps.

Rnd 7: Ch 4, *(tr, ch 3, tr) in next tr, tr in next tr, ch 2, skip next 3 chs, tr in

NOTES

You will work a flat doily first, which will be lined with fabric and stabilizer. A long crochet cord will be woven through the top side edges to form handles in the center, as well as gathering the side edges. If you prefer a handbag, just shorten your handle cords.

TIP

As an alternative to using 2 pieces of fabric and stabilizer in between, you can use one piece of quilted fabric with a different design on each side of the bag. Cut one circle, sew double-sided bias tape around the edge, and sew it to the doily.

STITCH KEY

◯ = chain (ch)

• = slip st (sl st)

+ = single crochet (sc)

T = half double crochet (hdc)

† = double crochet (dc)

‡ = half treble crochet (htr)

‡ = treble crochet (tr)

‡ = half double treble crochet (hdtr)

‡ = double treble crochet (dtr)

= beginning shell (beg shell)

= shell

= small puff stitch (sm puff st)

= large puff stitch (lg puff st)

= picot

⌢ = worked in back lp only (blo)

STITCH GUIDE

Picot: Ch 3, sl st in 3rd ch from hook.

Beginning Shell (beg shell): Ch 3, (dc, ch 3, 2 dc) in same sp.

Shell: (2 dc, ch 3, 2 dc) in same sp.

Small puff stitch (sm puff st): [Yo, insert hook in next st or sp, yo, draw yarn through] twice, yo, draw yarn through 5 lps on hook.

Large puff stitch (lg puff st): [Yo, insert hook in next st or sp, yo, draw yarn through] 3 times, yo, draw yarn through 7 lps on hook.

Half double treble (hdtr): Yo 3 times, insert hook in next st, yo and draw up a lp (5 lps on hook), yo and draw through 2 lps on hook (4 lps on hook), yo and draw through 2 lps on hook (3 lps on hook), yo and draw through all 3 lps on hook.

Half treble crochet (htr): Yo (twice), insert hook in designated st, yo, draw yarn through st, yo, draw yarn through 2 lps on hook (3 lps on hook), yo, draw yarn through all 3 loops on hook.

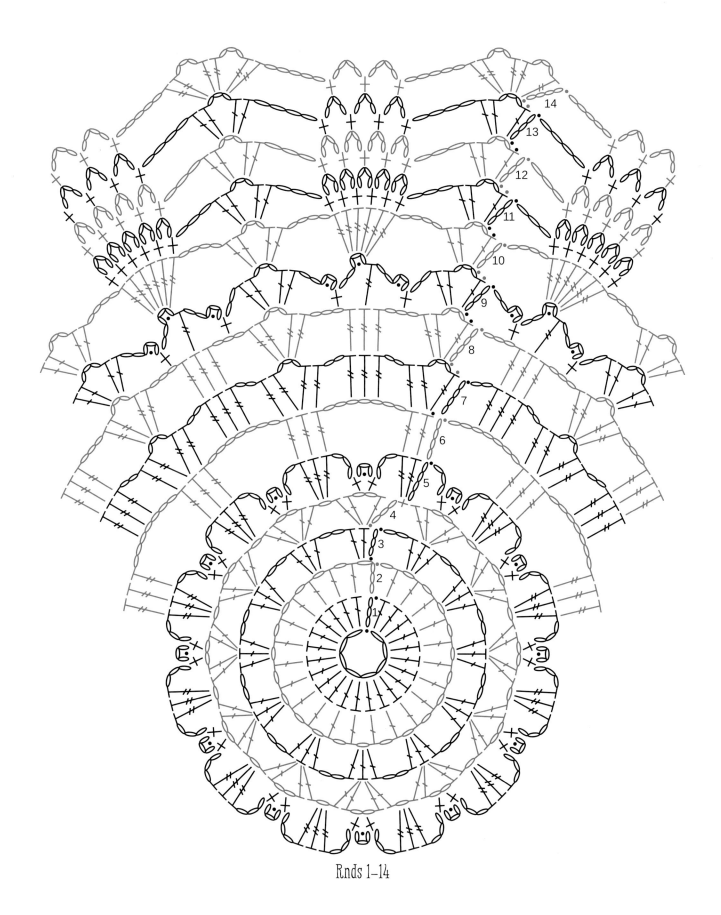

Rnds 1–14

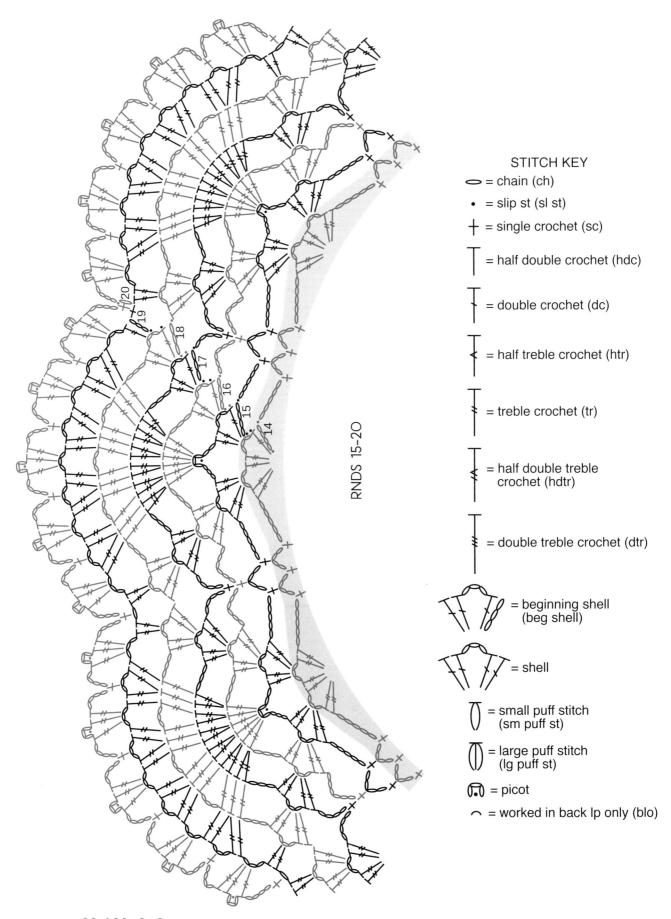

RNDS 15–20

STITCH KEY

◯ = chain (ch)

• = slip st (sl st)

+ = single crochet (sc)

⊤ = half double crochet (hdc)

⊤ = double crochet (dc)

⊰ = half treble crochet (htr)

⧧ = treble crochet (tr)

⧧ = half double treble crochet (hdtr)

⧧ = double treble crochet (dtr)

⋀ = beginning shell (beg shell)

⋀ = shell

⬭ = small puff stitch (sm puff st)

⬭ = large puff stitch (lg puff st)

⬭ = picot

⌒ = worked in back lp only (blo)

each of next 3 ch, ch 2**, tr in next tr; rep from * around, ending last rep at **, join with sl st in top of beg ch-4.

Rnd 8: Sl st in next tr and next ch-3 sp, ch 4, (tr, ch 3, 2 tr) in same sp, *ch 3, skip next ch-2 sp, tr in each of next 3 tr, ch 3, skip next ch-2 sp**, (2 tr, ch 3, 2 tr) in next ch-3; rep from * around, ending last rep at **, join with sl st in top of beg ch-4.

Rnd 9: Sl st in next tr and in next ch-3 sp, beg shell in same sp, *ch 2, sc in next ch 3-sp, picot, ch 2, skip next tr, tr in next tr, picot, ch 2, sc in next ch-3 sp, picot, ch 2**, shell in next ch-3 sp; rep from * around, ending last rep at **, join with sl st in top of beg ch-3.

Rnd 10: Sl st in next dc and next ch-3 sp, beg shell in same sp, *ch 4, skip next picot, 6 tr in next picot, ch 4**, shell in next ch-3 sp; rep from

* around, ending last rep at **, join with sl st in top of beg ch-3.

Rnd 11: Sl st in next dc and ch-3 sp, beg shell in same sp, *ch 3, skip next ch-4 sp, sc in next tr, (ch 4, sc) in each of next 5 tr, ch 3, skip next ch 4 sp**, shell in next ch-3 sp; rep from * around, ending last rep at **, join with sl st in top of beg ch-3.

Rnd 12: Sl st in next dc and ch-3 sp, beg shell in same sp, *ch 3, skip next ch-3 sp, sc in next ch-4 sp, (ch 4, sc) in each of next 4 tr, ch 3, skip next ch-3 sp**, shell in next ch-3 sp; rep from * around, ending last rep at **, join with sl st in top of beg ch-3.

Rnd 13: Sl st in next dc and ch-3 sp, beg shell in same sp, *ch 4, skip next ch-3 sp, sc in next ch-4 sp, (ch 4, sc) in each of next 3 ch-4 sps, ch 4, skip next ch-3 sp**, shell in next ch-3 sp; rep

from * around, ending last rep at **, join with sl st in top of beg ch-3.

Rnd 14: Sl st in next dc and ch-3 sp, ch 4, tr, ch 3 in same sp, (2 tr, ch 3, 2 tr) in same sp (6 tr total in same sp), * ch 5, skip next ch-4 sp, sc in next ch-4 sp, (ch 4, sc in next ch-4 sp) twice, ch 5, skip next ch-4 sp, (2 tr, ch 3, 2 tr, ch 3, 2 tr) in next ch-3 sp of dc-sh; rep from * around, ending last rep at **, join with sl st in top of beg ch-4.

Rnd 15: Sl st in next tr and next ch-3 sp, ch 4, (tr, ch 3, 2 tr) in same sp, *ch 2, picot, ch 3, (2 tr, ch 3, 2 tr) in next ch-3 sp, ch 5, skip next ch-5 sp, sc in next ch-4 sp, ch 4, sc in next ch-4 sp, ch 5, skip next ch-5 sp**, (2 tr, ch 3, 2 tr) in next ch-3 sp; rep from * around, ending last rep at **, join with sl st in top of beg ch-4.

Rnd 16: Sl st in next tr and next ch-3

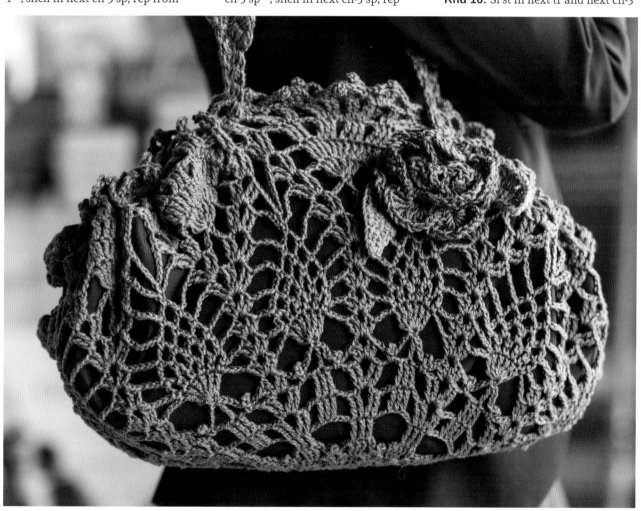

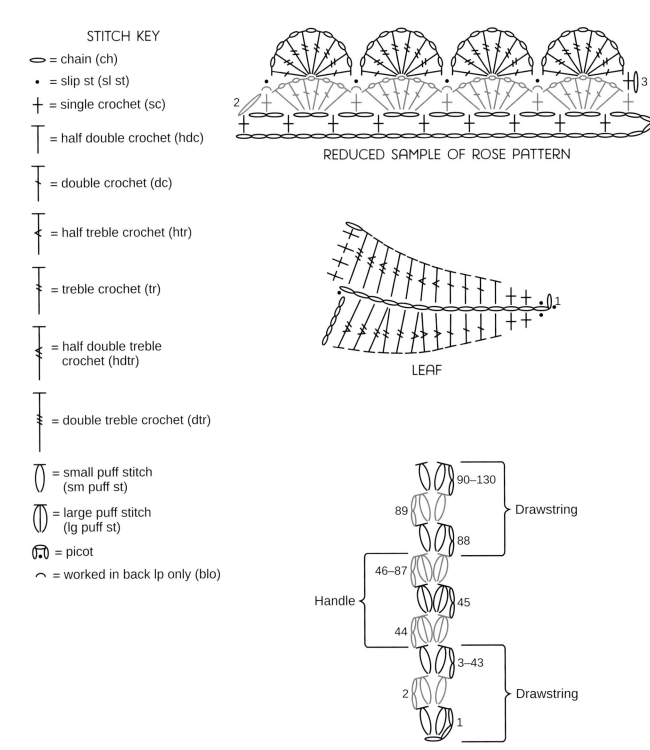

STITCH KEY

⬯ = chain (ch)

• = slip st (sl st)

✚ = single crochet (sc)

T = half double crochet (hdc)

⊤ = double crochet (dc)

≺ = half treble crochet (htr)

≹ = treble crochet (tr)

≼ = half double treble crochet (hdtr)

≹ = double treble crochet (dtr)

◖◗ = small puff stitch (sm puff st)

◖◗ = large puff stitch (lg puff st)

⊙ = picot

⌒ = worked in back lp only (blo)

REDUCED SAMPLE OF ROSE PATTERN

LEAF

DRAWSTRING/HANDLE

148 Colorful Crochet Lace

sp, ch 4, (tr, ch 3, 2 tr) in same sp, *ch 3, skip next ch-3 sp, 6 tr in next picot, ch 3, skip next ch-3 sp, (2 tr, ch 3, 2 tr) in next ch-3 sp, ch 6, skip next ch-5 sp, sc in next ch-4 sp, ch 6, skip next ch-5 sp**, (2 tr, ch 3, 2 tr) in next ch-3 sp; rep from * around, ending last rep at **, join with sl st in top of beg ch-4.

Rnd 17: Sl st in next tr and next ch-3 sp, ch 4, (tr, ch 3, 2 tr) in same sp, *ch 3, skip next ch-3 sp, 2 tr in each of next 6 tr, ch 3, skip next ch-3 sp, (2 tr, ch 3, 2 tr) in next ch-3 sp, ch 5, skip next ch-6 sp, sc in next sc, ch 5, skip next ch-6

sp**, (2 tr, ch 3, 2 tr) in next ch-3 sp; rep from * around, ending last rep at **, join with sl st in top of beg ch-4.

Rnd 18: Sl st in next tr and next ch-3 sp, ch 4, (tr, ch 3, 2 tr) in same sp, *ch 3, skip next ch-3 sp, tr in each of next 3 tr, [ch 3, tr in each of next 3 tr] 3 times, ch 3, skip next ch-3 sp, (2 tr, ch 3, 2 tr) in next ch-3 sp, skip next 2 ch-6 sps**, (2 tr, ch 3, 2 tr) in next ch-3 sp; rep from * around, ending last rep at **, join with sl st in top of beg ch-4.

Rnd 19: Sl st in next tr and next ch-3 sp, ch 4, tr in same sp, *ch 3, skip next ch-3 sp, [tr in next tr, (tr, ch 3, tr) in next tr, tr in next tr] 4 times, ch 3, skip next ch-3 sp, 2 tr in next ch-3 sp**, ch 1, 2 tr in next ch-3 sp; rep from * around, ending last rep at **, sc in top of beg ch-4 instead of last ch-1 sp.

Rnd 20: Ch 1, sc in same sp, *ch 4, (2 tr, picot, tr) in next ch-3 sp, ch 4**, sc in next sp; rep from * around, ending last rep at **, join with sl st in first sc. Fasten off.

Weave in ends.

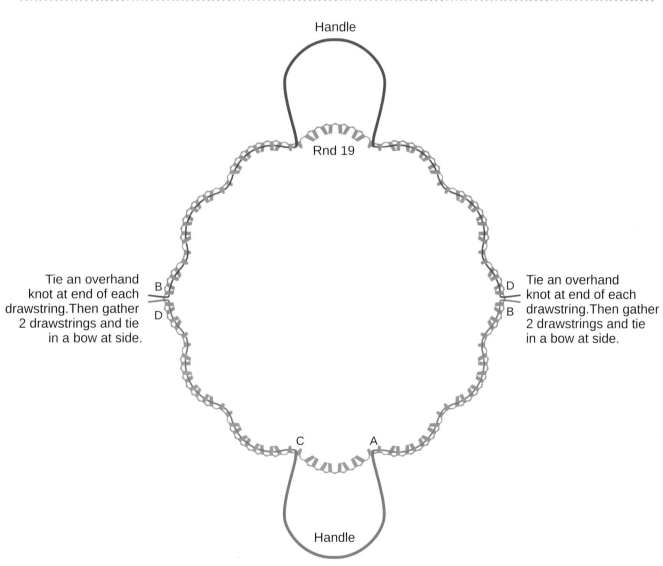

Handle

Rnd 19

Tie an overhand knot at end of each drawstring. Then gather 2 drawstrings and tie in a bow at side.

B
D

Tie an overhand knot at end of each drawstring. Then gather 2 drawstrings and tie in a bow at side.

D
B

C A

Handle

DRAWSTRING/HANDLE ASSEMBLY DIAGRAM

Drawstring/ Handles (MAKE 2)

DRAWSTRING

With A, ch 3.

Row 1: 2 sm puff sts in 3rd ch from hook, turn—2 sm puff sts.

Row 2: Ch 2, 2 sm puff sts between 2 puff sts in previous row, turn.

Rows 3–43: Rep Row 2.

HANDLE

Rows 44–87: Ch 2, 2 lg puff sts between 2 puff sts in previous row, turn.

DRAWSTRING

Rows 88–130: Rep Row 2. Fasten off.

Assembly

Following the assembly diagram, insert one end of one drawstring in space at A, weave the drawstring in and out of the larger spaces in Rnd 19 across first 2½ fans, exiting at B. Skip one fan from A, insert the other end of the same drawstring in the space at C, weave the drawstring in and out of the spaces in Rnd 19 across the first 2½ fans, exiting at D. Handles will lie loose over the center fan. Tack the base of the handle at A and C. Gather the drawstrings evenly on either side of the handle as desired. Tie each end of the drawstring in an overhand knot. Turn the doily over and rep on the other side of the bag with a second drawstring/handle. Tie two adjacent ends of the drawstring in a bow at the side of the bag. Repeat on the other side of the bag.

Finishing

LINING

NOTE: This process will be a little easier if your outside and inside lining are the same fabric, but if you chose 2 different fabrics as I did, it's worth it!

Lay the inside and outside fabric pieces with RS together on a flat surface. Lay the doily on top and pin all 3 thicknesses in place. With a marker, draw a circle on the outside edges on the WS of the fabric the same size as doily, being careful not to touch the doily with a marker. Remove the doily and cut both thicknesses of fabric in a circle where marked. If you want pockets, this would be the time to make them on one fabric piece. See pocket instructions below. Lay cut Lining on top of stabilizer and cut stabilizer the same size. Place lining pieces with RS together, then place stabilizer on top, which will be to WS of one lining piece. Pin all 3 thicknesses (stabilizer and both lining pieces) tog and sew a ½" (1.3 cm) seam

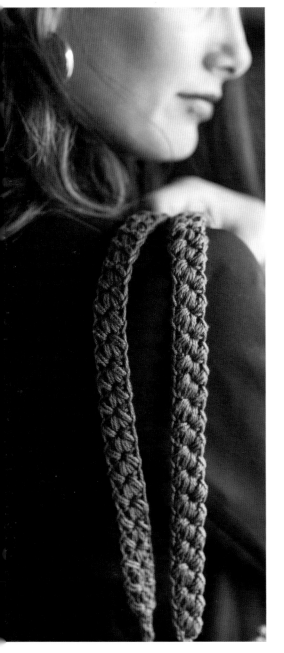

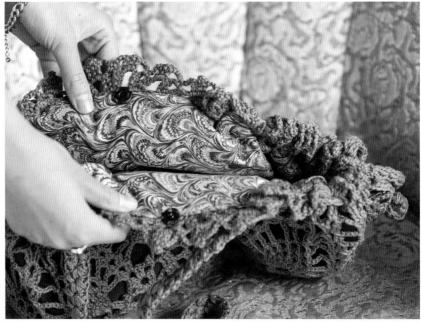

around circle, leaving an opening so you can turn the lining RS out. Lining and stabilizer piece is smaller than the doily, so the outside lacy edges of the purse will show without the lining being in the way. See photo. Before turning the lining RS out, being careful not to cut the seam, cut tiny ¼" (6 mm) slits around edge, making it easier to press the lining on the outside to the proper size and so the piece will be pressed to a smooth circle edge. Turn the lining RS out. After pressing the seam flat, pin the outside edges and sew a seam about ⅛" (3 mm) from the edge with machine or by hand. Place the lining piece you just sewed on top of the WS of the doily, making sure the fabric you chose to show through the front is placed on the doily. This way the fabric you chose for the inside is showing on the inside. There should be about ½" (1.3 cm) of doily exposed on the edges that will not have lining behind it. Pin the lining to the inside of the bag, whipstitch the lining to the doily with a needle and sewing thread by hand close to the edge.

NOTE: It will be best to have the handles woven through both sides of the purse and gathered in place before you handsew the lining inside the bag. Failing to do this will cause the lining and doily to pull if gathered afterward.

POCKET (OPTIONAL)
You need to do this with one thickness of inside lining fabric before sewing the lining pieces together.

Pocket has double fabric to avoid frayed edges. Cut 2 squares of fabric 5½" (14 cm) × 6½" (16.5 cm). Press all 4 edges under ½" (1.3 cm) to the WS on both pocket pieces. With WS together, pin both pocket pieces to each other, and then pin the pocket where desired to one side of the lining that will be showing on the inside of the bag. Stitch in place with machine or by hand, close to the edges, leaving the top edge free for the pocket opening. If you want 2 pockets inside the bag, rep this process on the other inside lining piece.

FLOWER
NOTE: Flower is worked in a long strip and rolled up into a rose.

With A, ch 79.

Row 1: Sc in 7th ch from hook, *ch 2, skip next 2 ch, sc in next ch, rep from * across, turn—25 ch-sps.

Row 2: Ch 1, sc in first ch-2 sp, (hdc, ch 1, dc, ch 1, dc, ch 1, dc, ch 1, dc, ch 1, hdc) in next ch-2 sp, sc in next ch-sp; rep from * across, ending with sc in last ch-6 lp, turn—12 shells.

Row 3: Ch 1, sc in first sp, *(dc, ch 1, tr, ch 1, tr, ch 1, tr, ch 1, tr, ch 1, tr, ch 1, dc) in center ch-1 sp of next shell, ch 1, sl st in blo of next sc, ch 1; rep from * across.

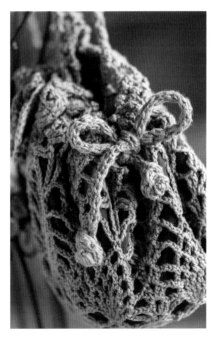

Fasten off, leaving a 12" (30.5 cm) tail for weaving through Row 1.

If you prefer a smaller rose, work only the first 2 rows of the flower.

With a yarn needle, weave the yarn tail through spaces in Row 1 all the way to the end, do not fasten off. Beg with other end, start rolling the strip up, bringing the end to the center into a circle. Pull tight and start rearranging the petals. From the bottom (underside) of the flower, sew the rows tog so they'll stay in place. You'll have to manipulate the petals to go where you want. The flower will look best if the petals are not directly in front of each other. Try to work it so the top of the petal curls back, which will make the flower look more realistic.

LEAF (MAKE 3)
With B, ch 15.

Rnd 1: Sl st in 2nd ch from hook, sc in each of next 2 chs, hdc in next ch, dc in each of next 3 ch, htr in each of next 2 chs, tr in each of next 2 chs, hdtr in each of next 2 chs, dtr in next ch, ch 1, rotate to work across end of leaf, work 4 sc across post of last dtr, sl st in first ch of foundation ch, ch 5, hdtr in next ch, 2 tr in next ch, tr in next ch, 2 htr in next ch, htr in next ch, dc in each of next 3 chs, hdc in next ch, sc in each of next 2 chs, sl st in each of next 2 chs. Fasten off.

Graduated Stitch Method

If you're familiar with my earlier book *Crochet That Fits: Shaped Fashions Without Increases or Decreases* (Krause, 2008), then you know all about my signature method of making shaped crochet garments without using increases or decreases. People who had previously made only afghans, scarves, and washcloths learned how to easily make flattering garments for themselves. The method was so popular that *Crochet That Fits* was voted "Best Crochet Pattern Book of 2008" by the Crochet Liberation Front.

In a nutshell, the Graduated Stitch Method (GSM) is an easy method I came up with that uses different stitch heights on the same row to create shaping that looks and acts like increases and decreases. Designs that incorporate this method are usually worked in vertical rows with the beginning chain at the side, so if your garment is too big or too small, all you have to do is delete some rows or add more rows!

Working stitches in the back loop only (blo) helps garments stretch and drape for a better fit and feel and is used with some, but not all, of my GSM designs.

The projects in this book that use the GMS are the Sleeveless Tunic (page 10), the Flared Dress (page 96), the Pullover (page 34), and the Peplum Top (page 58). The patterns for these projects include exact instructions for creating them, so you don't have to figure out how to apply the method, and also explain clearly how to easily make the garment larger or smaller to fit you exactly.

This diagram shows how crochet stitches gradually become taller, starting with the slip stitch (the shortest) and ending with the double treble stitch (the tallest).

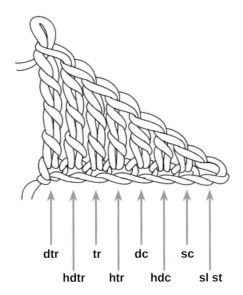

dtr tr dc sc

hdtr htr hdc sl st

Abbreviations

beg begin; begins; beginning

bet between

blo back loop only

ch(s) chain(s)

cl(s) cluster(s)

cm centimeter(s)

cont continue(s); continuing

dc double crochet

dec decrease(s); decreasing; decreased

dtr double treble (triple)

dtr-cl double treble cluster

g gram(s)

GSM Graduated Stitch Method

hdc half double crochet

hdtr half double treble

htr half treble crochet

inc increase(s); increasing; increased

lp(s) loop(s)

m meter(s)

mm millimeter(s)

patt(s) pattern(s)

PM place marker

pop popcorn

quad tr quadruple treble

rem remain(s); remaining

rep repeat; repeating

rnd(s) round(s)

RS right side

sc single crochet

sl slip

sl st slip(ped) stitch

sp(s) space(s)

st(s) stitch(es)

tch turning chain

tog together

tr treble crochet

tr-cl treble crochet cluster

tr tr triple treble crochet

WS wrong side

yd yard(s)

yo yarn over

***** repeat starting point

() alternative measurements and/or instructions; work instructions within parentheses in place directed

[] work bracketed instructions a specified number of times

Glossary

Stitches

CHAIN (CH)
Make a slipknot and place it on crochet hook. *Yarn over hook and draw through loop on hook. Repeat from * for the desired number of stitches.

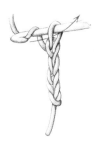

SLIP STITCH (SL ST)
*Insert hook into stitch, yarn over hook and draw loop through stitch and loop on hook. Repeat from *.

SINGLE CROCHET (SC)
Insert hook into a stitch, yarn over hook and draw up a loop **(figure 1)**, yarn over hook and draw it through both loops on hook **(figure 2)**.

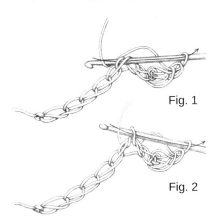

Fig. 1

Fig. 2

HALF DOUBLE CROCHET (HDC)
*Yarn over, insert hook in stitch **(figure 1)**, yarn over and pull up loop (3 loops on hook), yarn over **(figure 2)** and draw through all loops on hook **(figure 3)**; repeat from *.

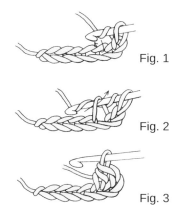

Fig. 1

Fig. 2

Fig. 3

DOUBLE CROCHET (DC)
*Yarn over hook, insert hook in a stitch, yarn over hook and draw up a loop (3 loops on hook; **figure 1)**, yarn over hook and draw it through 2 loops **(figure 2)**, yarn over hook and draw it through remaining 2 loops on hook **(figure 3)**. Repeat from *.

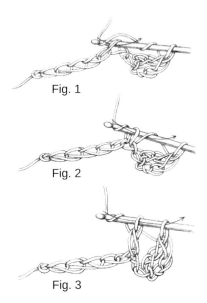

Fig. 1

Fig. 2

Fig. 3

TREBLE CROCHET (TR)
*Wrap yarn around hook twice, insert hook in next indicated stitch, yarn over hook and draw up a loop (4 loops on hook; **figure 1)**, yarn over hook and draw it through 2 loops **(figure 2)**, yarn over hook and draw it through next 2 loops, yarn over hook and draw it through the remaining 2 loops on hook **(figure 3)**. Repeat from *.

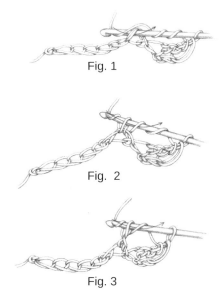

Fig. 1

Fig. 2

Fig. 3

DOUBLE TREBLE CROCHET (DTR)
Yarn over hook three times, insert hook in a stitch, yarn over hook and draw up a loop (5 loops on hook). [Yarn over hook and draw it through 2 loops] four times. Repeat from *.

Decreases

SINGLE CROCHET TWO TOGETHER (SC2TOG)

Insert hook in stitch, yarn over, and draw up a loop. Insert hook in next stitch and draw up a loop. Yarn over hook **(figure 1).** Draw through all 3 loops on hook **(figures 2 and 3)**—1 stitch decreased.

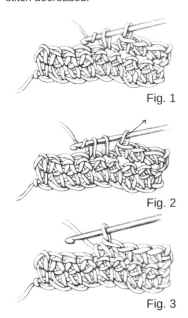

Fig. 1

Fig. 2

Fig. 3

SINGLE CROCHET THREE TOGETHER (SC3TOG)

[Insert hook in next stitch, yarn over, pull loop through stitch] three times (4 loops on hook). Yarn over and draw yarn through all 4 loops on hook. Completed sc3tog—2 stitches decreased.

DOUBLE CROCHET THREE TOGETHER (DC3TOG)

[Yarn over, insert hook in next stitch, yarn over and pull up loop, yarn over, draw through 2 loops] three times (4 loops on hook), yarn over, draw through all loops on hook—2 stitches decreased.

Seaming

WHIPSTITCH

With right sides (RS) of work facing and working through edge stitches, bring threaded needle out from back to front, along edge of piece.

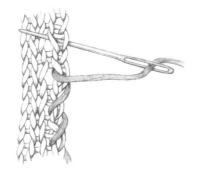

A WORD ABOUT GAUGE

If you're making a scarf, afghan, or purse, gauge is not that important, but I cannot stress how important it is when you're crocheting garments. You don't want your garment meant for an adult to end up fitting a five-year-old. It can easily happen. (With my Graduated Stitch Method [see page 152], you can easily adjust the size to fit, but that's another story.) To check your gauge, work up a 4″ x 4″ (10 x 10 cm) swatch before beginning any garment and check your gauge. Check your gauge often as you work a pattern, because your gauge could change. When we are stressed, we tend to crochet tighter, and I can attest to that! Note that I tend to crochet more loosely than most people, so you may need to use a larger hook than what my patterns call for.

Sources for Yarn

BERROCO
1 Tupperware Dr., Ste. 4
N. Smithfield, RI 02896
(401) 769-1212
berroco.com

BE SWEET
7 Locust Ave.
Mill Valley, CA 94941
(415) 388-9696
besweetproducts.com

CARON
Distributed by Spinrite

CASCADE
cascadeyarns.com

COATS & CLARK
PO Box 12229
Greenville, SC 29612
(800) 648-1479
coatsandclark.com

JUNIPER MOON FARM
Distributed by Knitting Fever, Inc.

KNIT ONE, CROCHET TOO
91 Tandberg Trail, Unit 6
Windham, ME 04062
(207) 892-9625
knitonecrochettoo.com

KNIT PICKS
13118 NE 4th St.
Vancouver, WA 98684
(800) 574-1323
knitpicks.com

KNITTING FEVER, INC.
PO Box 336
315 Bayview Ave.
Amityville, NY 11701
(516) 546-3600
knittingfever.com

LOUISA HARDING
Distributed by Knitting Fever, Inc.

MALABRIGO
(786) 866-6187
malabrigoyarn.com

PATONS
Distributed by Spinrite

RED HEART
Distributed by Coats & Clark

ROWAN
Distributed by Westminster Fibers

SMC
Distributed by Westminster Fibers

SPINRITE
320 Livingstone Ave. So.
Box 40
Listowel, ON
Canada N4W 3H3
(800) 351-8356
yarnspirations.com

TAHKI YARNS
70-60 83rd St., Bldg. #12
Glendale, NY 11385 USA
(718) 326-4433
tahkistacycharles.com

UNIVERSAL YARN
5991 Caldwell Park Dr.
Harrisburg, NC 28075
(877) 864-9276
universalyarn.com

WESTMINSTER FIBERS
165 Ledge St.
Nashua, NH 03060
(800) 445-9276
westminsterfibers.com

Acknowledgments

There were many obstacles put before me during the process of creating this book. I had a slow start when my little sister suffered a heart attack. She did not wake up for fifteen days, and I could not keep my mind on crochet or even think about designing a pattern. After several other setbacks and many panicky moments, knowing I was behind schedule, I finally decided the best thing to do was to take one day at a time and keep plugging along. I'm pretty sure I would not have finished if several people hadn't helped me out. I'm eternally grateful to Renee Huffman, Renee' Rodgers, Melody Kelley, Deb Kociszewski, and Natalia Kononova for working up projects for the book. And of course my very dear friend Merry Moses, who helped get the patterns and manuscript in order before my deadline. You will never know how much I appreciate all of you and your willingness to work quickly, even with your own very busy schedules.

I also want to thank my editor, Michelle Bredeson, who was amazingly sweet and patient with me and always helped to calm me down with her kind words of encouragement, giving me hope that there truly was a light at the end of the tunnel. You're the best! And Kerry Bogart (book acquisitions editor): I don't know how she managed not to tell me to forget it, when I was having such a hard time tweaking my designs and getting through the tedious process of choosing the right yarns in the right colors, fibers, and weights. I'll never forget your kindness and patience as well. And last but not least, thanks to all the staff at F+W and Interweave for each and every thing you have done to make it possible and for believing in me enough to get this book put on the shelves. It's been a very long process, but well worth it! I'm ready to start another book. Well, maybe not just quite yet, but I have many other exciting ideas and won't be able to sit still until they become a reality also. I love you all!

And now I'm ready to get some much-needed sleep!

Index

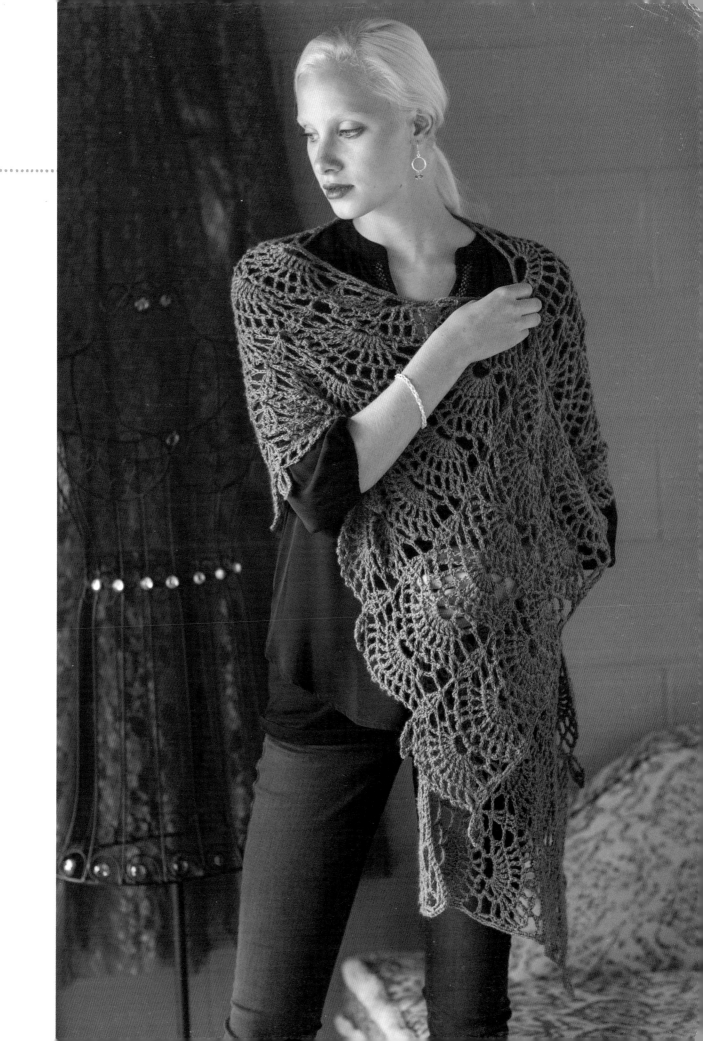